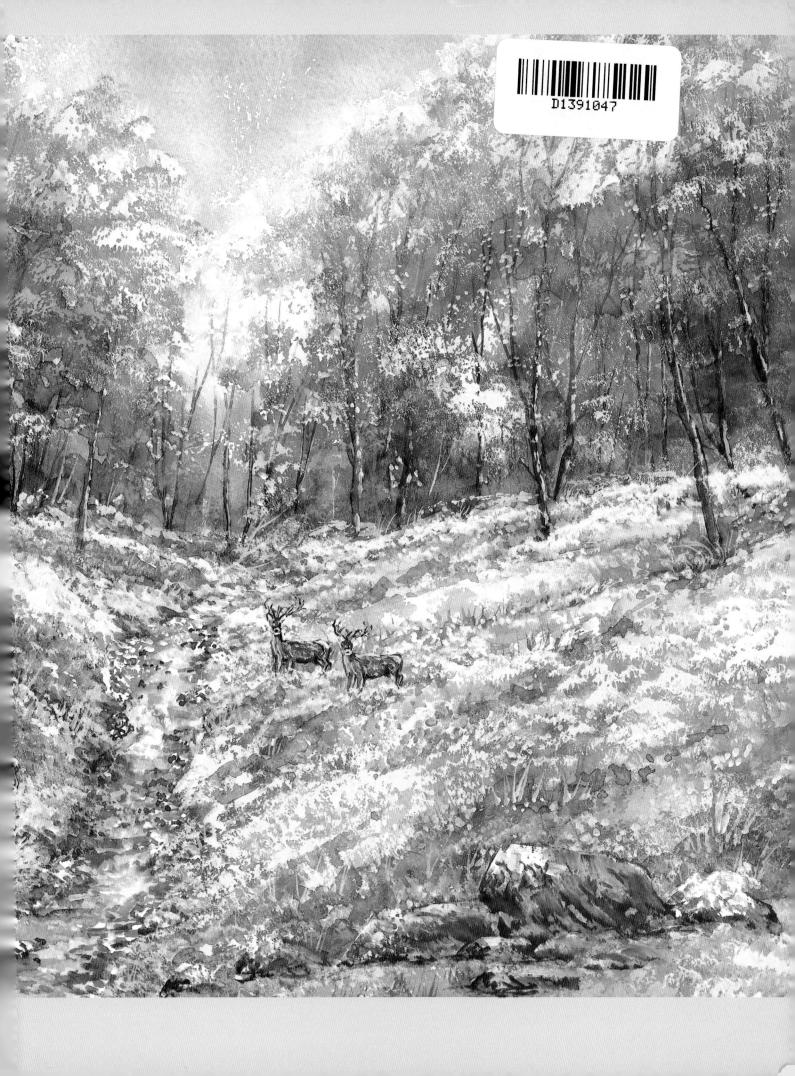

INTRODUCTION

SPRING

Leaves that are bursting open

Daffodil buds uncurled

This is the giving of glory

The offer of gold to the world

SUMMER

And all the goodness of the earth

Shall shine in glad array

As if lifetime's loveliness

Lived in one summer's day

AUTUMN

A world of wealth and wonders

Where the leaves dance as they fall

And all we lack is just the time

To go and see it all

WINTER

A fairyland of wisdom

In the filigree of frost

Where the golden leaves have fallen

And the foliage is lost.

Kathleen Partridge

HE LANDSCAPES IN THIS BOOK REPRESENT THE "ARTIST'S YEAR" from the gradual awakening of life in the Spring, the blossoming of colour through Summer and Autumn to the gradual slowing down of nature in the cold of

My aim in this book is to show my approach to painting a landscape from concept to finished painting, in the hope that the techniques I describe will be of use to both the beginner and the more experienced painter.

I have never believed that painting is a gift; whatever you wish to achieve in life has to be worked at. Watercolour painting is no exception, but it is easier than you think. By means of this book, I hope to prove it to you. Running workshops and painting holidays over many years has verified my belief that anyone can be taught to paint. All I ask of you is that you practise the techniques I am going to show you and follow the logical process I describe. You can do it if you really want to. By following these techniques and applying the principles of design you will soon be able to produce paintings that will give you immense satisfaction and pleasure.

Painting is a wonderful pastime - it will change your life. Just ask any artist! You will see things you have never noticed before and appreciate more fully the wonders of nature.

Don't forget, "Practice makes Perfect" - winners never quit and quitters never win. It is an artist's dream to see their paintings in book form and to know from the many phone calls and letters received that in a small way they are helping other artists to fulfil their dreams and aspirations.

In my paintings, I attempt to capture the ever-changing light and mood in the landscape. What better way to present them than by painting the seasons of the year?

Happy painting!

Keith Fenwick

HOW TO USE THIS BOOK

IF YOU ARE A BEGINNIFR, commence by studying the sections dealing with the basic materials, the principles of design, colour mixing, techniques for painting the elements and most importantly, the section covering tonal values. Follow this by attempting the more simple projects and as your skills and confidence grow, tackle more advanced subjects.

THE MORE EXPERIENCED PAINTER may have difficulties painting certain elements such as skies, trees, etc. I suggest you work through the projects and close-ups referring to the sections dealing with the elements with which you are having difficulty.

Why not paint a particular project in a different season to the one portrayed?

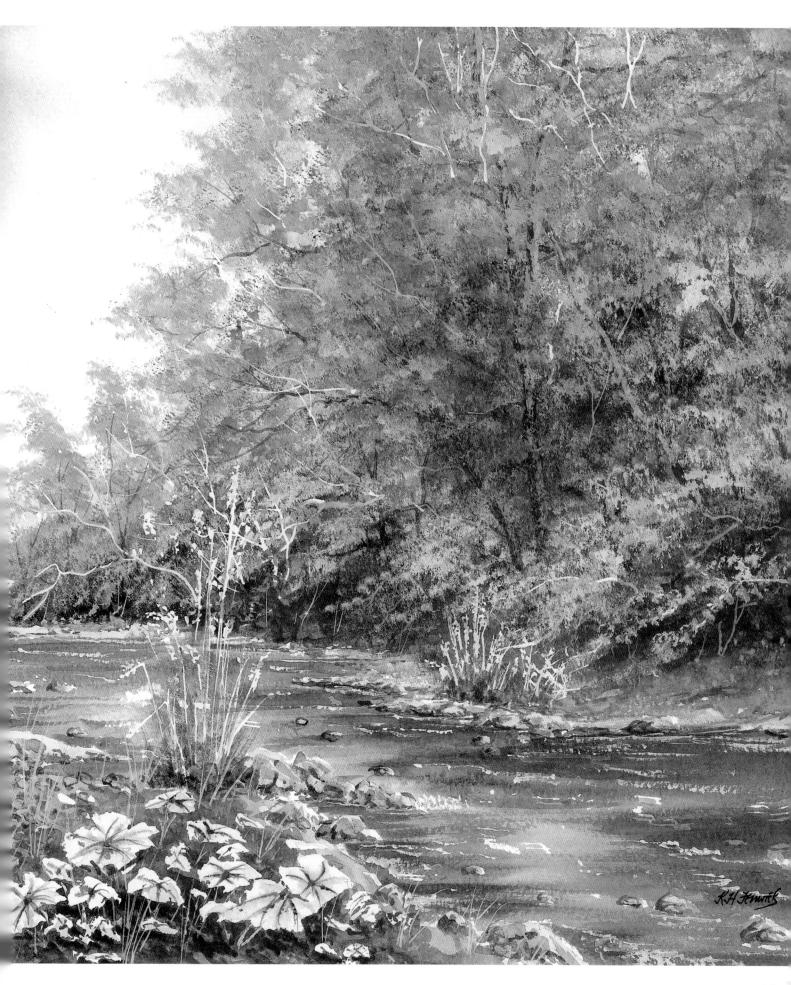

MATERIALS & EQUIPMENT

THERE IS A SCHOOL OF THOUGHT THAT RECOMMENDS BEGINNERS TO PURCHASE CHEAP, poor quality brushes, cheap paper and cheap paints when starting out. Having run workshops and painting holidays for many years and observed at first hand the difficulties that beginners encounter using such materials, I don't hold with this opinion. I recommend you purchase the best materials you can afford – your investment will work out cheaper in the long term and your frustration will be considerably less.

PAINTS

Whether you use pans of paint or tube colours is a matter of preference. Most professional artists prefer tube colours because they are more convenient for mixing large washes and are moist and more easily used for general painting. Pans of paint become very hard if left unused and release less colour. They are more suitable for carrying on holiday and for sketching purposes.

The choice of colours is personal to the artist but you won't go far wrong if you begin with my basic palette and as you progress, purchase additional colours as required.

BASIC PALETTE

SKY	EARTH	MIXERS	
Payne's Gray	Raw Sienna	Cadmium Yellow Pale	
Cerulean	Burnt Sienna	Permanent Sap Green	
Alizarin Crimson	Burnt Umber		

SUPPORTIVE PALETTE

French Ultramarine	Gold Ochre	Winsor Yellow	Brown Madder
Cobalt Blue	Winsor Red	Purple Madder	Vermilion

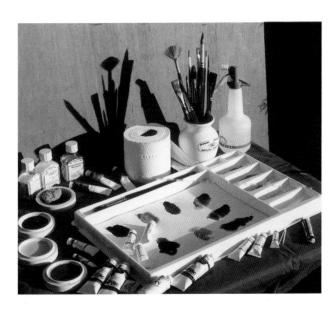

BRUSHES

For painting skies and other large areas, I use a $1^{1}/_{2}$ " hake brush.

For control, I use a size 14 round, for buildings and angular shapes, a $^{3}/_{4}$ " flat brush and for detail, a size 3 or larger rigger brush.

A size 6 round brush is useful for shadows and when painting smaller elements.

PALETTE

I prefer to use a palette that has a large open area for colour mixing, allowing me to draw my colours into the centre and mix them to my requirements. For larger washes, I pre-mix them in ceramic saucers. One of the greatest difficulties my

students experience is attempting to mix colours on palettes with small indentations to hold paint and a very limited mixing area. Don't give yourself unnecessary problems; purchase a large palette.

PAPERS

Paper can be purchased in gummed pads, spiral bound pads, blocks (where the paper is glued all round, except for a small area where the sheets can be separated) and in sheet form. The sheets are less expensive and can be cut to the required size.

Quality paper can be purchased in various textures and weights.

The paintings in this book are painted mainly on 200lb and 300lb rough textured paper with a few on the thinner 140lb. 140/300gsm paper doesn't need stretching unless heavy washes are applied.

200lb/425gsm or 300lb/640gsm are my preference. They don't need stretching, a process whereby the paper is soaked in a bath, the water allowed to drain off and then secured all round to a board using gummed brown paper (not masking tape) and allowed to dry.

The paper will be as tight as a drum when dry. I have never stretched paper in 20 years although many artists do. There are three basic surfaces:

HP (Hot pressed) has a smooth surface, used for calligraphy, pen and wash.

CP/NOT (Cold pressed) has a slight texture (called the "tooth") and is used by the majority of artists.

ROUGH or EXTRA rough paper has a more pronounced texture that I prefer. It is wonderful for skies, tree foliage, dry brush techniques and creating sparkle on the water.

SUPPORTIVE ITEMS

The following items clearly seen in the photograph (left) support my painting kit:

Tissues: (toilet roll) for creating skies, applying textures and cleaning palettes.

Mediums: Art Masking Fluid, Permanent Masking Medium, Granulation Medium and Lifting Preparation are all useful and selectively used in my paintings.

Masking Tape: to control the flow of paint, masking areas in the painting and for fastening paper to backing board. I prefer $\frac{3}{4}$ width as it is easier to remove.

Cocktail sticks: useful for applying masking when fine lines are required.

Greaseproof paper: for applying masking.

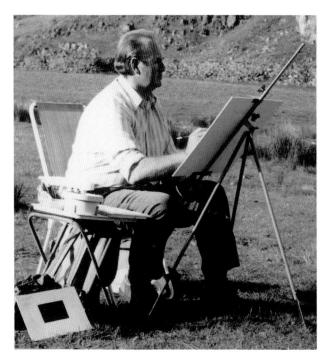

Atomiser bottle: for spraying paper with clean water or paint.

Painting board: your board should be 2 inches larger all round than the size of your watercolour painting. Always secure your paper at each corner and each side (8 places) to prevent it cockling when you are painting.

Eraser: a putty eraser is ideal for removing masking.

Sponge: natural sponges are useful for removing colour and creating tree foliage, texture on rocks, etc.

Water-soluble crayons: for drawing outlines, correcting mistakes and adding highlights.

Palette knife: for moving paint around on the paper (see page 79).

Saucers: for mixing large washes and pouring paint.

Hairdryer: for drying paint between stages.

Easel and stool: I occasionally use a lightweight easel

PAINTING OUTDOORS

and a stool for outdoor work.

I like to be comfortable when painting outdoors. The photograph above shows the set-up I prefer. If I am painting a scene that isn't too far from the car, I carry a folding chair. If I have to walk a considerable distance, I usually sit on a rock or wall. A lightweight metal easel is useful for holding the paper/board and a haversack/stool useful for carrying materials to my destination. The stool is then used to support my palette and water pot. As the photograph shows, this set up provides a very comfortable painting station. A viewfinder shown in the photograph enables me to view the best composition.

WATERCOLOUR **TECHNIQUES**

WATERCOLOURISTS HAVE A WIDE RANGE OF TECHNIQUES AVAILABLE TO THEM TO USE IN their paintings, some very common, some more imaginative. The more experienced watercolourist will know which basic technique to use to paint a particular element in their painting and which special technique to use to create a specific texture or effect. In the following pages, I have shown a wide range of techniques for you to practise.

Some will be used in every painting, whilst others will only be selected as needed to create a special effect.

FLAT WASH Created by brushing a fluid paint evenly over a damp or dry surface.

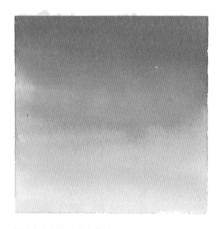

GRADED WASH As the flat wash, but add more water to each brush stroke as you work down.

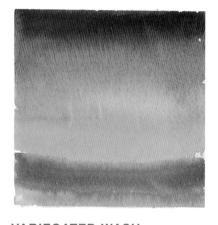

VARIEGATED WASH As the flat wash but change the colours between brush strokes.

GLAZING Useful effects can be achieved by brushing various washes over a dry under-painting.

DRY BRUSH A paint-loaded damp brush washed over a dry surface quickly is useful for creating texture or sparkle when painting water.

WET IN WET Paint applied to a wet surface will blend freely to create soft effects. The under-painting should be no more than one third dry or hard edges will form.

WET ON DRY

Paint applied to a dry surface will create crisp hard edges or dry brush effects. Applying the paint with different pressures will create a range of wide or narrow lines.

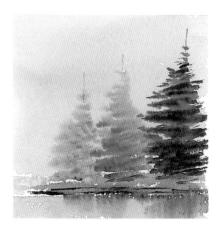

DRY ON WET

Varied effects can be achieved by painting a fairly dry paint into a wet under-painting. Soft effects can be achieved, and as the under-painting dries, more detail will result.

Paint can be easily removed from a wet under-painting using a clean moist absorbent brush. Clouds etc can be created using this technique.

CREATING TEXTURE

Here a piece of masking tape has been pressed over a moist under-painting and removed. The masking tape will pick up the colour, creating a textured effect. Useful tip for texture on grass, rocks, tree trunks etc.

CREATING TEXTURE

Both permanent masking medium and deposits made with an oil pastel have been over-painted to create shape and texture. Ideal as a resist when painting rocks, tree structures etc. With permanent masking the medium isn't removed. Colour can be added to the medium.

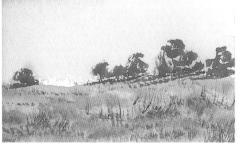

BRUSH WORK

A useful technique for creating the effects of tufts of grass is to fan the hairs of a paint laden round brush and holding the brush by the tip of the handle, flick upwards to create the desired effect.

MASKING FLUID

Here masking fluid has been overpainted to create the effect of mortar between stonework. The masking is removed when the paint is dry, using a putty eraser.

GRANULATION MEDIUM

Produces a mottled or granular appearance to colours, which usually give a smooth wash.

LIFTING PAINT

Wet a dry under-painting with a clean wet brush and remove paint by wiping with an absorbent tissue. By shaping the tissue, various thick or thin lines can be created.

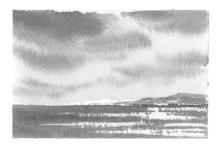

SCRAPING

Sparkle on the water has been achieved by scraping a razor blade over the surface. Care must be taken to ensure the paper surface isn't too badly damaged.

WATER DROPLETS

Water dropped or flicked onto a moist under-painting can create an interesting range of effects.

Interesting effects can be created by brushing stiff moist paint into a very wet under-painting and tilting the surface in different directions,

encouraging the paint to run and blend

together - ideal for skies.

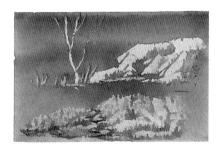

PALETTE KNIFE

A palette knife can be used effectively to move wet paint. Dependent on the angle of the knife to the paper and timing, various effects can be achieved.

TABLE SALT

BLENDING

Sprinkle table salt over a moist underpainting to create special effects. Dependent on the wetness of the under-painting, different effects can be achieved. When dry blow away the salt.

BRUISING

By stroking a cocktail stick through a wet under-painting to slightly bruise the paper surface, the paint will gather in the indentations, creating the effect of wood grain etc.

PLASTIC WRAP

Crumple plastic wrap and press it on to a wet under-painting and leave to dry. The pigment will create interesting effects when removed. Use for the background of a woodland scene or to create a rough foreground.

STIPPLING

Use a hog hair or other stiff brush and stipple paint to create the effect of tree foliage or rough grass.

SPATTERING

Wet paint flicked or flung over a moist or dry surface, creates interesting effects. Use for tree foliage, wild flowers or wherever texture is needed.

IMPRINTING

Various shapes cut from mount card can be dipped in paint and pressed on to a dry under-painting to produce various effects. Useful for leaf effects.

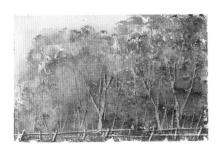

SCRAPING OUT

In this example, the corner of a palette knife has been used to scratch in the tree structures when the paint was approximately one third dry. If scratched out when the paint is too wet, bruising of the surface will occur and dark tree structures will result.

OIL PASTEL

Here an oil pastel has been used to represent flowers. Over-painting is repelled by the pastel. Useful for painting garden scenes, textures on rock, sparkle on water, window frames and other highlights. Ideal for painting veins in leaves.

SPONGING

Dip a damp sponge into paint and stipple to create tree foliage, foreground texture etc. A sponge moistened with clean water can be used to wipe across mountaintops etc to remove paint to represent low cloud or mist.

DESIGN PRINCIPLES

COMPOSITION

Choosing the best viewpoint to give a pleasing composition is a basic requirement. By composition, we mean the best arrangement of the elements in the landscape to produce an attractive painting. This includes several stages; tonal studies of possible compositions, simplifying the scene by discarding any details that make no positive contribution to the painting, and balancing the composition. By choosing a different viewpoint the composition can be significantly improved.

The two examples shown illustrate this point. Instead of looking at the scene straight on, the artist has viewed the scene from the left, giving a much-improved representation of the mountains. Pages 42-45 give a detailed analysis of composition.

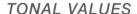

I believe the most significant design principle in ensuring a successful painting is determining the most appropriate tonal values, ie the establishment of light and dark areas in the painting.

Visualise or construct a scale from 1 - 10 where black is represented by 1 and white by 10. For your painting to be successful establishing the relationship between the lightness and darkness of any hue is paramount. This is where the quick tonal sketch is important in helping you

clarify your thinking, prior to putting paint to paper. Pages 16-19 explain further how tonal values are used.

RECESSION

Recession in your painting is a simple matter of producing a quick tonal study, making elements farthest away pale in tone, middle distance a middle tone and foreground darker in tone. This process ensures that the viewer is able to look into the painting into the distance. Compare the tonal study above with the completed sketch.

BALANCE

I think of balance in three areas: compositional balance, tonal balance and colour balance. The first two are covered in more detail in the book. With colour balance it is a matter of

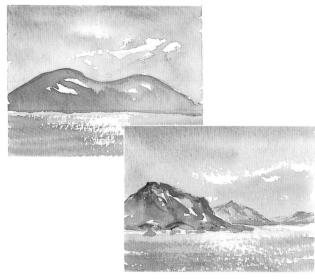

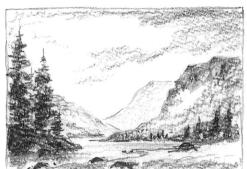

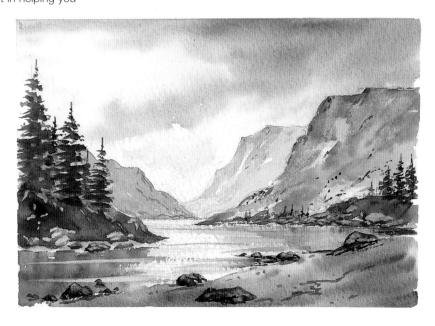

taste. As artists, subtlety is our watchword! In design we try to create an initial attraction and colour combination that the viewer can live

with over time. A colour balance that works is to contrast a warm area, say sienna and yellows, with a cold area of say, cold blue or green.

COLOUR MIXING

I have included a very comprehensive section on colour mixing in pages 62-69.

WARM COLOURS

Warm colours are generally thought of as combinations of yellows, sienna, browns and reds. In this "doodle" I have used Cadmium Yellow Pale, Raw Sienna, Burnt Sienna, Burnt Umber and Alizarin Crimson.

COOL COLOURS

In this "doodle", I have mixed Cadmium Yellow Pale with Cobalt Blue and produced darker tones by adding various quantities of Payne's Gray.

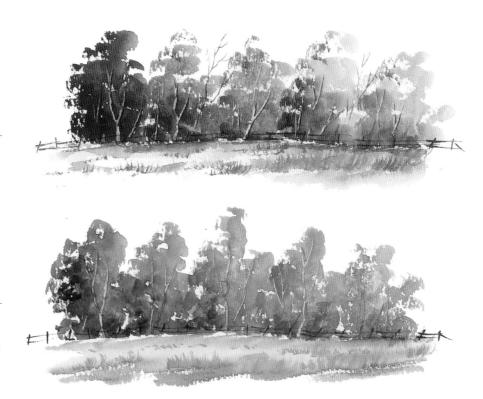

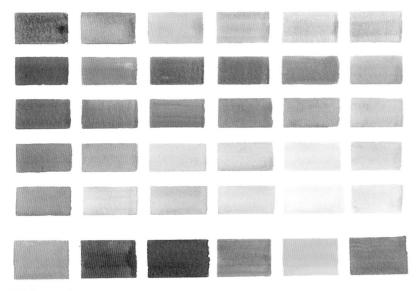

COLOUR COMBINATIONS

Over one hundred shades of green can be produced by mixing combinations of Payne's Gray, Cobalt Blue, Raw Sienna, and Cadmium Yellow Pale. Thirty shades of green are shown here but on pages 62-69 an extensive range of colour combinations to satisfy most needs are illustrated.

TEXTURES

All paintings will show three types of texture.

SMOOTH TEXTURE: Achieved by lightly brushing a wellloaded brush over dry paper.

ROUGH TEXTURE: Achieved by brushing a moist brush quickly over dry papers.

SOFT TEXTURE: By using the wet in wet technique brushing with a loaded moist brush into an under-painting that must be less than one third dry to avoid hard edges. Here, timing is important.

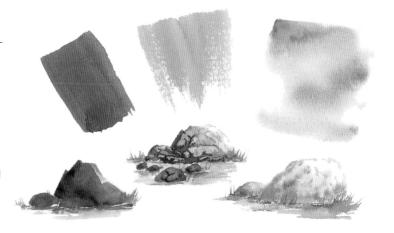

HARMONY

Harmony in a painting is achieved by providing small changes between size, shape, line, value/tone, texture or colour etc. An example of colour harmony can be observed in the sketch on the right. Only two colours have been used here - blue and yellow. The simplest way to achieve colour harmony is to use a limited range of colours. If the aforementioned elements are repeated using great change, the result is contrast. If however, little change is implemented, the principles of harmony are being observed.

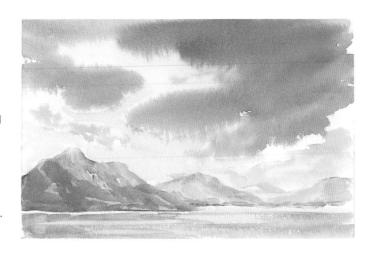

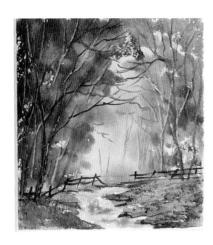

CONTRAST

Contrast involves an abrupt change from one element to another. In the woodland "doodle", the warm foreground trees on the left, contrast with the cool background leading the eye in to the distance.

Contrasting colours are those directly opposite each other on the colour wheel ie red/green, orange/blue, purple/yellow. Contrast involves conflict between the elements of colour, shape, line, value or texture. In the U.K we use the term **COUNTERCHANGE** to describe the painting of a light object against a dark background, as in the "doodle", or vice versa.

GRADATION

Gradation means a gradual change. Skies for example represent a gradual change of colour and value. Daylight gradually changes from light to dark.

When painting a group of trees there may be a gradual change between the green foliage of neighbouring trees or the grass in a foreground meadow.

Whilst contrast provides a distinctive sharp change, gradation involves a more gradual change. Gradation occurs in values, colours, shapes, size, line and direction.

Gradation in direction for example, a woodland path that bends from left to right can be used to lead the eye into the distance or to the focal point.

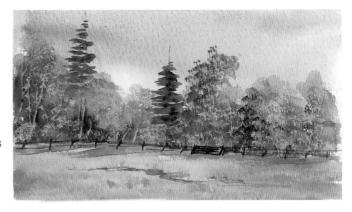

VARIATION

As previously stated contrast involves an abrupt change, gradation is a gradual change and harmony a small change.

Variation embraces all of the above three principles of design. As artists we are entertainers and our job is to embrace all of the elements in design into a finished painting to inspire the viewers.

Expressing it simply, variation involves making changes abruptly, gradually or in a small way to ensure the viewer doesn't become bored. These practices are those that distinguish the professional painter from the amateur.

In the example shown, the roughly made fence looks much more pleasing than a beautifully made fence that has perfectly positioned upright posts and three perfectly horizontal bars.

All the elements of contrast, gradation and harmony are illustrated in the seascape.

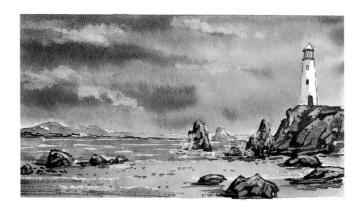

To paint a natural looking grass area, I have shown my approach below in simple stages:

STAGE 1 involves a simple wash

STAGE 2 involves brushing a darker tone whilst the underpainting is still wet.

STAGE 3 involves adding darker tones using a stiffer paint whilst the under-painting is still less than one third dry. The colours and tones will fuse together to create a natural looking grass area.

SHAPE, SIZE, LINE, UNITY

The variety of shapes artists produce all fit into three categories - rectangular, angular or curved. As an artist, you are in the shape-making business, as all paintings will embrace these shapes even if one of these will be dominant.

In a mountainous scene the triangle will be dominant – in a scene with a building, the rectangular shape will be dominant and in a tree grouping, the circular shape may be dominant. Dominance can be ensured by shape, tonal value or colour. Size and shape can create contrast in a painting, for example, a large granular rock contrasting with smaller round rocks. The direction of line can dominate a painting.

In a woodland scene for example, the vertical tree trunks can dominate, creating a sense of awe, whilst horizontal lines create a sense of peace and tranquillity.

Study the principles of design and with experience embrace these in your painting. It's better to spend time producing tonal studies to clarify our thinking, before ruining a perfectly good piece of watercolour paper.

The painting should appear as a unit when finished.

The colours should be repeated in various values across the painting. The sky colours being represented in the foreground, darker smaller shapes should balance larger, light shapes. There should be only one focal point so as not to confuse the viewer. Two similar elements should never be placed above or below each other. Study the section on composition on pages 42-45.

THE IMPORTANCE OF TONAL STUDIES

I TOUCHED BRIEFLY ON THIS SUBJECT ON PAGE 12. I WANT TO SHOW IN THE following pages my approach to painting landscapes.

As has already been stated, value is the lightness or darkness of a particular hue and how these can be easily numbered from one to ten; 1 being black and 10 being white. This arrangement of lights and darks in a painting can contribute more to the success of a painting than any other design principle.

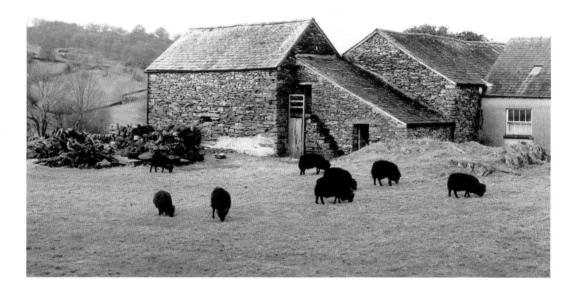

APPROACH - Concept to completed painting

When I visit a location for the first time, I like to view the scene from several vantage points. I'm looking to determine the best compositions. Some are quickly ruled out, others give me an immediate buzz. I look for distinctive features; the focal point or centre of interest, which may be a tree, a large rock, an impressive mountain peak or a figure in the landscape. I discard any elements that if leπ out worl't affect the overall composition. Don't forget to simplify - you can't compete with nature.

Having selected several possible compositions, I produce quick tonal value studies. These sketches completed in a few minutes help me to determine a final composition that appeals and helps me think through my approach to the

painting before beginning my outline drawing on watercolour paper and applying colour. Of course, as I produce these quick value studies, my mind is taking into account the principles of design and the various ways that tonal values can be incorporated into the composition.

I have chosen a photograph of a Lakeland farmstead to illustrate my approach from concept to finished painting. My viewpoints were limited, due to the view being restricted by a high hedge and limited access due to the stonewall and the road. Using a viewfinder, (mine consists of a $4^{1}/_{2} \times 3$ inch aperture cut into a 71/2 x 5 inch piece of mount card), I studied several possibilities, finally selecting the composition shown.

POSSIBLE TONAL STRATEGIES

There are six possible value patterns shown below, that I could use to complete this painting.

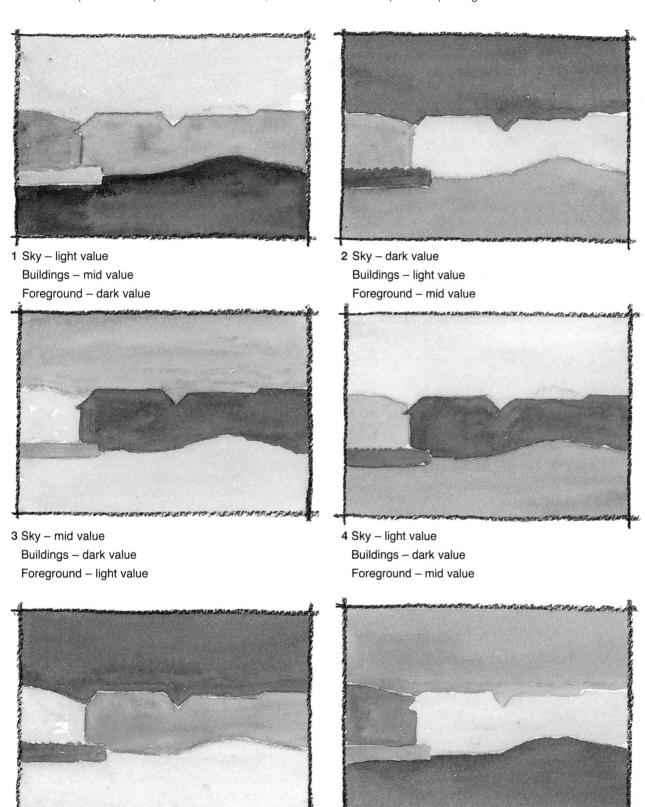

5 Sky - dark value Buildings - mid value Foreground - light value

6 Sky - mid value Buildings - light value Foreground - dark value

CONCEPT TO COMPLETED PAINTING

Any of the six possible tonal value patterns on the previous page would make a successful painting. The aim is to provide contrast/counterchange between each element in the painting, ensuring that each element is distinctive. Examine these value patterns and you will see that lights are placed against darks and darks against lights. Note especially the tonal relationships between the wall and the building.

To complete this landscape, I have basically chosen value pattern number 1 but have decided to vary it slightly, by making the wall darker and counterchanging it with a light value in the distant foreground.

Incidentally, the black sheep in the photograph are not indigenous to the Lakeland area so I have used artistic licence and replaced them with the normal black-faced sheep.

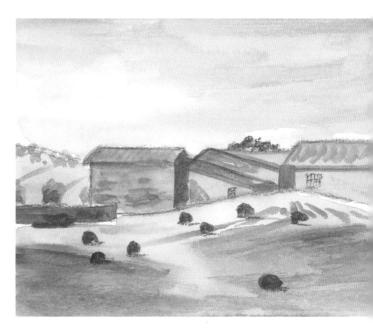

TONAL VALUE PATTERN 1

WHAT YOU WILL NEED

PAPER:

300lb Winsor and Newton Rough

BRUSHES:

Winsor & Newton Sceptre Gold II Series size 14 round, size 3 rigger, $\frac{3}{4}$ " flat, $\frac{11}{2}$ " hake

COLOURS:

Payne's Gray, Cerulean Blue, Alizarin Crimson, Raw Sienna, Burnt Sienna, Sap Green

SUPPORTIVE:

Masking fluid, dark brown water-soluble crayon, gouache or acrylic white paint for sheep, palette knife

SKY

This was painted wet into wet, using the $1^{1}/_{2}$ " hake brush. The sky area was initially washed with a very pale Raw Sienna and when the shine had gone from the underpainting, a stronger mix of Cerulean Blue was brushed in to represent the cloud structures.

DISTANT HILLS AND BUSHES

A pale green wash was applied to represent the distant hills and when dry the bushes and walls were added.

The middle distant bushes were painted with a mix of Sap Green and Burnt Sienna. The depth in the bushes was achieved by adding some Payne's Gray to the mix.

This area of the painting wasn't completed until the buildings and broken-down stone wall had been added.

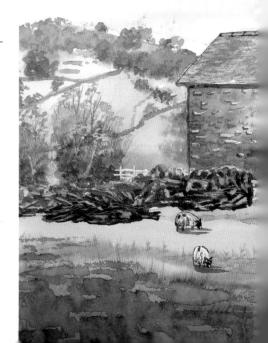

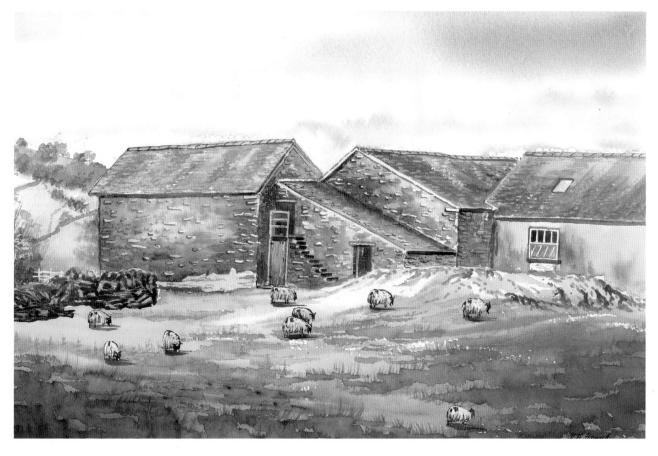

BUILDINGS

Care was taken to draw the buildings to scale and in relation to each other. A Payne's Gray/Alizarin Crimson mix was applied to the roofs in various light and dark values to indicate weathering. The rigger brush was used to add a few tile shapes in lighter values.

The $\frac{3}{4}$ " flat brush was used to paint the walls by applying an initial Raw Sienna wash, followed by the selective addition of Burnt Sienna. When approximately one third dry a palette knife was used to move paint, representing areas of lighter toned stonework.

The doorframes, handrail at the top of the stairs and the window frames were initially masked prior to applying paint.

FOREGROUND GRASS AND SHEEP

The foreground grass was painted by initially applying a Raw Sienna wash over the whole of the grass area and adding darker tones of Sap Green/Burnt Sienna mix at varying stages, flicking upwards with the corner of the hake indicating tufts of rough grass.

The sheep were finally painted, taking care to follow the principles of design and not placing them equally spaced or in straight lines. See page 151 for painting sheep.

SPRING

The Spring comes in with all hues and smells In freshness, breathing over hills and dells O'er woods where May her gorgeous drapery flings And meads washed fragrant by their laughing springs Fresh are new open'd flowers, untouched and free From the bold rifling of the amorous bee The happy time of singing birds is come And love's lone pilgrimage now finds a home; Among the mossy oaks now coos the dove And hoarse crow finds softer notes for love.

John Clare

In England, March 21st is recognised as the first day of Spring. The earth seems to be reborn; new shoots push through as soon as the frost and snow has melted. The grasses change colour and dormant buds grow fatter, waiting to burst into leaf at the first opportunity. Frisky lambs play in the fields whilst the rooks build their nests and daffodils dance in the breeze.

The birds are in their sparkling plumage, their songs spread through the woodland and the dawn chorus reaches a crescendo.

Everything appears clean and fresh. April showers and warmer temperatures stimulate new growth and the air can literally be tasted at this time of year. Spring is one of my favourite times of year - the beginning of the artist's year.

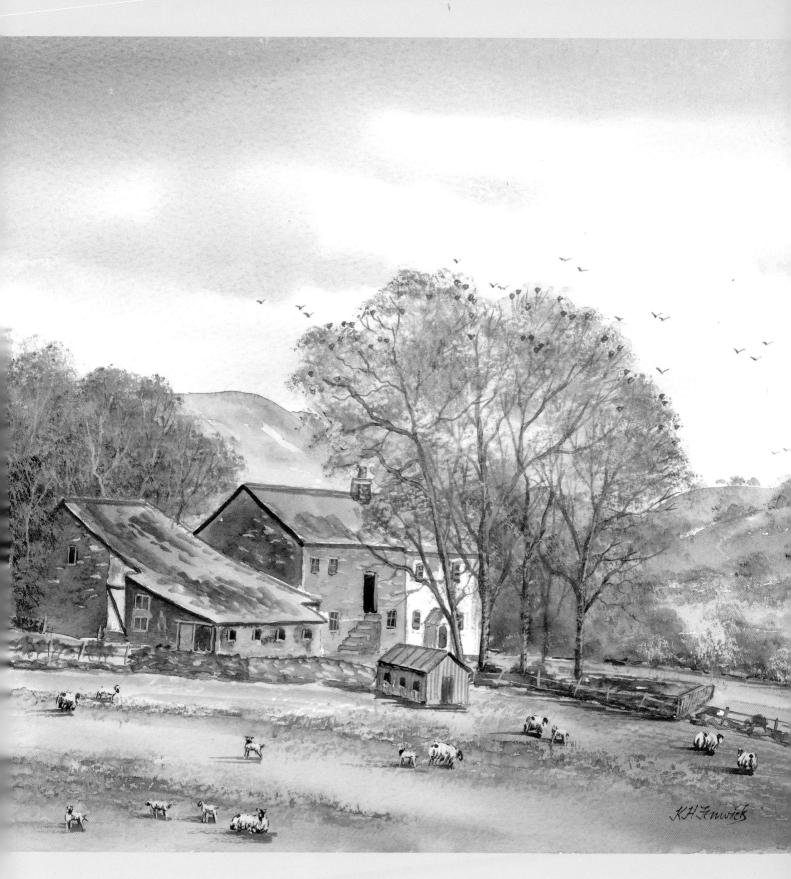

ABOVE: Lambing Time

SPRING SNOW - PROJECT

The photograph was taken on Thurstaston Hill, a few miles from home on the Wirral Peninsular. The area is a popular beauty spot, overlooking the Dee Estuary and one of my favourite places to walk. It is riddled with woodland paths and is famous for its red sandstone rocks that are characteristic of this region.

It is said that the famous watercolourist JMW Turner visited Thurstaston to capture, in paint, the wonderful sunsets that we enjoy here. From Thurstaston Hill one

can see for miles in all directions. The photograph shown makes a pleasing composition. I made a television programme here for Granada Television's Art School.

The actual painting was completed a little earlier than shown in the photograph, after a fall of snow and before it had time to melt.

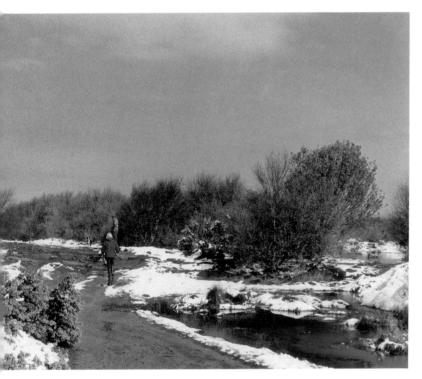

The tonal study became the plan for the painting. Although produced in a few minutes, it provides thinking time to establish one's approach to the final painting.

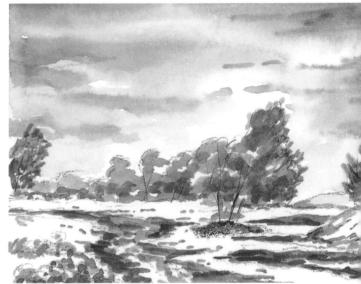

WHAT YOU WILL NEED

PAPER:

Winsor & Newton 300lb rough

BRUSHES:

Winsor and Newton Scentre Gold II Series size 14 round, size 3 rigger, 11/2" hake, 1/2" round hog hair brush

COLOURS:

Payne's Gray, Cerulean Blue, Alizarin Crimson, Raw Sienna, Burnt Sienna, Burnt Umber, Sap Green, Cadmium Yellow Deep

SUPPORTIVE:

Masking fluid, white acrylic paint, tissues (toilet roll) dark brown water-soluble crayun

STAGE 1: **DRAWING AND MASKING**

A rough outline drawing was completed using a dark brown watersoluble crayon. The areas to be preserved to represent snow were masked.

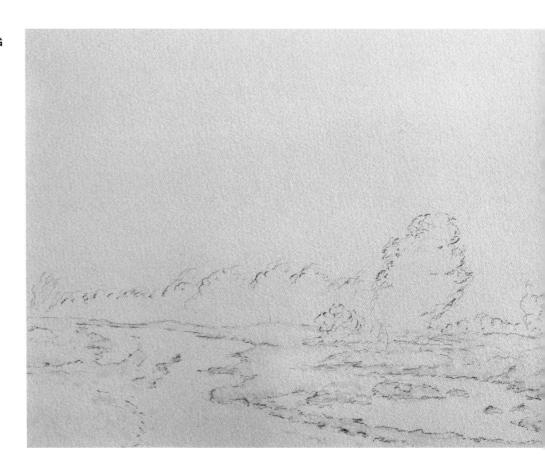

STAGE 2: SKY

The sky was a soft Cerulean Blue, applied with the $1^{1}/_{2}$ " hake brush over a Raw Sienna under-painting applied to wet the paper. A very small quantity of Payne's Gray was added to the Cerulean Blue to produce slightly darker values of blue at the top of the sky and in selected areas. A tissue was used to remove colour by dabbing to create white clouds.

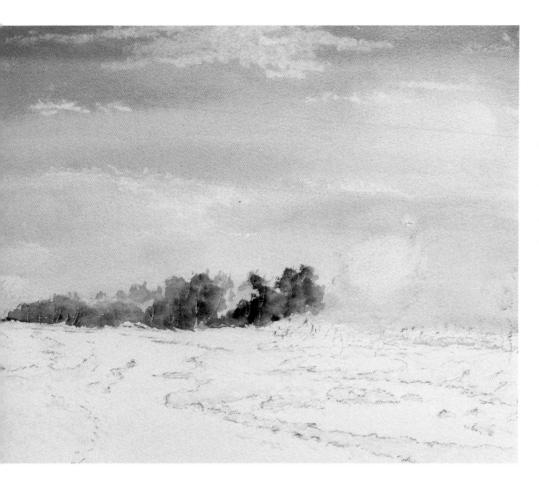

STAGE 3: DISTANT BUSHES

The side of the size 14 round brush was used to twitch downwards from the top of the bushes to establish their mass. Raw Sienna and Payne's Gray were used to produce various tonal values. A quick twitch of the brush combined with a light touch is what is needed.

STAGE 4: DISTANT TREES AND **PATHS**

Using the same technique and colour combinations described in Stage 3, the large trees were positioned. A touch of Burnt Sienna was added to the trees to provide colour variation and a cocktail stick used to scratch in the tree structure whilst the paint was still wet.

The size 14 round brush loaded with the Cerulean Blue wash was used to represented water in the pools and on the paths. The distant hills were then painted.

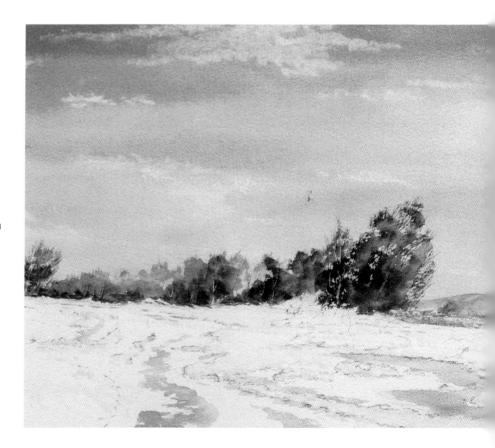

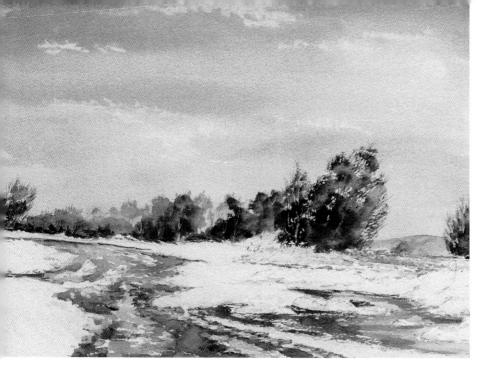

STAGE 5: PATH AND FOREGROUND POOL

A Burnt Sienna/Burnt Umber mix was used to paint the paths. Payne's Gray was added to Cerulean Blue to create depth in the pool and to provide definition to the edges of the paths.

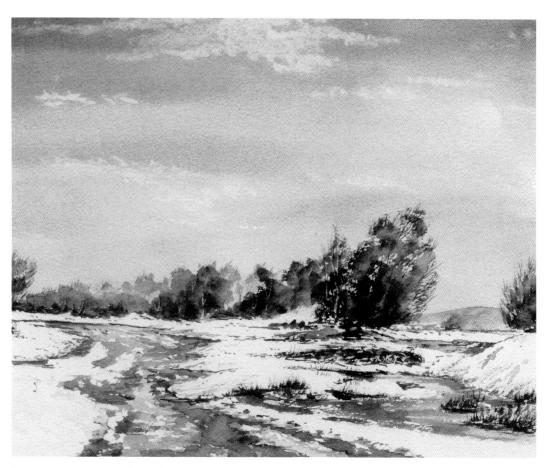

STAGE 6: ROUGH GRASSES

The land areas uncovered by snow and tufts of grass were painted using the size 14 round brush. To paint the tufts of grass, load the brush with a Burnt Sienna wash, fan the hairs of the brush between the thumb and forefinger, hold the brush by its tip and

twitch upwards – easy and effective. The masking was removed by gently rubbing with a putty eraser and then a few cloud shadows were painted with a size 6 brush loaded with Cerulean Blue.

KEY POINTS

- 1 Paint a simple sky remember, the "Golden Rule", a detailed foreground demands a simple sky to avoid the painting becoming too fussy.
- 2 Take care to ensure your drawing accurately represents the scene. Take particular care with the angles of the path.
- 3 Add depth to your painting by the application of darker values in the path, tree and water.
- 4 Take a snippet of gorse and match your colour to it.
- 5 A painting must be a completed unit. To achieve this, colours, textures, shapes etc should be repeated in areas of the painting. Splashes of Burnt Sienna for example, have been echoed in the distant trees, the gorse, path and tufts of grass. The sky colours are reflected in the pool and path. Remember to apply the principles of design - variation, gradation, contrast, harmony etc (see pages 12-15).

STAGE 7: GORSE BUSHES

Gorse bushes vary in colour from a soft yellow to deep yellow, dependent on the soil in which they are growing and the length of time that they have been in flower.

It's a good idea to take a small cutting and compare it with the colour you hope to use to paint them. In this case, I found that Cadmium Yellow Deep was the exact colour. The underpainting was a mix of Burnt Sienna and Sap Green. A little white acrylic paint was added to the Cadmium Yellow Deep to ensure the flowers remained sharp and the colour did not soak into the watercolour under-painting which would have resulted in a blurred representation.

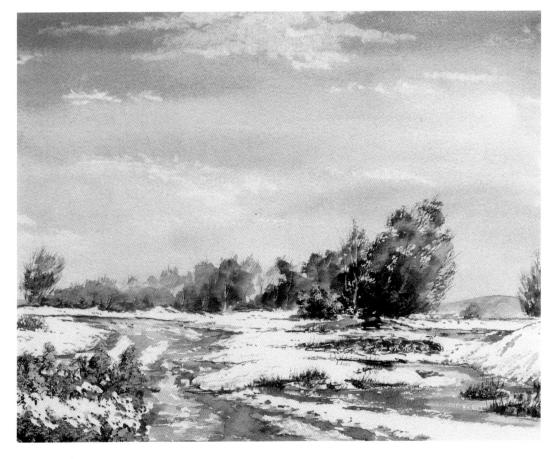

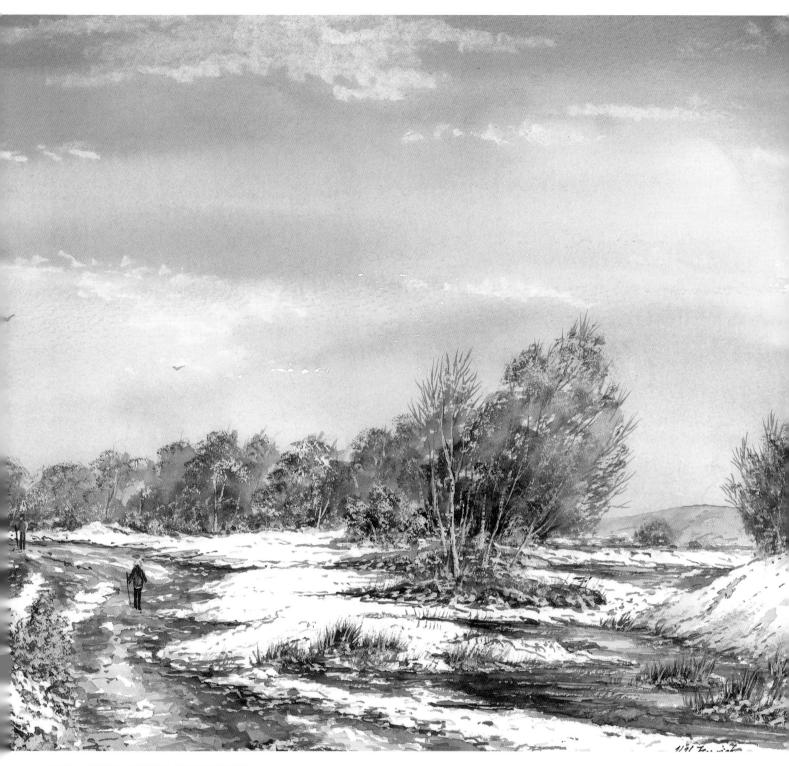

FINAL STAGE: ADDING THE DETAILS

My normal practice is never to complete a painting in one sitting. I like to look at the painting over a period of several days - it's amazing what you failed to see in your first effort. Using the rigger brush loaded with a white acrylic paint and a little Raw Sienna, I have painted in some tree structures. I have added more detail in the path and painted the walkers (just the shape of a lemon for a body, two legs that touch at the feet, a small head and add a rucksack, or stick etc.) It's as easy as that. Finally I have used the hog hair brush to stipple a little white acrylic paint into the foliage to represent snow and added a few birds on the left. I hope you enjoyed painting this one.

GREEN HARMONY

- CLOSE UP

There are many shades of green in this painting providing an opportunity to practise colour mixing.

BACKGROUND

It's important to ensure that the background does not detract from the more detailed right hand tree group and the foreground.

A weak Cerulean Blue/Sap Green wash was applied using a 11/2" hake brush and whilst the paper was moist, darker tones of Sap Green/Payne's Gray were brushed into selected areas to establish a soft varied background. Whilst wet a cocktail stick was used to scratch in a few tree structures. When dry a moist sponge was used to stipple impressions of foliage using mixes made from Cadmium Yellow Pale/Sap Green and a little white acrylic paint.

SPECIMEN TREE GROUPING

A moist sponge dipped into mixes of Cadmium Yellow Pale/Sap Green was used to create the groups of foliage. It's important not to squeeze the sponge as the paint is stippled. Whilst still wet some tree structures were scratched in and when dry a Payne's Gray/Burnt Umber mix was used to add tree structures with the rigger brush.

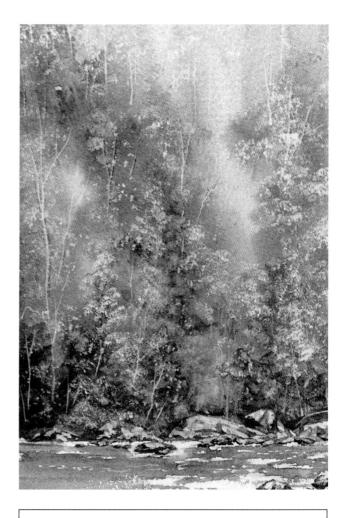

WHAT YOU WILL NEED

PAPER:

300lb Saunders Waterford rough

BRUSHES:

Winsor & Newton Sceptre Gold II Series size 14 round, size 3 rigger, and $\frac{3}{4}$ " flat, $\frac{1}{2}$ " hake, $\frac{1}{2}$ " round hog hair

COLOURS:

Payne's Gray, Cerulean Blue, Raw Sienna, Burnt Sienna, Burnt Umber, Cadmium Yellow Pale, Sap Green

SUPPORTIVE:

Palette knife, white acrylic paint, natural sponge

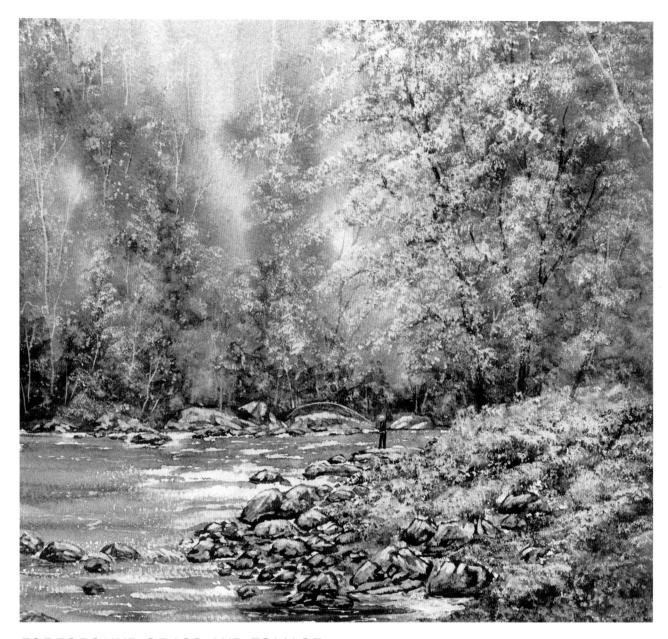

FOREGROUND GRASS AND FOLIAGE

A dark background was under-painted using a Payne's Gray/Sap Green mix and when dry an old hog hair brush was used to stipple in a representation of rough growth. To create sparkly on the foreground a little white acrylic was added to the Cadmium Yellow Pale/Sap Green mix.

WATER

The water was painted by applying horizontal strokes of a Payne's Gray/Cerulean Blue mix with the side of the size 14 round brush, taking care to leave some white of the paper uncovered.

ROCKS

The rocks were created with the ³/₄" flat brush, commencing with a Raw Sienna wash, followed by Burnt Umber and Payne's Gray for depth. When approximately one third dry, a

palette knife was used to move paint, creating realistic looking rocks.

FISHERMAN

This was painted last using the rigger brush. Take care not to paint the figure too full bodied, with short legs and a large head. Keep it simple.

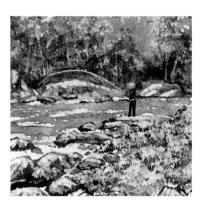

THE BLUEBELL WOOD - PROJECT

Bluebell woods are one of the wonders of nature and nowhere are they more spectacular than in the British countryside. The violet-blue carpet of flowers shimmers in the spring sunlight and thrives in the moist atmosphere of a British woodland.

Bluebells spread very slowly; a concentrated area of bluebells generally signifies the site of ancient deciduous woodland. The shafts of sunlight shining though the spring green leaves or the beech and oak trees on to the intense blue carpet on the woodland floor make me feel assured that nature has fully

awakened from winter hibernation. They are irreplaceable and fortunately these poisonous plants are not eaten by the fallow deer that tend to frequent these areas.

This composition has been created using photographs as a guide only. The tonal study was the starting point here. I wanted to include a path that led through the woodland to direct the eye of the viewer into the painting. The photographs were taken less than two miles from my home on the Wirral peninsula.

WHAT YOU WILL NEED

PAPER:

Winsor & Newton 300lb Rough

BRUSHES:

Winsor & Newton Sceptre Gold II Series 3/4" flat, size 3 rigger, 11/2" hake, 3/4" round hog hair

COLOURS:

Payne's Gray, Cobalt Blue, Raw Sienna, Burnt Sienna, Cadmium Yellow Pale, Sap Green

SUPPORTIVE:

Palette knife, natural sponge, white acrylic paint, dark brown water-soluble crayon

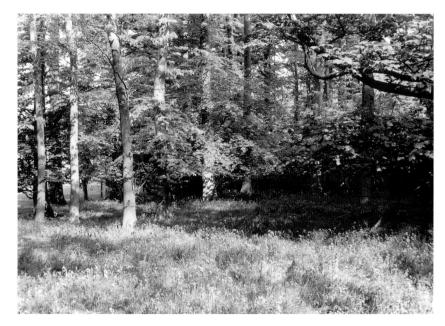

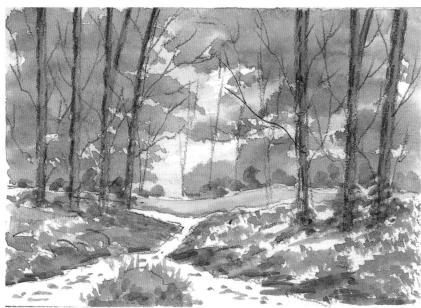

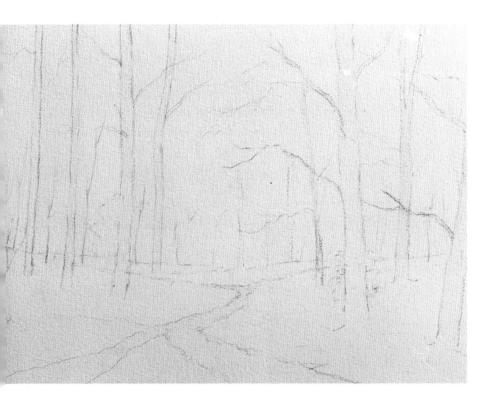

STAGE 1 DRAWING AND MASKING

The outline shapes of the trees and path were drawn using a dark brown water-soluble crayon. Masking fluid was applied to these areas and also to selected areas of the foreground using a rigger brush. The masking was allowed to dry completely.

STAGE 2 BACKGROUND

Using the $1^{1}/_{2}$ " hake the sky area was washed with a pale Raw Sienna. Cobalt Blue was brushed in using downward strokes to create an atmospheric background sky. Whilst still wet, I used the hake brush loaded

with mixes of Cobalt Blue and Sap Green, to brush in rough tree shapes which blended in, providing a background for further detail to be added later.

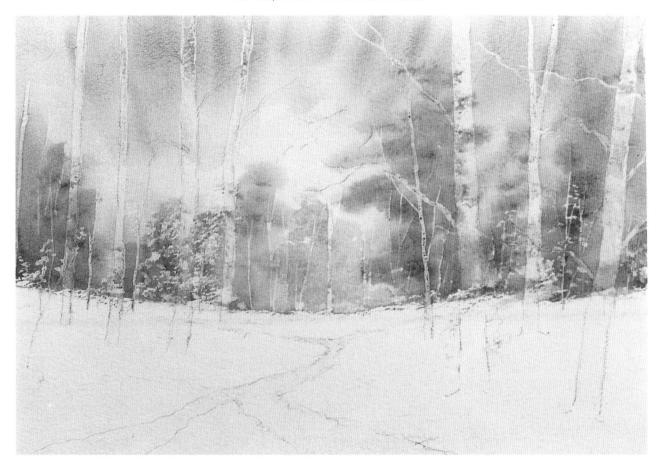

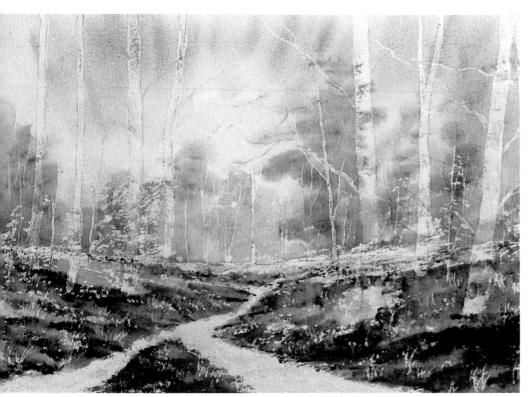

STAGE 3 FOREGROUND WASHES With the hake brush loaded with Sap Green, various toned washes were

applied. Payne's Gray was added to the Sap Green to give depth here and there. Note how the masking fluid which repels the watercolour shows through.

STAGE 4 REMOVE MASKING Using a putty eraser the dry masking fluid was removed from the trees and bushes.

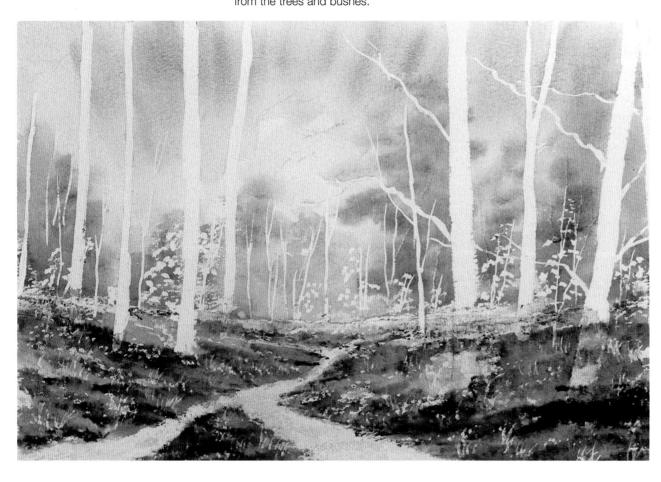

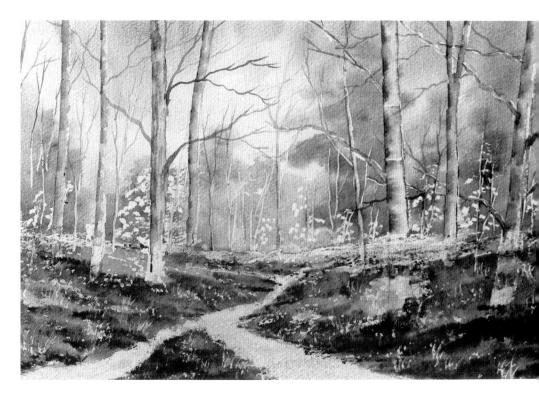

STAGE 5 TREE STRUCTURES

The tree trunks were painted using the 3/4" flat brush by initially applying a weak Raw Sienna wash, followed by a little Burnt Sienna to create variation in the bark. When the paint was approximately one third dry, darker tones were added to represent shadows.

STAGE 6 FOLIAGE

The foliage was painted with varying tones of Cadmium Yellow Pale and Sap Green. A natural sponge was used to stipple colour - darker values on the left, lighter values on the right.

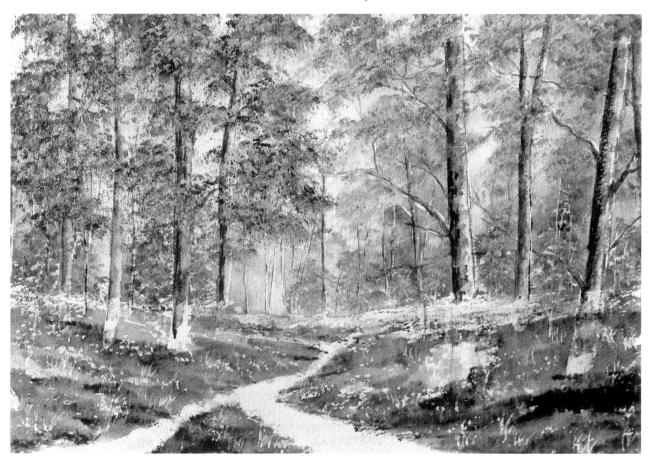

KEY POINTS

- 1 Mask your trees before applying the background washes.
- 2 Draw the outlines with a dark brown water-soluble crayon because as paint is applied the crayon washes out - pencil marks will spoil a finished painting.
- 3 Use a natural sponge to create the foliage but don't squeeze the sponge as you will lose definition.
- 4 Paint the tree trunks wet into wet.
- 5 Paint the edges of the path to look naturally uneven, never straight lines, shaping them to vanish into the distance.

STAGE 7 BLUEBELLS

Cobalt Blue was used to provide the background colour for the bluebells and to establish their distribution over the foreground, the masking was removed from the foreground base of the trees and the tree trunks painted to ground level.

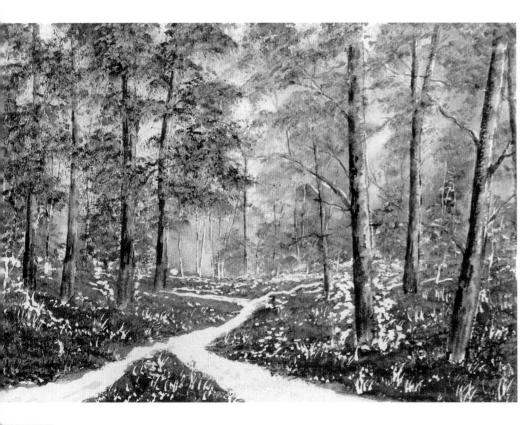

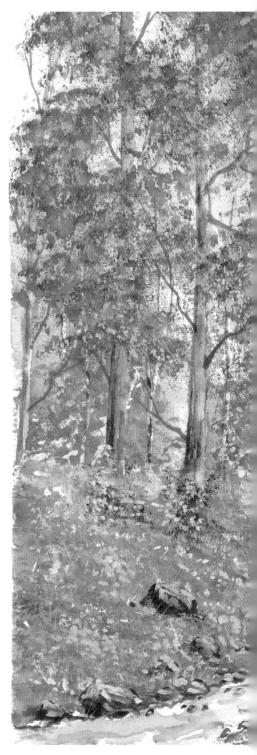

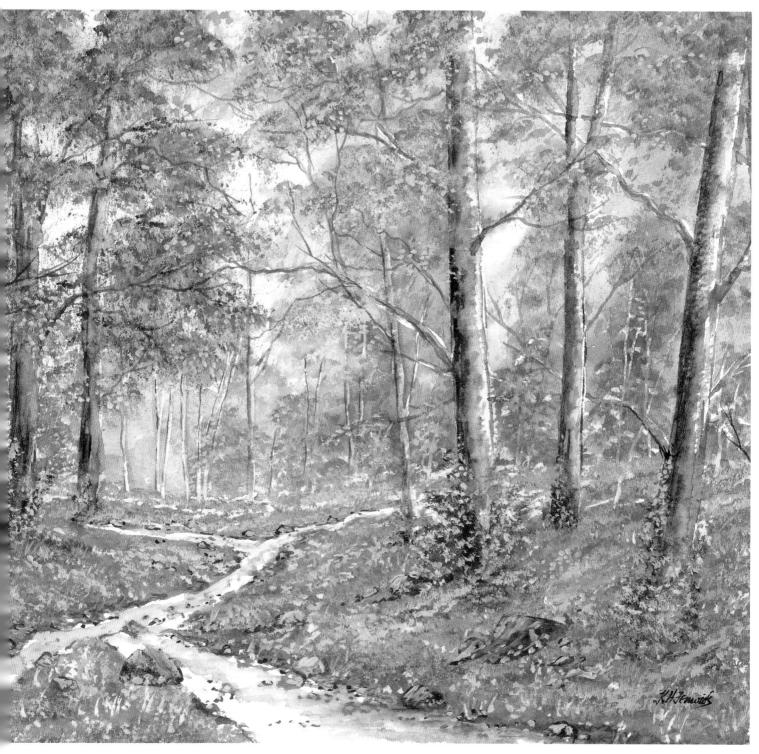

FINAL STAGE **DETAIL**

The carpet of bluebells was completed; the tones varying, lighter values in the distance and highlights in selected areas. These were stippled in using a hog hair brush. The paler values were achieved by adding a little white acrylic paint to the Cobalt Blue. The small bushes at the base of the trees were added and some tree foliage was highlighted to make a more pleasing composition.

A few additional branches were painted. The masking was removed from the path and a Raw Sienna wash was over-painted with a little Burnt Sienna. Rocks were painted to improve the composition using a 3/4" flat brush and knifed out to provide realism to their appearance.

Note: Bluebell colours vary significantly between areas of the country. They can be bright blue, soft blue or even a violet blue. It's a good idea to pick one and match the colour to it. I find Cobalt Blue is usually the most appropriate colour but sometimes I need to add a little Alizarin Crimson or even white to vary the values and colours.

ULLSWATER **DAFFODILS**

- CLOSE UP

Ullswater is the second largest lake in the English Lake District and certainly one of the most beautiful.

It was the poet William Wordsworth who publicised its beauty in his famous poem written in 1804 when he wrote:

I wandered lonely as a cloud,

That floats on high o'er vales and hills,

When all at once I saw a crowd,

A host, of golden daffodils;

Beside the lake, beneath the trees,

Fluttering and dancing in the breeze.

Ullswater is one of my favourite painting spots and a joy to behold at any season of the year but best of all in the spring time.

WHAT YOU WILL NEED

PAPER:

Winsor & Newton 300lb Rough

BRUSHES:

Winsor & Newton Sceptre Gold II Series size 14 round, size 6 round, size 3 rigger, 3/4" flat, 11/2" hake

COLOURS:

Payne's Gray, Cerulean Blue, Raw Sienna, Burnt Sienna, Burnt Umber, Cadmium Yellow Deep, Cadmium Yellow Pale, Sap Green

SUPPORTIVE:

Masking fluid, sponge, palette knife, tissues

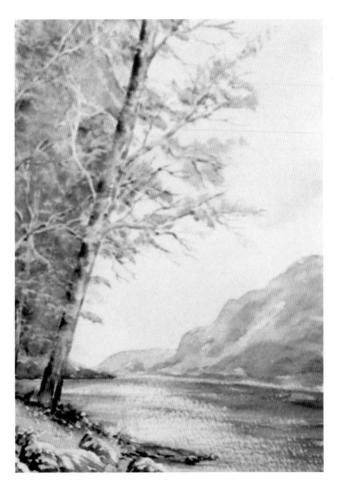

TREES

Masking fluid was used to preserve the white of the paper necessary for the tree structures. When dry, the background was painted by applying washes of Raw Sienna and Sap Green with the hake brush. At ground level Burnt Umber was washed in to create depth. When completely dry the masking was removed and the tree structures painted. A pale Raw Sienna was applied using a 3/4" flat brush and darker values of Burnt Umber painted to create variation. Finally, impressions of clumps of foliage were painted by stippling light values of a soft green, produced by adding a little white acrylic paint to a mix of Sap Green/Cadmium Yellow Deep. A sponge was used to stipple paint.

MOUNTAINS AND WATER

The mountains were painted using sweeping strokes of the hake brush from peak to ground level.

The distant mountains were painted in pale blue and some Sap Green and Burnt Sienna added for the larger mountain.

The sparkle on the water was created using the dry brush technique; a light quick stroke with the side of the size 14 round brush, commencing with Cerulean Blue and adding a little Payne's Gray for the darker values was my choice.

The sky was a simple Cerulean Blue using the hake brush.

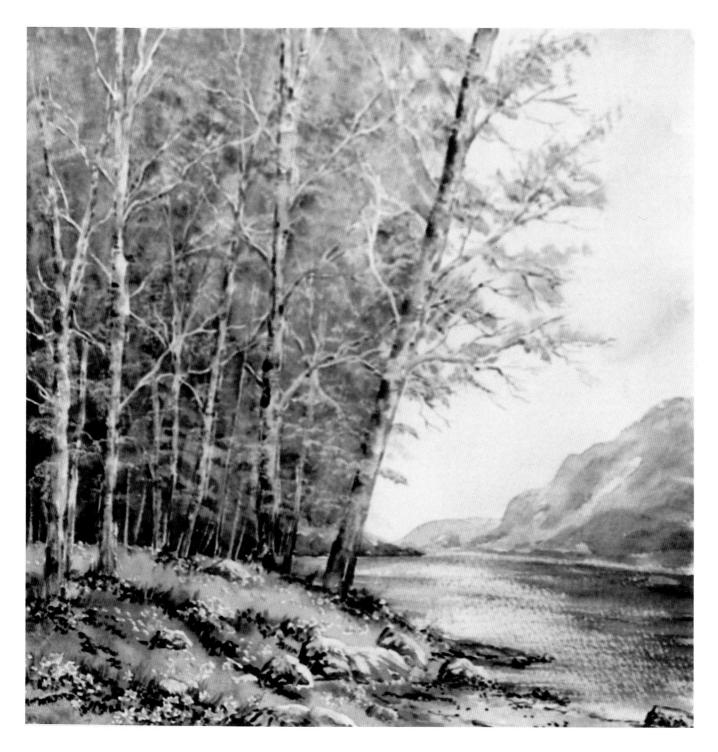

FOREGROUND

The areas to be preserved for the rocks and daffodils were masked. The daffodils were masked by crumpling a tissue to a point, dipping it in masking fluid and stippling. To ensure differing sizes and a variety of shapes of flowers, the size of the pointed tissue and the pressure applied to the watercolour paper with the soaked tissue was important.

When the masking was completely dry, soft yellow green washes were applied, mixed from combinations of Sap Green and Cadmium Yellow Pale. Darker values were painted in to selected areas by adding a little Burnt Umber.

The masking was removed from the foreground. Using a size 6 brush, Cadmium Yellow Deep was applied to the white of the paper to indicate the daffodils. A rigger brush was used to paint the stems of the flowers.

Raw sienna was used to define the water's edge and to wash in the rocks. Darker tones of Burnt Umber/Burnt Sienna were used to indicate shadows on the rocks and their form and structure was created by removing paint with a palette knife.

MOONLIGHT

- PROJECT

Derwent Water in the English Lake District is another of my favourite painting spots. I was fascinated on one of my recent evening walks around its shores to observe the moonlight shimmering across the lake, hence this project. The painting was completed in my studio using the value study shown and a photograph taken at the time.

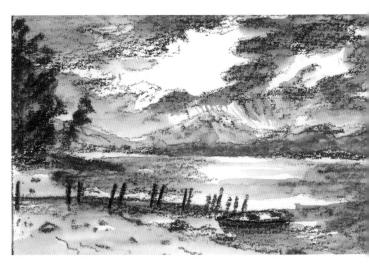

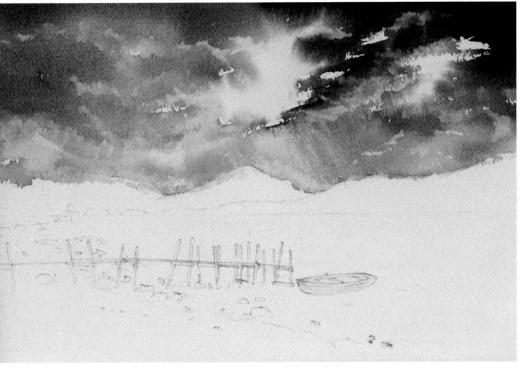

WHAT YOU WILL NEED

PAPER:

Winsor & Newton 300lb Rough

BRUSHES:

Winsor & Newton Sceptre Gold II Series size 14 round, size 6 round, size 3 rigger, 1¹/₂" hake

COLOURS:

Payne's Gray, Cerulean Blue, Alizarin Crimson, Raw Sienna, Burnt Sienna, Sap Green

SUPPORTIVE:

Palette knife, masking fluid

STAGE 1 DRAWING AND SKY

The outline drawing was completed using a dark brown water soluble crayon. The sky is the important feature in this painting and needs a little thought before applying paint. To create the effect I wanted, I decided to initially, wet the paper with clean water so that I could paint a wet into wet sky but as can be seen, I left small areas of the paper uncovered. I quickly painted the areas of Raw Sienna followed by Cerulean Blue near to the horizon and stiffer mixes of a Payne's Gray/Alizarin Crimson mix above the Cerulean Blue. The board was lifted and tilted, allowing the paint to run together, taking care to leave the areas of Raw Sienna uncovered. Finally, the board was laid flat and with a tissue, a few light clouds were blotted out.

STAGE 2 MOUNTAINS

Using the hake brush I painted the distant mountains in lighter tones to ensure recession.

When applying paint, it's important that the brush strokes follow the structure of the mountain - from peak to ground level.

Initially, I applied a little masking fluid to create a few highlights. When dry, I over-painted the area with Raw Sienna washes and then followed on by adding mixes of Burnt Sienna and Payne's Gray/Alizarin Crimson. A size 14 round brush was used for the variation in tone and detail. When dry, the masking was removed with a putter eraser and a pale Raw Sienna wash applied with a size 6 round brush, to represent moonlight reflecting over the peaks.

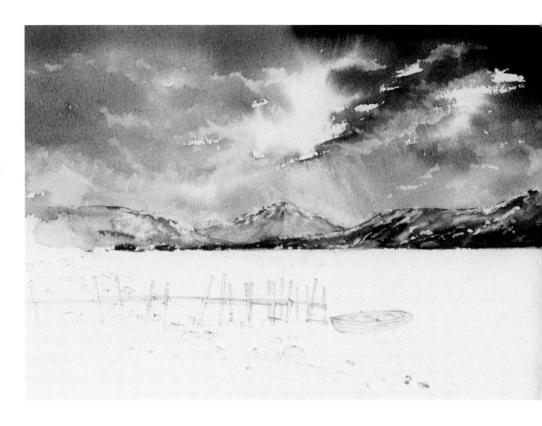

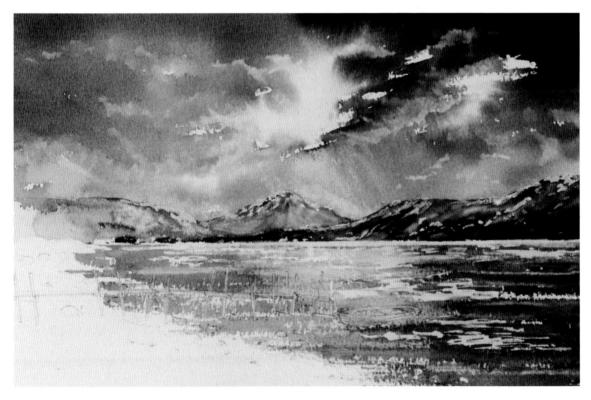

STAGE 3 MASKING AND WATER

Masking fluid was applied to the landing stage, the boat and highlights on the lake's surface. With the sky colours, washes were applied using

the side of the size 14 round brush. Take care when applying the reflected colours from the sky. These must be accurately distributed in the water.

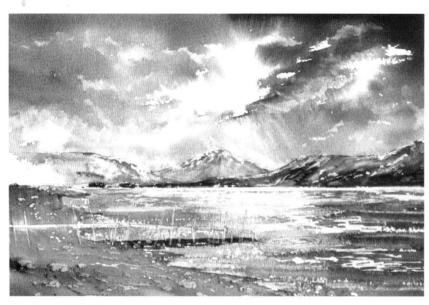

STAGE 4 SHORELINE

Sweeping strokes with the hake brush initially loaded with a pale Raw Sienna were applied. This was followed by Burnt Sienna over selected areas and a Payne's Gray/Alizarin Crimson mix being added to give darker values over areas where the rocks were to be painted.

Darker values of the Payne's Gray/Alizarin Crimson mix were painted under the landing stage for shadow effect. When the paint was approximately one third dry a palette knife was used to move paint to give the impression of rocks and boulders in the foreground.

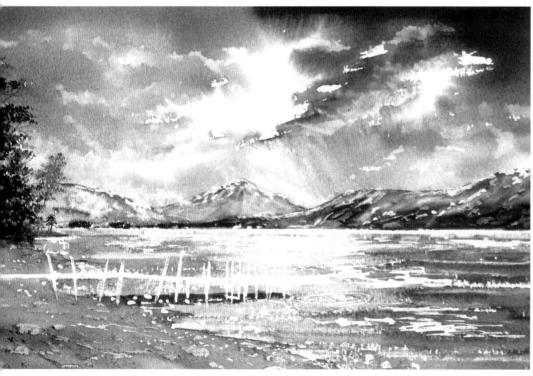

← STAGE 5 REMOVAL OF

MASKING

Use a putty eraser to remove the masking fluid from the landing stage. This method of removal is ideal as being soft, it doesn't damage the paper and readily adheres to the masking.

The left hand trees were painted using a stippling action with a well worn, round hog hair brush.

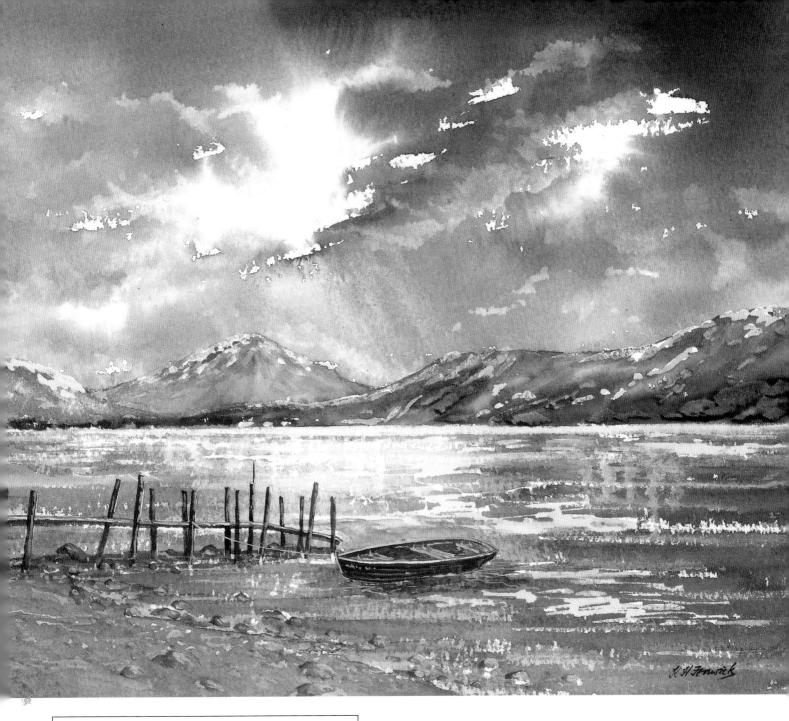

KEY POINTS

- 1 Take care when painting the wet into wet sky. When tilting the board, do not allow the paint to run over the light area that is to represent the moonlight.
- 2 Ensure a pale line is preserved between the land and the water. This is always visible when painting distant water.
- 3 When painting boats, make sure they are in proportion. The usual error is to make them too wide and short in length.
- 4 To ensure harmony, the sky colours should be reflected in all areas of the painting.
- 5 Don't forget to paint shadows under the landing stage, the boat and under the trees and rocks.

FINAL STAGE BOAT AND LANDING STAGE

The masking, previously applied, was removed from the boat and the boat painted, using Raw Sienna, Burnt Sienna and Payne's Gray. Highlights on the boat and the mooring line were added using the rigger brush and a little white acrylic paint. The landing stage was painted using the rigger brush.

COMPOSITION

COMPOSITION CAN BE SAID TO BE THE PROCESS OF ARRANGING ALL THE ELEMENTS IN A painting to make a unified whole that is pleasing to the viewer. When first we begin painting, we simply want to copy what is in front of us but in order to create a good composition, it may be necessary to move the elements around or use counterchange or scale to highlight a particular feature that leads the viewer's eye into the painting. A centre of interest or focal point is needed. It isn't always necessary to paint exactly what we see.

We may need to make one tree larger or darker in value. to add a splash of colour or to counterchange it with its background to direct the eye to it. For example, in a river scene the foliage of trees on each side of the river may have the same tonal value and colour. For the painting to work, it may be necessary to make the foreground tree on the left of

the painting, darker in value than it actually appears and to make the right hand trees gradually lighter in values as they disappear into the distance. The eye is led down the river and out of the painting behind the dark value tree in the left hand foreground. Artistic licence is necessary for the painting to be aesthetically acceptable.

THE CENTRE OF INTEREST OR FOCAL POINT

This point must be a dominant feature. It may be a dark colourful figure against a light background, an interesting shape or a large dominating feature, such as a tree or church steeple.

The first thing to be decided upon is where the centre of interest is to be positioned. It should never be in the centre or at the extreme edges of a painting. Ideally the centre of interest should be placed at unequal distances from each edge of the paper.

Artists have developed suitable methods for positioning their centre of interest or focal point. Two such approaches are shown. They are basically similar; the choice is yours. The focal point should ideally be placed at A, B C or D, dependent on whether you are looking up or down on the subject.

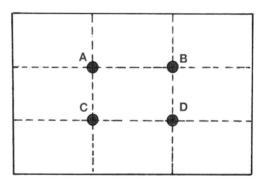

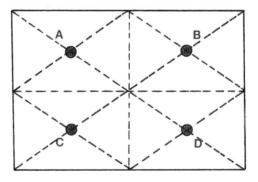

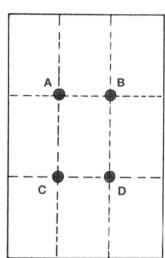

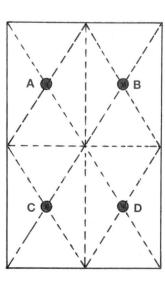

Possible focal points for a good composition

RIGHT AND WRONG COMPOSITIONS

Experience has taught me that some compositions look right and others don't. I'm going to show you some of the pitfalls to avoid. No matter how successful you are at applying paint, if your composition is lacking, your painting won't look right.

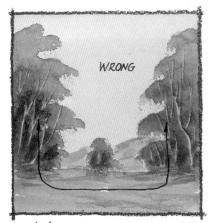

'U' shape - there are trees both sides and centre

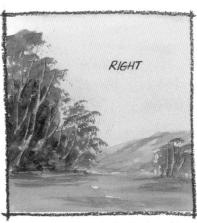

Improved by a varied distribution of trees

1 'U' shape

This is poor composition with trees at both sides and one in the middle. It is much more pleasing to show a larger group on one side and a smaller group on the opposite side.

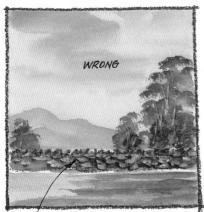

A continuous wall conveys the message 'don't enter my picture

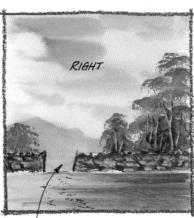

An opening in the wall improves the composition

2 Continuous wall, hedge or fence For example; by painting a wall right across the painting, the message to the view is "don't come into my painting." Always add a gap or gate to break the continuity but not in the centre. In this case, it has been positioned - offset in order to balance the right hand trees.

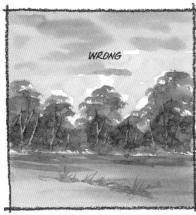

A continuous tree span

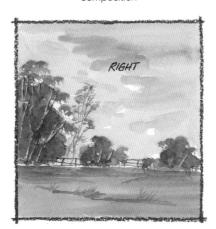

Improved by spaces between trees

3 Continuous tree span

This is similar to above. Vary the height of the trees or bushes and add a few gaps to show a fence. It makes a more pleasing composition. If it isn't feasible to do this, add other features such as sheep, or a winding river, which directs the eye away from the mass of trees or by adding variation of colour in the foliage with one or two bright areas will help.

To ensure a pleasing composition view your chosen landscape from different viewpoints and select the most inspiring - the best arrangement of the different elements. A successful composition is vital in creating an interesting painting. Always ask yourself basic questions such as: "What is it that inspires me to paint this scene?" "Is it the elements in the picture, the effect of light or the atmospheric conditions?" When you have questioned your reasons you may find that the scene doesn't have a focal point. In this case you will need to create one. Use value, counterchange, size, shape, colour, line or direction to create one, but only one: more than one will confuse the viewer. Always try to lead the eye into the painting and out in the distance.

RIGHT AND WRONG **POSITIONS**

4 Horizon halfway up the picture This is a general failing with beginners. It brings back memories of when I began painting. It took time for me to appreciate why other artists' paintings looked so much better than mine. Ideally, place the horizon (in this case, the sea) approximately one third up the painting. Note also that in the left hand composition, the boat is facing out of the picture, whereas in the right hand picture, it is facing into the picture.

5 Elements above each other In the left hand composition the small building has been placed directly above the larger building. Not good design - place the buildings diagonally opposite each other.

6 Looking directly onto a building In the left hand composition the picture is unbalanced. The background mountain is directly above the farmhouse, with the road directed horizontally across the picture and the cloud structure is above the mountain. In other words, all of the elements are to the left leaving little interest on the right.

By viewing the scene from a viewpoint on the left, the composition is more pleasing. The gable end of the farmhouse can be seen and the elements are more evenly distributed. The track leads the eye into the painting and the darker clouds on the right balance the mountain on the left of the picture.

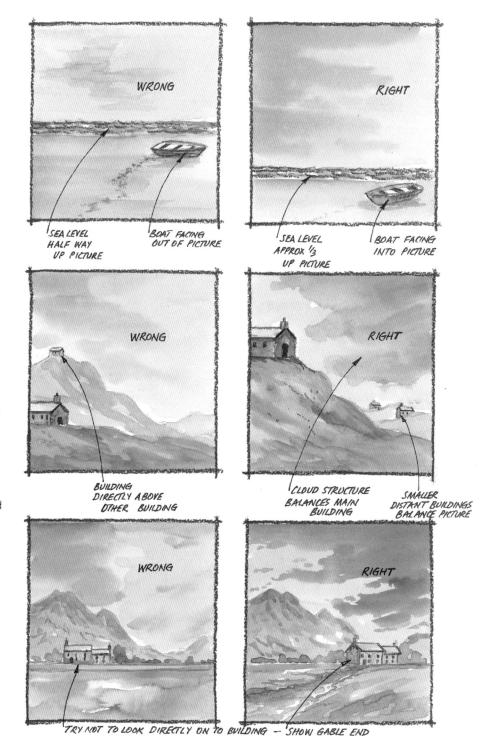

SUCCESSFUL **COMPOSITIONS**

To summarise - choose a viewpoint at an angle to the subject, which shows it to its best advantage: simplify, discarding those elements that don't contribute to the success of the painting. Decide what it is about the subject that inspired you to want to paint it and enhance that appeal using value and colour. No matter how

experienced an artist you think you are, you are different from all other artists, you're unique, because your painting is the equivalent of your handwriting in paint. The following examples are those of compositions that experience has shown are successful. Use them as a guide there are others that work just as well.

7 The "L" shape

Here the main elements on the left and across to the right form an "L" shape. It's important to paint the larger and darker toned clouds in this example to the right to balance the elements on the left.

8 The double "L" shape

This composition works if the "L"s are a different height and their bases are on different levels. Paint the foreground "L" in a darker value to the distant "L" that is a lighter value, providing recession in the painting.

9 Compositional balance

Here the main mountain is balanced by the darker clouds. The mountain stream leads the eye into the painting and diagonally balances the mountain.

10 Flowing line

The path leads the eye into and through the painting and out in the distance. Ideal when painting rives scenes or woodland paths.

11 Height and isolation

Very simply painted - low horizon line, atmospheric sky; in this example, one boat on the beach facing into the picture.

12 Filled area

Effective for woodland scenes, where the frame is filled with foliage and foreground.

All of the above compositions are pleasing to the eye.

When I'm designing a painting, I think of an expression commonly used in the theatre:

THE L'SHAPE

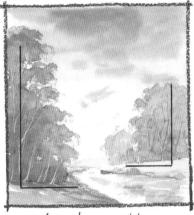

THE L J'DOUBLE L'SHAPE

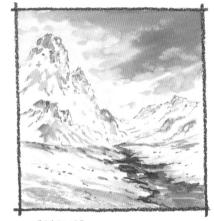

BALANCE

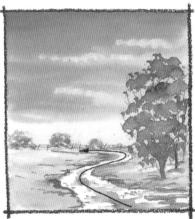

FLOWING LINE

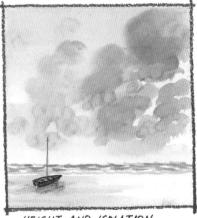

HEIGHT AND ISOLATION

FILLED AREA

- Build the set the tonal study, the
- Put in the props paint the scene, add the detail
- Then light it add highlights to make the painting sparkle. Use your imagination to create the paintings but don't be afraid to break the rules - Enjoy your painting!

SPANISH VISTA

CLOSE UP

I came across this Andalucian village on my travels and was fascinated by the range of flowering plants in the foreground. The quick value study becomes the plan for the final painting. These simple thumbnail sketches, easily completed in a few minutes are helpful in establishing the lights and darks and one's approach to the painting. They can help avoid future problems by clarifying the painting process prior to applying paint. A dark brown water soluble crayon was used to complete the value study.

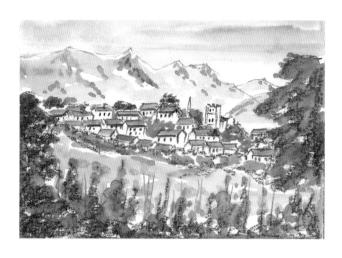

FOREGROUND AND TREES

Initially, all of the foreground area was painted with a Raw Sienna wash and brushing in various greens mixed from Sap Green/Cadmium Yellow Pale. When dry the trees were painted using an old oil painter's hog hair brush, loaded with a Sap Green/Payne's Gray mix. Highlights were added when dry, using Cadmium Yellow Pale.

The 11/2" hake brush was used to paint this simple sky using a Raw Sienna wash with a little Cobalt Blue brushed in. Keep it simple or the painting with its detailed foreground will look too fussy. Similarly, the mountain range was painted using the hake brush, keeping them simple but highlighting the peaks and promontories.

BUILDINGS

These were painted very simply using a 3/4" flat brush to create the shapes. An Alizarin Crimson/Burnt Sienna mix was used for the roofs and a Payne's Gray/Burnt Sienna mix for the windows and shadows under the eaves. The detail work was completed using the rigger brush.

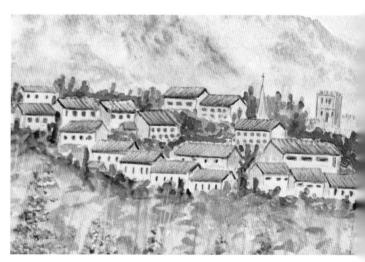

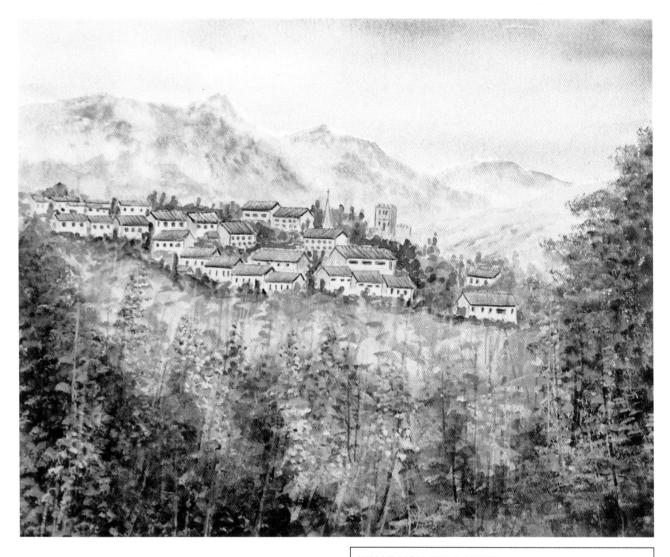

FLOWERING PLANTS

The corner of a 3/4" flat brush was used to create the shape of leaves and the wild flowers. Build up gradually beginning with the shapes of individual plants and leaves. Finish by stippling the flowers using the corner of the flat brush. Here I have used Cobalt Blue, Alizarin Crimson and a little acrylic white to ensure the paint did not sink into the underpainting. I wanted the flowers to be defined. The stems were scratched in using the palette knife whilst the paint was still moist.

Finally, depth was added by applying a Payne's Gray/Alizarin Crimson glaze. I have no idea what the flowering plants are but they provide an interesting foreground in this quick sketch.

WHAT YOU WILL NEED

PAPER:

Bockingford 140lb rough

BRUSHES:

Winsor & Newton Sceptre Gold II Series size 3 rigger, 3/4" flat, 3/4" round oil painter's brush, 11/2" hake

COLOURS:

Payne's Gray, Cobalt Blue, Alizarin Crimson, Raw Sienna, Burnt Sienna, Cadmium Yellow Pale, Sap Green

SUPPORTIVE:

Palette knife, acrylic white paint, dark brown water soluble crayon

WASTWATER - CLOSE UP

Pages 78/79 show a range of techniques for painting mountain structures. It's important to create recession by painting distant objects in light values and gradually darkening the values as the foreground approaches.

In this painting, I have used tissues folded to wedges, brush strokes and a palette knife to achieve various effects.

SKY

The traditional wet in wet technique has been adopted, whereby the hake brush has been used to apply a pale Raw Sienna wash over the whole of the sky area with a little darker tone applied to selected areas. Whilst still wet, stiffer mixes of Payne's Gray/Cobalt Blue were added to paint the clouds.

A tissue was used to blot out colour to enhance the cloud structures and to soften edges.

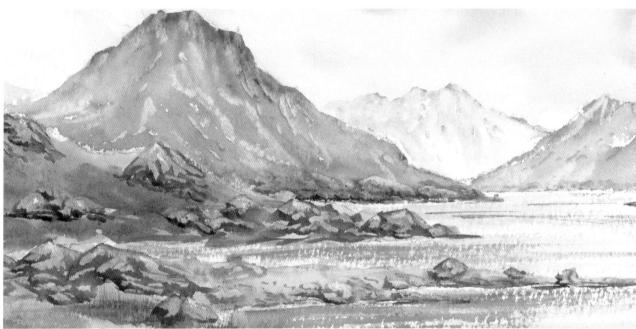

MOUNTAIN AND ROCKS

I have used two brushes to paint tho mountains – the $1^{1}/_{2}$ " hake to rough out the structure, my brush strokes following the shape of the mountains from peak to ground level and the size 14 round brush to add a variety of colours and detail.

To represent the distant mountains, weak mixes of Cobalt Blue/Allzarin Crimson were used and for those nearer, the foregoing mixes were varied with over-painting using Raw Sienna/Burnt Sienna. Definition was given to the peaks using a Payne's

gray/alizarin mix. The light areas to shape the peaks was achieved by wiping with a tissue shaped to a Unisol edge in a downward direction and the rocks were defined using the palette knife (see pages 78/79 for techniques).

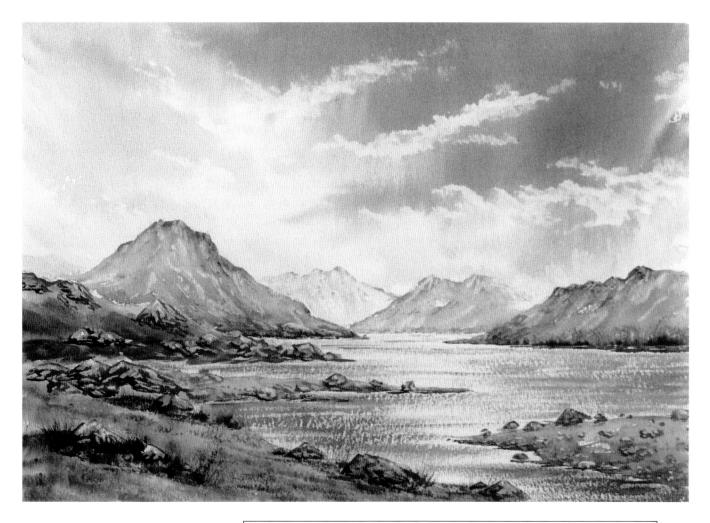

WATER AND **FOREGROUND**

The foreground was initially completed using mixes of Raw Sienna with Burnt Sienna added whilst the under-painting was still wet. Using this technique a more natural effect is achieved. The rocks were painted with the 3/4" flat brush and the shapes knifed out using the palette knife.

The foreground grass was painted with the hake brush using various shades of green made from Cobalt Blue/Cadmium Yellow Pale. Finally the water was painted by applying horizontal strokes with the side of the size 14 round brush. The colours used were those used for the sky. A light touch of the brush is all that is required to create sparkle on the water.

WHAT YOU WILL NEED.

PAPER:

Saunders Waterford 300lb rough

PAINTS:

Payne's Gray, Cobalt Blue, Alizarin Crimson, Raw Sienna, Burnt Sienna, Cadmium Yellow Pale

BRUSHES:

Winsor & Newton Sceptre Gold II Series size 14 round, 3/4" flat, 1¹/₂" hake

SUPPORTIVE:

Tissues, palette knife

KEY POINTS

- 1 Paint an atmospheric sky; the darker clouds should be diagonally opposite to balance the larger left hand mountain.
- **2** Use the colours in the sky to paint the water to ensure harmony.
- 3 Use light, quick strokes of the brush to ensure sparkle on the water.
- 4 Shape the rocks, vary their size and distance apart.

THE POND - PROJECT

The Revack Highland Estate near Nethy Bridge, Scotland is a particular favourite of mine. The pond makes a lovely composition but the great variety of colours and tonal values in the foliage need careful thought and planning prior to applying brush to paper.

As always a quick tonal sketch helps to establish the lights and darks and provides thinking time to plan one's approach to the painting. A few quick colour mixes before the start of the painting is helpful in establishing the various greens required.

The painting was completed early in the morning when there were very few visitors. The distant trees had a blue green appearance being shrouded in early morning mist.

WHAT YOU WILL NEED

PAPER:

Bockingford 200lb extra rough

BRUSHES:

Winsor & Newton Sceptre Gold II size 14 round, size 6 round, size 3 rigger, 3/4" flat, 11/2" hake, 1/2" round hog hair brush

COLOURS:

Payne's Gray, Cobalt Blue, Alizarin Crimson, Raw Sienna, Burnt Umber, Cadmium Yellow Pale, Cadmium Yellow Deep, Sap Green

SUPPORTIVE:

Masking fluid, dark brown water soluble crayon

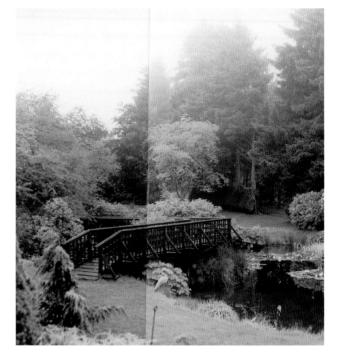

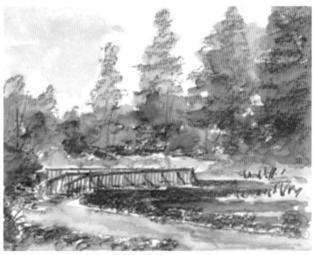

The TONAL VALUE STUDY enables you to plan your approach to the painting.

 ★ This quick colour representation helps to establish the colour combinations that are needed. I found mixes made from Cadmium Yellow Pale, Raw Sienna, Cobalt Blue and Sap Green were needed for the foliage and mixes of Payne's Gray, Alizarin Crimson and Cobalt Blue for the shadows.

STAGE 1 DRAWING, MASKING, SKY

An outline drawing was completed using a dark brown water soluble crayon - only general shapes in little detail, except for the wooden bridge. Masking fluid was used to preserve the structure of the bridge, some trees branches and the land and grasses on the islands in the pond.

When the masking was dry, a pale wash of Raw Sienna with a little Cobalt Blue was brushed in to paint the misty sky. A $1^{1}/_{2}$ " hake was used for this. When dry the distant trees were roughly painted using an old hog hair brush loaded with a pale Cobalt Blue/Raw Sienna mix.

STAGE 2 TREE FOLIAGE

The left hand tree/brush groupings were painted using a variety of greens made from Cadmium Yellow Pale, Raw Sienna, Cobalt Blue and Cadmium Yellow Deep. Cadmium Yellow Deep was used for the foreground bush and an old hog hair brush used to paint the foliage.

The grass area was painted with weak washes of Cadmium Yellow Pale and Cobalt Blue. As can be seen, the masking repelled the paint to indicate tree structures.

When painting such a grouping, it is important to consider the grouping as consisting of a variety of individual trees and bushes displaying different heights and shapes.

The shadows were painted in last, by over-painting areas of foliage with a Payne's Gray/Alizarin Crimson mix, to give depth to the trees.

STAGE 3 TREE GROUPING

The procedure discussed in Stage 2 was followed to complete the tree grouping on the far side of the pond. The colours used were the same. To add a few highlights to the foliage a little white acrylic paint was mixed with the variety of greens. Watercolour white will sink into the paper, white gouache or acrylic is better, ensuring the paint stays on the surface of the paper, creating light areas, adding sparkle to the foliage.

STAGE 4 FOREGROUND AND

WATER

Using a 11/2" hake, a pale Raw Sienna wash was brushed over the foreground grass. When less than one third dry, darker greens were brushed in, allowing the colours to fuse together creating a soft effect.

The water was painted using the round brush loaded initially, with a pale Cobalt Blue and whilst still wet adding dark values using vertical strokes with a Payne's Gray/Alizarin Crimson mix.

Some green was brushed down to represent reflections. Finally the two small bushes were added. Note how the masking has repelled the paint to indicate tree structures reflecting in the pond.

STAGE 5 REMOVE MASKING,

FOLIAGE

A Raw Sienna wash was applied to the islands in the pond and a little green brushed in here and there. When dry, the masking was removed to reveal the tufts of grass. To remove masking, I always use a putty eraser that adheres to the masking, facilitating removal.

The right hand bush was painted using previously described techniques. The foreground bushes on the left need to be realistically painted. The green upright conifer and the yellow low growing bush have lacy branches, which necessitate painting them with a size 3 rigger brush to achieve a realistic effect.

In both cases the dark background was painted first and when dry a little white acrylic was added to the mixture - for example, Cadmium Yellow Deep for the low growing bush and using

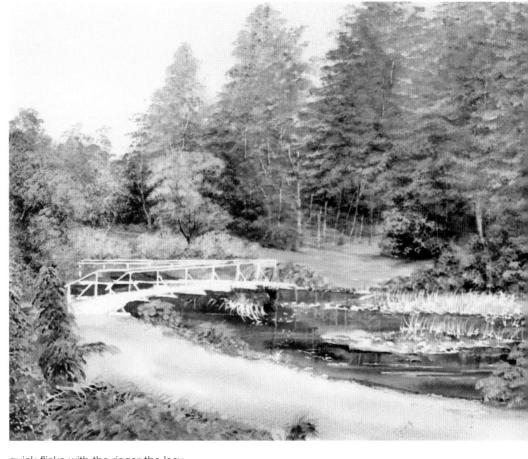

quick flicks with the rigger the lacy foliage was created. Finally, the masking was removed from the bridge.

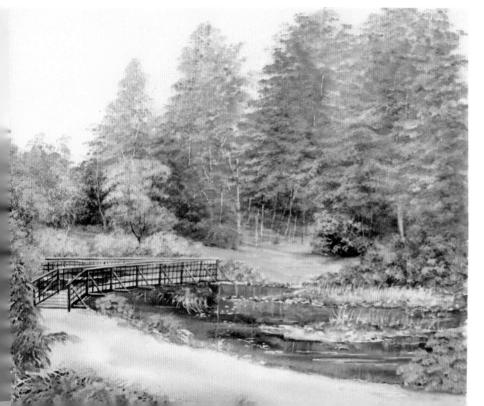

STAGE 6 BRIDGE

The bridge was painted with a rigger brush using a weak Raw Sienna for the boards and Burnt Umber for the uprights. Light effects were the white of the paper washed over with a very weak Raw Sienna - just a hint of colour.

Raw Sienna washes were applied to the island areas and the grasses under the bridge.

KEY POINTS

- 1 Don't attempt to capture this scene exactly you can't compete with nature. Attempt to capture the essence of the scene that inspired you to paint it.
- 2 Before putting paint to paper, think through your approach all paintings need a plan to follow. The tonal study provides you with thinking time and establishes your value patterns.
- 3 Experiment with mixing a wide range of greens and visualise where they fit into your painting.
- 4 The bridge over the pond is your focal point. It needs to stand out against its surroundings.
- 5 Paint each bush and tree free standing, although part of an overall mass. Those light toned tree structures are significant. These can be masked as in this project or scratched out with a palette knife, whilst the paint is less than one third dry.
- 6 Don't attempt to complete the painting in one sitting. View it carefully over a few days to establish where a few highlights will improve the painting and where darker values are needed to create depth.
- 7 A few small details like shadows in the foreground grass, highlights here and there, make all the difference. This is what distinguishes the professional from the amateur.

It's now time to look at the painting over a few days. I like to contemplate and decide where a few highlights or additional shadows would improve the painting. Highlights were added to shape the foliage on the distant trees. I use a hog hair brush cut to a chisel edge for this effect.

I have added highlights to several of the bushes to provide more

contrast/counter change and emphasised the lacy foliage of the low growing foreground bushes. Finally, I painted in a few darker shadows in the foreground grass.

This was quite a challenging painting in that it was important to represent the wide range of greens and to make each tree or bush distinctive rather than look like an overall mass.

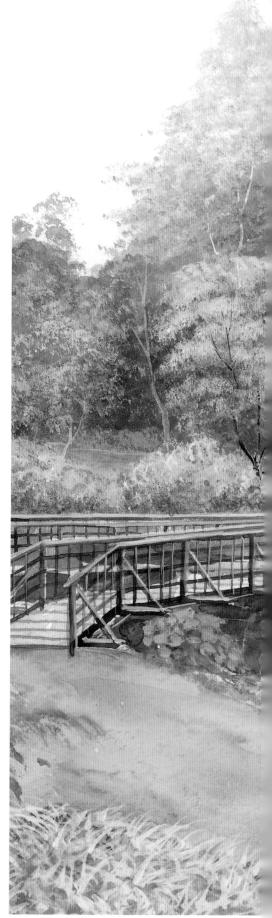

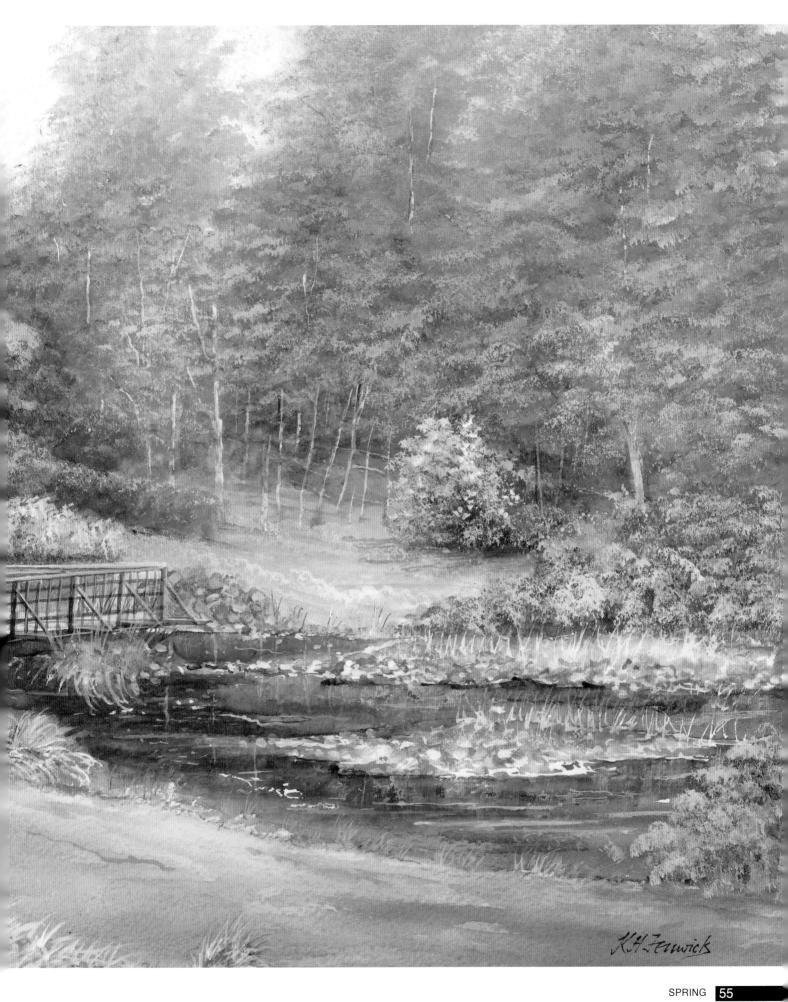

PAINTING SKIES

THE ABILITY TO PAINT A SUCCESSFUL SKY IS IMPORTANT - AFTER ALL, THE SKY CAN REPRESENT two thirds of your painting. They aren't difficult to paint but there are basic rules that must be followed:

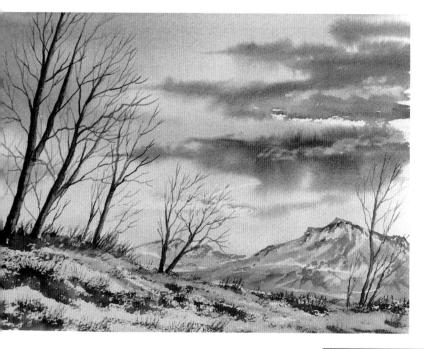

- 1 Use a large hake brush. I find a 2" brush too large and a 1" brush too small. A $1^{1}/_{2}$ " hake is ideal. The hake brush is made of goat hair with the ability to hold a lot of paint, enabling the paper to be covered quickly.
- 2 When painting cloud structures over a wet under-painting, timing is important. Apply a less wet paint over an underpainting, once the shine has left the surface - the underpainting must be less than one third dry or hard edges will occur.
- 3 Use a light touch with the brush and apply the minimum number of brush strokes to retain freshness. Just dance across the paper, depositing paint. The sky must be painted in less than three minutes to avoid hard edges.
- 4 Use an absorbent tissue to control edges and wet runs and to remove paint representing light cloud formations.

♠In this first example representing an evening sky, a pale Raw Sienna wash was applied overall to the sky area and a little Cobalt Blue added to the top left. The colours blended together. When the under-painting was approximately one third dry, stiffer mixes of Raw Sienna, Cobalt Blue and Alizarin Crimson were brushed in to represent the evening clouds. A tissue was shaped to a wedge and by using a dabbing action some colour was removed to represent light coloured clouds. Note, that I dabbed - not wiped. The stiffer paint will blend in well with the wet under-painting - not a hard edge in sight.

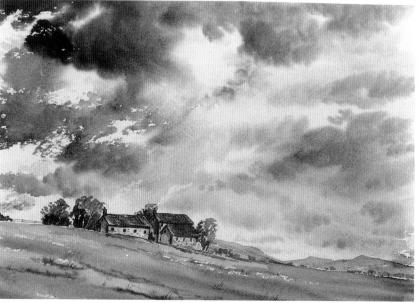

↑This atmospheric sky was painted by initially applying a Haw Sienna wash approximately two thirds of the way across the painting, leaving the one third on the left dry. The 11/2" hake brush allowed the paper to be covered quickly. When the under-painting was less than one third dry, a less wet mix

of varying tones of a Cobalt Blue/Alizarin Crimson/Payne's Gray mix was brushed in, using circular movements with the corner of the hake brush to form the cloud structures. The area of dry paper on the left created a different effect to the wet-in-wet washes applied to the right.

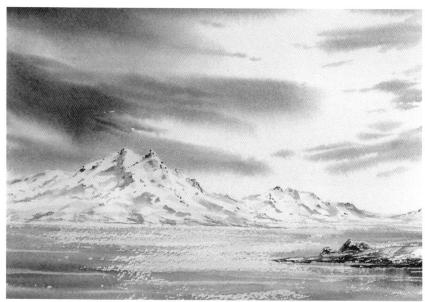

←This "cirrus" type sky was painted in less than two minutes by applying a Raw Sienna wash and when the shine had left the surface of the paper. Cobalt Blue cloud structures were painted in. Use broad sweeps of the hake, with an arm, rather than a wrist movement. When painting skies, the timing is so important to avoid hard edges forming. The result is a lovely fresh sky, without the dreaded hard edges.

→ For this colourful evening sky, I used the hake brush and a Raw Sienna wash and painted in a little Cadmium orange. This was followed by Cobalt Blue and even darker clouds made up from a Payne's Gray/Alizarin Crimson mix. The clouds were almost in horizontal layers, painted by simply touching the paper with the edge of the hake brush and allowing the paint to blend with the under-painting. To prevent the cloud layers from running into one large mass, the sky was completed with the paper virtually flat. Finally, a tissue was used to soften the edges and to create a few white clouds. Note the sparkle on the water achieved by using a dry brush effect.

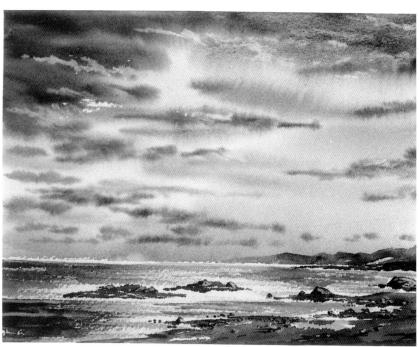

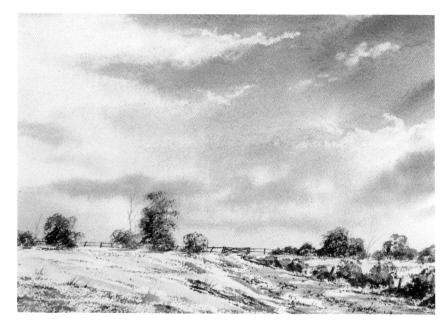

←This soft evening sky works well with this landscape. Note that the colours of the sky have been reflected in the foreground snow. Snow is rarely seen as white, as it reflects the colours of the sky and the surrounding elements. The darker cloud elements have been painted on the right to balance the larger bush on the lett. Skies are a pleasure to paint. As usual, I have painted a Raw Sienna wash and whilst still wet, brushed in Alizarin Crimson in areas, followed by stiffer mixes of Cobalt Blue/Alizarin Crimson.

CREATING ATMOSPHERE AND MOOD - CLOSE UP

This is an exercise in painting an atmospheric sky necessitated by a simple foreground.

SKY

The $1^{1}/_{2}$ " hake brush was used to apply a Raw Sienna wash overall with some Cobalt Blue being brushed in on the top left. Before this under-painting was one third dry a stiffer mix of Cobalt Blue and Burnt Sienna was brushed in to create cloud formations. An absorbent tissue was used to remove paint to represent white clouds.

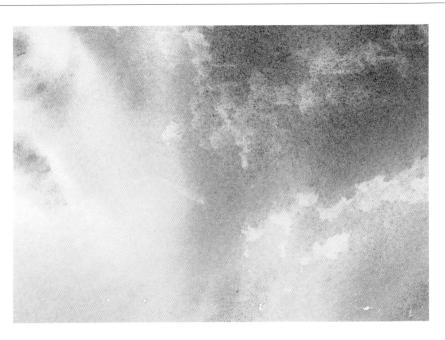

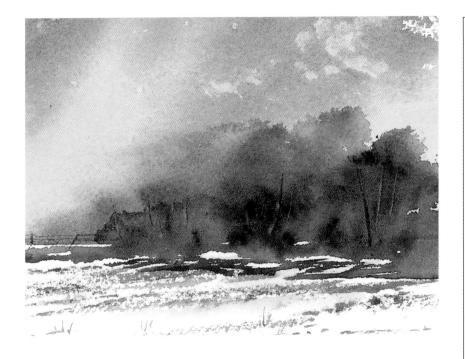

BUSHES

The bushes were painted using the hake brush loaded with mixes of Burnt Sienna, Payne's Gray and Alizarin Crimson whilst the sky under-painting was still moist. The tree structures were then scratched in.

WHAT YOU WILL NEED

PAPER:

Winsor & Newton 140lb rough

BRUSHES:

Winsor & Newton Sceptre Gold II Series size 3 rigger, 11/2" hake

COLOURS:

Payne's Gray, Cobalt Blue, Alizarin Crimson, Raw Sienna, Burnt Sienna

SUPPORTIVE:

Tissues

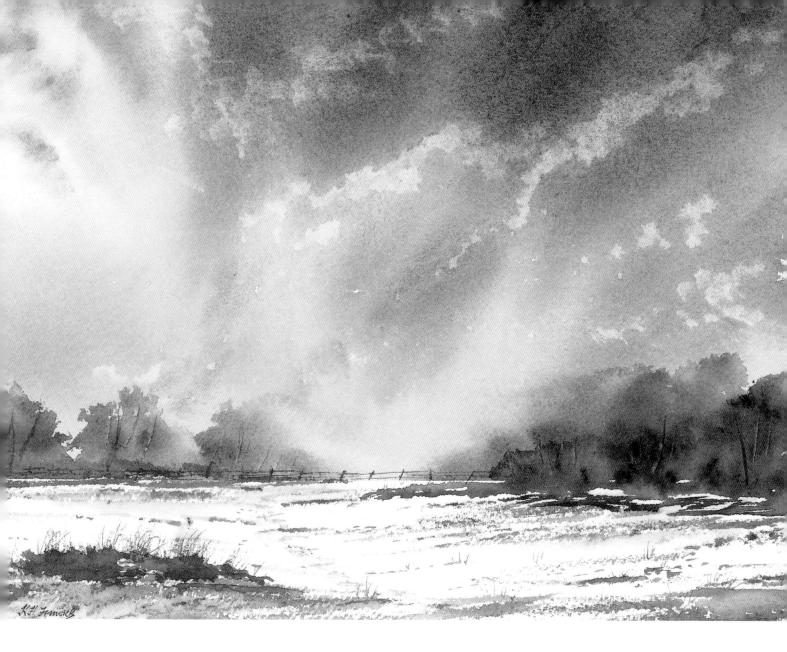

FOREGROUND AND **FENCE**

The fence was painted using a Payne's Gray/Burnt Sienna mix with the rigger brush. Note the distance between the fence posts needs to be approximately twice the height of the fence.

The 11/2" hake brush was used to paint the foreground texture/stubble visible through the snow. The hake brush is ideal for this, by using less wet paint and lightly touching the paper using quick twitches with the brush to deposit paint. Practise this technique on an off-cut of paper before applying paint to your actual painting.

KEY POINTS

- 1 Be bold when painting the sky. Leave approximately 50% of the under-painting uncovered when brushing in the cloud structures.
- 2 Paint the middle distant bushes using circular movements with the corner of the hake brush whilst the under-painting is still wet to create a wot blurred effect.
- 3 Practise painting the foreground using twitches with the edge of the hake brush - just lightly dancing across the paper.
- 4 Do not paint square fences.

SPRINGTIME AT CATHEDRAL ROCKS - CLOSE UP

Cathedral Rocks in the distance contrast with the flower-filled meadows in Yosemite National Park evoking a pastoral scene of peace and tranquillity.

ROCKS

Time was taken to draw the profile of the rocks, ensuring a realistic impression evolved.

The establishment of lights and darks was paramount. Masking fluid was applied to selected areas on the rocks. Initially, the rocks were painted wet into wet, with the detail being added when this under-painting was dry. I used Raw Sienna for the underpainting and whilst still wet, a Payne's Gray/Alizarin Crimson mix was used to paint the shadows to create depth and structure. Cobalt Blue and Burnt Sienna was added to provide variation. Paint one rock at a time - it's like putting together the pieces of a jigsaw. The masking fluid was finally removed using a putty eraser.

TREES

There are a variety of shapes, sizes and colours displayed in the trees. Although they appear as a total mass across the middle distance, take care to paint each tree with its own identity and don't forget to add the shadows. Trees appear dark on the inside and lighter on the outside. Add a few highlights for sparkle. The techniques for painting

MEADOW

Using the hake brush, a pale Raw Sienna with a little Sap Green was painted in the distance with more Sap Green being added as the foreground is approached; for the darker trees are shown on pages 112-115. shadows some Payne's Gray was added to the mix. When dry, the flowers were added

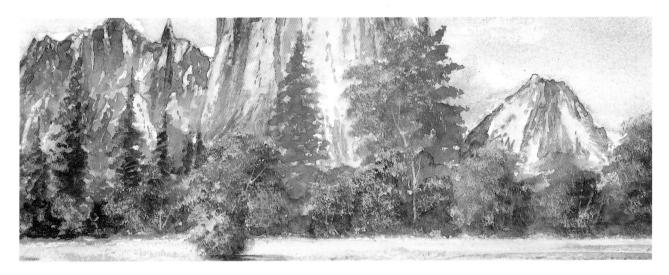

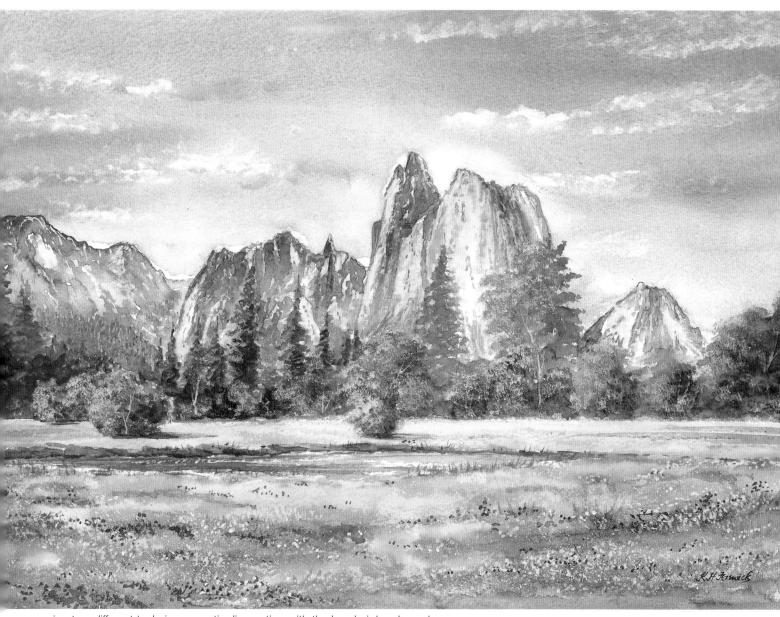

using two different techniques: a stippling action with the hog hair brush, and spattering colour by running a thumb over the bristles of an old toothbrush to control the direction of spatter. When spattering, it is important to mask above the horizon line, or the spatter will spray everywhere. An ordinary piece of newspaper is fine for this purpose.

WHAT YOU WILL NEED

PAPER:

Saunders Waterford 300lb rough

BRUSHES:

Winsor & Newton Sceptre Gold II Series ³/₄" flat, size 3 rigger, 1¹/₂" hake, ³/₄" round bristle

COLOURS:

Payne's Gray, Cobalt Blue, Alizarin Crimson, Raw Sienna, Burnt Sienna, Cadmium Yellow Pale, Sap Green

SUPPORTIVE:

Masking fluid, old toothbrush

KEY POINTS

- 1 Produce a tonal study to establish the lights and darks, in particular, to add to depth and form the rocks.
- 2 Paint a simple sky, in this case, Cobalt Blue with whit clouds created by removing paint with a tissue.
- 3 Paint your trees as individual shapes.
- 4 Create variation in the foreground by applying several values.
- 5 Use old newspaper to mask areas of the painting prior to spattering.
- 6 For unity add touches of the foreground colours to the rocks and trees.

COLOUR MIXING - US COMBINATIO

MOST NEW STARTERS TO WATERCOLOUR PAINTING EXPERIENCE DIFFICULTY IN MIXING colours. Some of my students go to extremes. They have been told that all they will need is three primary colours, consisting of a red, yellow and blue and from these, they will be able to mix any colours they require, others arrive with dozens of different colours, including horrendous turquoise blues and garish greens and a variety of greys.

Colour has fascinated artists for generations. Many books have been written about this subject but there's no substitute for experience. I'm often asked by my students, the percentages of each hue I have mixed together to achieve a particular colour but I can't really tell them - I just mix quantities of colour together until I am satisfied with the outcome. Certain rules obviously have to be followed. If fresh clean colours are required, it's best to mix only two colours but for more subtle shades, mix three colours together. If more than three colours are mixed, they are likely to produce dull colours which artists call "mud", but there may be occasions when a dull colour is needed.

RED ORANGE **PURPLE** RED RED PURPLE ORANGE **ORANGE** YFLLOW BLACK YELLOW BLUE GREEN YELLOW BLUE **GREEN GREEN**

THE BASICS OF COLOUR MIXING

The PRIMARY colours are: RED, YELLOW and BLUE. If similar quantities of each primary colour are mixed together, the result is almost a black colour, as shown in the colour circle below. If blue and yellow are mixed together they will produce green; mixing red and yellow give an orange and red and blue a violet or purple colour. These are known as SECONDARY colours. If a primary colour is mixed with a secondary colour, TERTIARY colours are created.

Follow the arrows in the colour circle below, it's easy. By using three primary colours in the combination shown with various amounts of water, a wide range of tints can be produced but of course, companies such as Winsor & Newton produce over 90 colours, allowing plenty of scope to experiment.

For your first exercise, follow the arrows in the colour circle. The colours and tints you will produce will depend on which particular red, yellow and blue you mix and the amount of water you add. For the exercises in this brochure, I suggest you purchase a small watercolour pad and experiment to build yourself a colour mixing resource to

which you can refer as required, until mixing

BLUE

PURPLE

becomes second nature. Don't forget to record your mixing combinations.

By varying the amount of each colour and water content, various shades and tones can be mixed.

Common sense tells you, that if you wish to mix a light tone, you should start with the lighter colour and add a small amount of the darker colour. If you're aiming to mix a dark colour, start with the dark colour and add a small amount of the lighter colour until you achieve the required tone.

For example, if you require a rich orange red, then start with the red and add a small amount of yellow. For a bright orange, start with yellow and add a small amount of red. It's really just common sense. To lighten your colours, add more clean water. A useful exercise for you to try is to mix two colours together using a little water to achieve a dark tone and paint a small area on a sheet of watercolour paper. Hold some absorbent tissue (toilet roll) in your hand, dip the paint loaded brush without shaking or wiggling it into the water pot about half an inch, then removing it gently, wipe it on the tissue and make an adjoining deposit on the paper. You will observe your colour mix has become lighter in tone. Repeat this process (without dipping the brush into your original colour mix) and you will be able to produce between six and twelve tones of the original colour. My students don't go to sleep counting sheep - they dip and wipe, but it works.

When mixing colours, never dip your brush into the middle of the paint. I always tease the paint away, using circular movements of the brush, lightly touching the side of the deposited paint. By this means, I'm able to control the strength of paint on the brush and it helps to keep my wrist supple.

My preference is using tube colours, as the paint is soft and responsive. I prefer to mix two colours together. sometimes three to create a particular colour. If more than three colours are mixed together, the likelihood of creating a dull colour, often referred to as "mud" is almost certain.

I use my supportive palette and any other colours that I feel I require for special effects but in the main, 90% of my paintings are completed from my basic palette.

Below I have shown how I lay out my colours on the palette. They are laid out to a system, starting with Payne's Gray. Clockwise the first three are my sky colours, the next three, my earth colours and the following two my mixers.

I cover my palette with plastic wrap prior to depositing paint, which enables me to clean the palette with ease, using a soft tissue and when it becomes too messy to clean easily, I simple remove the wrap and start again. This saves me the task of having to clean my palette under the tap.

My BASIC PALETTE

consists of the following colours in tube form:

Payne's Gray

Cerulean Blue

Alizarin Crimson

Raw Sienna

Burnt Sienna

Burnt Umber

Cadmium Yellow Pale Permanent Sap Green

My SUPPORTIVE PALETTE

consists of the following colours, that I use to complement my basic palette as required:

French Ultramarine

Cobalt Blue

Winsor Yellow

Gold Ochre

Brown Madder

Vermilion hue

Cadmium Orange

Winsor Red

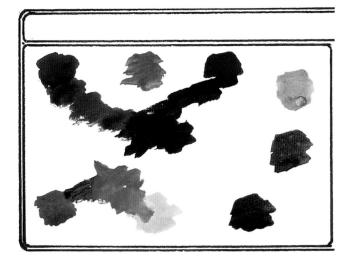

By positioning the paint deposits around the perimeter of the palette, I am able to draw the colours into its centre to mix my required colour. The larger your mixing area, the less restricted you are. Those tiny palettes with small indentations do not allow the use of large brushes and don't provide adequate mixing areas. I use my 11/2 inch sky and texture brush (hake) for most of my painting but it is unusable in the indentations provided in a small palette.

THE SECRETS OF WATERCOLOUR PAINTING

- 1. Use the largest brushes possible in relation to the size of the element you're painting to ensure freshness.
- 2. Use the minimum number of brush strokes.
- 3. Use a light touch of the brush loaded with fresh colour over the surface of a rough paper to create texture.
- 4. The secret of watercolour painting is knowing how wet the paint on the brush is in relation to the wetness or dryness of the paper and when to apply the paint.
- 5. To avoid hard edges forming, each successive layer of paint should be drier than the under-painting. Once the underpainting becomes more than one third dry, hard edges will occur if you apply wet paint.

SOME COLOUR COMBINATIONS THAT I FIND USEFUL ARE SHOWN BELOW

Practise mixing these colours following the techniques mentioned earlier, until they become second nature.

PAINTING SKIES

MIXING BLUES:

Payne's Gray/Cerulean Blue - cloud colours

Payne's Gray/French Ultramarine blue - cloud colours

Payne's Gray/Alizarin Crimson – warm cloud colours

Raw sienna – under-painting

Cobalt Blue or indanthrene blue - deep blue clouds

COLOUR HARMONY

One of the best ways to ensure colour harmony in a painting is to use a limited range of colours. For example, the sky could be painted blue, the mountains a blue green, the water blue and the foreground bank and trees green. Using only three colours, that could be Cerulean Blue, Cadmium yellow and Payne's Gray, plus various amounts of water, enables you to paint a wide range of spring and summer scenes.

Similarly, by using mixes of Raw Sienna, Burnt Sienna and French Ultramarine blue, autumn scenes can be created.

PAINTING TREES AND BUSHES

MIXING GREENS:

Payne's Gray/Sap Green - dark rich greens

Sap Green/Raw Sienna - yellow greens

Cerulean Blue/Cadmium Yellow Pale - spring greens

Cerulean Blue/Raw Sienna - olive greens

Payne's Gray/Cadmium Yellow Pale - mid grass green

French Ultramarine blue/Winsor Yellow - bright greens

MIXING AUTUMN FOLIAGE

Burnt Sienna/Raw Sienna - warm browns

Alizarin Crimson/Raw Sienna – rich reds/oranges

Alizarin Crimson/Cadmium Yellow Pale – warm oranges

MIXING GREYS

20% of any colour on your palette, mixed with 80% Payne's Gray will result in an extensive range of cool and warm greys.

My favourites are:

Payne's Gray/Alizarin Crimson – purple grey

Payne's Gray/Sap Green – dark rich green grey

Payne's Gray/Burnt Sienna – dark brown grey

Payne's Gray/Cerulean Blue - depth in distant trees

French Ultramarine blue/Alizarin Crimson – warm shadow grey

Payne's Gray/Sap Green - dark water under trees

Payne's Gray/Cerulean Blue - surface water

Payne's Gray/French Ultramarine blue - bright surface water

Payne's Gray/Alizarin Crimson - pale shadows

Payne's Gray/Burnt Umber – dark shadows

PAINTING WATER

Don't forget that water is colourless but its surface reflects the sky colours and those of surrounding objects. For colour harmony in your painting the colour of the water should reflect the sky colours.

PAINTING MOUNTAINS

Raw Sienna/Sap Green - tree and grass areas

Raw Sienna/Burnt Sienna - under-painting

Payne's Gray/Alizarin Crimson - mountain peaks and

Cerulean Blue or Cobalt Blue - shadows

Payne's Gray/Burnt Umber - dark promontories

PAINTING ROCKS

Raw Sienna/Burnt Sienna - warmth

Payne's Gray/Cerulean Blue - cold under-painting

Payne's Gray/Alizarin Crimson – warm shadows

Payne's Gray/Burnt Umber – dark shadows/texture

Davy's gray or Raw Sienna - under-painting

PAINTING BUILDINGS

Raw Sienna – under-painting Burnt Sienna - variation in texture Burnt Umber - darker texture/cracks/crevices/weathering

cracks/crevices/weathering Cobalt Blue/Alizarin Crimson – shadows/weathered effects Vermilion/Alizarin Crimson - brick colour

Payne's Gray/Alizarin Crimson -

PAINTING STONE WALLS AND BRIDGES

Raw Sienna or neutral grey - under-painting Burnt Umber - variation French Ultramarine blue/Alizarin Crimson - shadows/texture Payne's Gray/Alizarin Crimson - dark shadows, depth Burnt sienna/Burnt Umbor - dark texture

SPECIAL EFFECTS

Raw Sienna – under-painting for sky

Cobalt Blue - snow shadows

Raw Sienna/Alizarin Crimson - under-painting for evening sky

Payne's Gray/Alizarin Crimson - cloud colours for evening sky

Payne's Gray/Cerulean Blue - rain clouds

Payne's Gray/Raw Sienna - rain clouds/mist/fog

Payne's Gray/Burnt Umber - storm clouds

Payne's Gray/Burnt Umber/Alizarin Crimson - storm clouds

French Ultramarine blue over Cadmium Yellow Pale - light in the sky

Mixing greens and greys - mentioned earlier in text

PUDDLE PAINTING

A technique often used by the professional artist to achieve colour harmony is to mix a range of coloured washes on the palette and as colour mixing progresses, the brush is dipped into these mixes to create similar base colours throughout the painting avoiding extremes of colours.

Painting should be fun and experimenting with colours is no exception. You will be amazed at the range of colours and shades that can be achieved. Above all else, enjoy your painting.

PAINTING WATER

WATER IS A CHALLENGING AND EXCITING SUBJECT FOR THE WATERCOLOURIST.

There's nothing that helps to establish the effect of peace and tranquillity like painting near a stretch of water, particularly moving water as it splashes off protruding rocks. It engenders a sense of well being that inspires the artist to produce their best work.

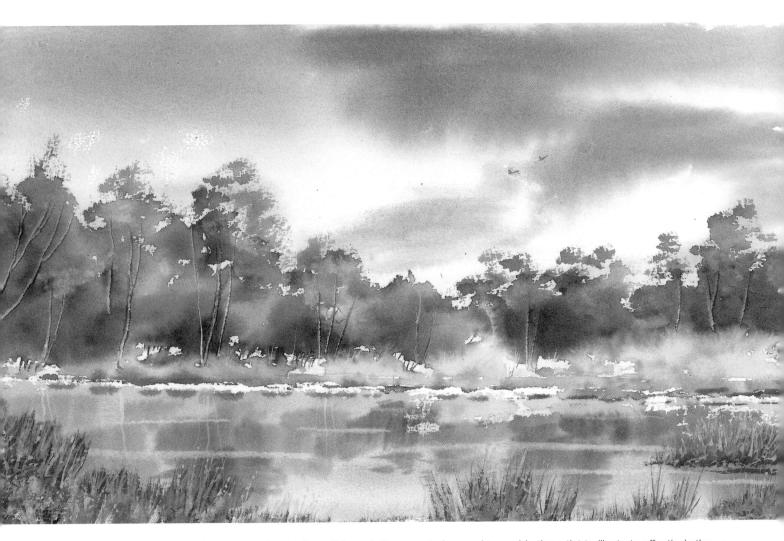

Basically, there are three types of water the artist needs to represent:

MOTIONLESS - a still lake, a pond or even a puddle in a country lane is included in this category;

MOVING - consider a slow flowing river, a windswept lake or a mountain beck;

TURBULENT - includes a turbulent seascape, a fast flowing river or mountain stream cascading over a rocky base or a waterfall.

Representing water in a painting needs an understanding of the techniques necessary and the most suitable brushes to be used to enable the artist to illustrate effectively the type of water required.

The colours will vary, depending on the source of water and the land over which it flows. For example, if the land is peaty, the water may have Burnt Sienna tinges, but if the water bed is rocky, the water may be perfectly clear and its ourface will show the cloud colours and reflections of adjacent objects. For water to look real it should be painted with minimum brush strokes. There are many examples in this book enabling you to study and practise your new found techniques.

REFLECTIONS

Water in reality is colourless; its surface colour reflects the colour of the sky and that of reflecting objects in general. If the water is flowing over land rich in mineral deposits, then it may be coloured by such deposits or if fast flowing or turbulent it may be coloured by stirring up the deposits from the riverbed.

The sharpness of reflections will depend on the speed of flow. If water is flowing quickly, the reflections will appear blurred; if the water is motionless the reflections will appear as a mirror image. There only has to be a slight wind blowing across the surface and the areas of light and dark can change significantly. When painting water, don't attempt to change it every time the surface colours and values change. Keep a picture in your mind and paint it as you remember it in the first place.

The simplest way to paint reflections is to paint an initial wash, usually the colours in the sky and using a 3/4" flat brush pull down vertical strokes of the colours in the reflecting objects - in the painting above, it is the trees. Notice a few wind lines have been created by wiping a tissue folded to the shape of a chisel edge across the paper to remove paint.

BRUSH STROKES

The following exercises cover virtually all of the techniques you will need to paint water effectively. Practise these techniques; they will serve you well.

1 SPARKLE ON WATER

Think of your paper surface as mountains and valleys. Move the side of the size 14 round brush loaded with moist paint, quickly and lightly over the peaks of the paper. The valleys (white of the paper) will be left uncovered, creating a broken

wash, ideal for representing sparkles on water.

See pages 41, 49, 57.

2 WATERFALLS

Use the 11/2" hake brush to create the effect of falling water. Use a quick

circular motion, lightly touching the paper to deposit paint. The action is just a quick twitch of the brush. Practise the technique on a similar piece of paper until the paint is being deposited to your satisfaction before applying it to your painting. Build up gradually, applying at least two tonal values, working from light to dark. See pages 77, 85.

3 FAST FLOWING WATER

This is the technique I use when painting a fast flowing river or mountain stream. Using the hake brush, I touch the paper to deposit paint and in between deposits, I twitch the brush to represent small falls of water between protruding rocks. The whole action is completed in seconds; a dab followed by a twitch repeated, working from distance to foreground.

See pages 127, 155, 167, 175.

4 WAVES

Apply curved motions with the hake brush to create the effects of waves. Work light to dark, leaving some white paper uncovered. Build up the values stage by stage. Stand back and observe; don't rush it. See page 73.

5 DISTANT SEASCAPE

To produce a believable impression of distant waves.

use the full width of the hake to deposit paint. The action is to touch the paper, depositing a 11/2" line of paint, progressing along the line to the end. Paint each line this way and then use the corner of the hake to twitch the brush, spreading the deposited line slightly to represent breaking waves. See page 81.

SEASCAPE - CLOSE UP

This is an exercise to demonstrate the use of the brush stroke shown on page 71. The tonal study establishes the value patterns acting as the route plan for the painting. All paintings need a plan. The few minutes needed to produce these simple, monochrome "doodles" using a water soluble crayon is time well spent.

SKY

I wanted an atmospheric sky to balance the rough surface of the sea. A Cerulean Blue wash was overpainted whilst less than one third dry using a Payne's Gray/Alizarin Crimson mix to represent cloud structures. Note the diagonal direction of the clouds, helping to create a sense of wind and movement.

ROCKS

The two smaller rocks have been painted to improve the composition by helping to balance the cliff face. Their profile is jagged and directed towards the cliff face, which tends to lead the eye into the painting. Washes were applied and the light areas created by moving paint with a palette knife - see page 79. The effect of waves splashing against the rocks was

achieved by flicking upwards with the moist white water-soluble crayon.

WATER

Using the technique for painting waves shown on page 71 the sea was quickly painted. Curved strokes with the hake, reflecting the shape of the waves, can create a realistic effect. Start by applying the lighter tones, followed by darker tones of the same mix. I used mixes of Cerulean Blue for the under-painting, followed by darker tones of a Cerulean Blue/Sap Green/Payne's Gray mix.

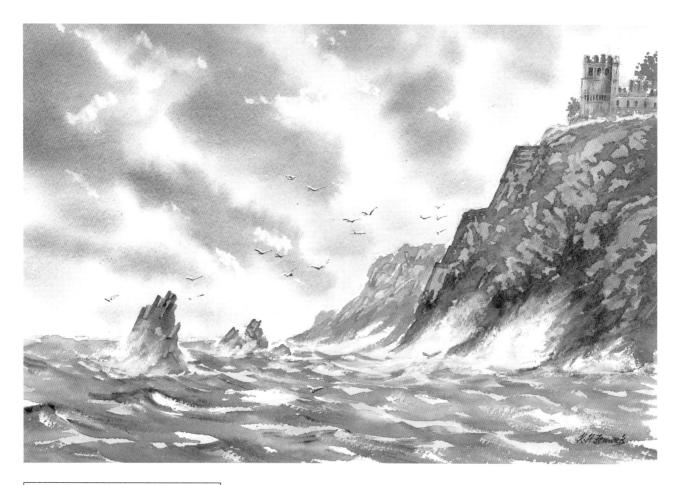

WHAT YOU WILL NEED

PAPER:

Bockingford 200lb extra rough

BRUSHES:

Winsor & Newton Sceptre Gold II Series 3/4" flat, size 3 rigger and 11/2" hake

COLOURS:

Payne's Gray, Cerulean Blue, Alizarin Crimson, Raw Sienna, Burnt Sienna, Sap Green

SUPPORTIVE:

White water-soluble crayon, tissue or kitchen roll

CLIFF FACE

Beginning with a wash of Raw Sienna, brush in some Burnt Sienna and a Payne's Gray/Alizarin Crimson mix for the darker tones. The distant cliffs must be painted in lighter values. When the paint is approximately one third dry, use the palette knife to create the structure. Using a moist

tissue, wipe upwards from the water line to remove paint representing the waves splashing against the cliff face.

The seabirds were painted to add interest to this sketch.

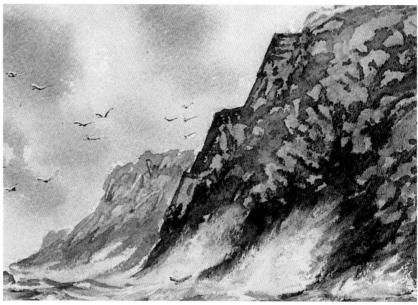

FAST FLOW - CLOSE UP

"Fast flow" is a painting created from my imagination It is the type of landscape that stirs my emotions as an artist. Although not an actual scene, each of the elements represents features that I have seen previously. I have merely linked them together, like a jigsaw to create a painting, taking into consideration the principles of good design.

Although the new starter may look at a painting like this with apprehension, instead, they should think of it as different elements linked together as in a jigsaw and not be deterred from experimenting,

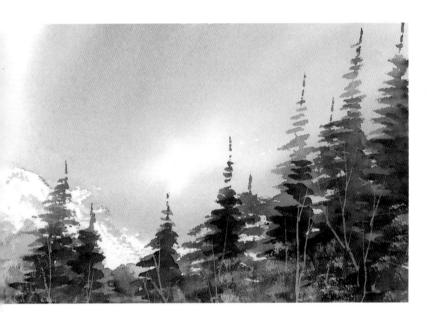

SKY AND FIR TREES

Remember the "Golden Rule" when painting skies; if the foreground is detailed, the sky should be simply painted. With this in mind, the sky was painted by washing a very pale Raw Sienna wash over the area and using the 11/2" hake loaded with Cobalt Blue, some cloud structures were painted as soon as the shine had gone off the underpainting.

The fir trees were painted after the mountain and sky area was dry by using the full width of a 3/4" flat brush loaded with a Burnt Sienna/Sap Green mix. Start at the base and work upwards gradually decreasing the amount of the brush face in contact with the paper to produce the desired shape.

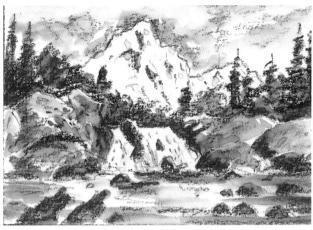

TONAL STUDY

The simple tonal study produced with a water-soluble crayon helps me to establish the composition and values. It ensures that I have thought through my approach to the painting before applying brush to paper. All paintings must have a plan to follow. Tonal value studies are simple, quick sketches completed in a few minutes.

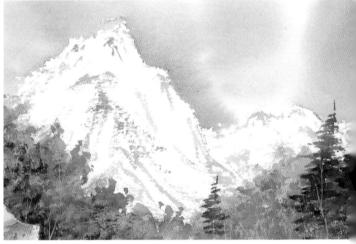

MOUNTAINS

I wanted to keep the mountains simple and pale in tone with little detail to ensure recession in the painting. Prior to painting the sky, it's a good idea to paint masking fluid around the perimeter of the mountain to ensure the paint doesn't run over the white of the paper to be preserved for the mountains when painting the snow. When the sky is dry remove the masking.

To crease the impression of a few promontories projecting through the snow, the dry brush technique was adopted, using the side of the size 6 loaded with Cobalt Blue.

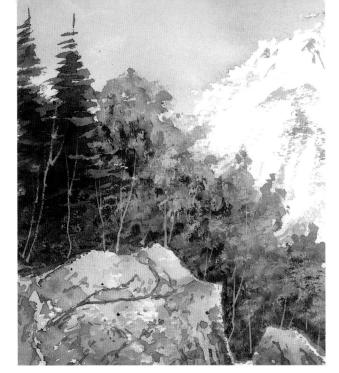

AUTUMN TREES

To paint the autumn trees, variation was achieved by mixing Cadmium Yellow Pale, Raw Sienna, Burnt Sienna and Payne's Gray with a little Sap Green being brushed in here and there.

When the paint was approximately one third dry, some tree structures were scratched in with the corner of a palette knife.

ROCKS

The rocks are a main feature in this painting with more detail being added to the larger rock to the left of the fall.

When painting rocks, I use many techniques available to me.

This feature rock was painted as follows. Having initially drawn the shapes with a dark brown water-soluble crayon, a wash of Raw Sienna was painted over the rock as a whole. Whilst still wet, some Burnt Sienna and Burnt Sienna/Payne's Gray was brushed in, using the 3/4" flat. An absorbent paper tissue was used to blot chosen areas creating light effects and when approximately one third dry a palette knife was used to move the moist paint, creating various rock like patterns.

When dry, a rigger brush loaded with darker tones was used to paint shadow and fissures in the rocks.

Finally, when the paint had dried, using an old toothbrush loaded with a Payne's Gray/Burnt Sienna mix, I spattered paint over the rock after masking it with paper off-cuts placed around its profile.

WHAT YOU WILL NEED

PAPER:

300lbs SAUNDERS WATERFORD rough 15" x 11"

BRUSHES:

Winsor & Newton Sceptre Gold II Series size 14 round, size 6 round, size 3 rigger, 3/4" flat, 11/2" hake

COLOURS:

Payne's Gray, Cobalt Blue, Raw Sienna, Burnt Sienna, Cadmium Yellow Pale, Sap Green.

SUPPORTING:

Dark brown and white water-soluble crayons, masking fluid, paper tissues

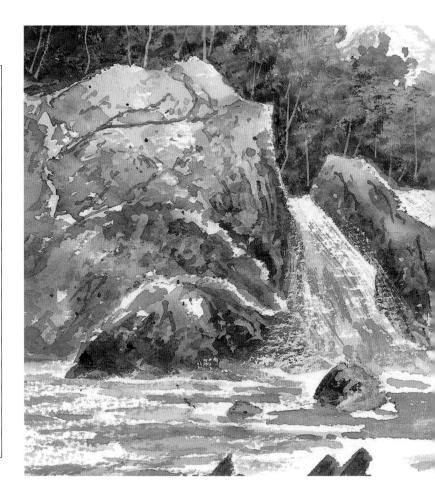

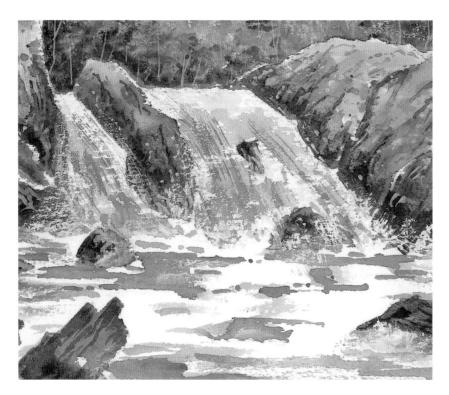

LEVEL WATER

Because the fall of water is flowing fast, there will be lots of white water in the foreground. It's important therefore, to leave plenty of the white of the paper uncovered.

To complete the water, I have used the hake brush loaded with a Payne's Gray/Cobalt Blue mix and simply danced quickly across the paper, depositing the paint, taking care not to over do it.

You will note that I have painted two foreground rocks more jagged than the surrounding rocks to provide variation.

WATERFALL

This is the most tricky part of the painting as overworking can spoil the whole effect. Before applying paint to your painting, practise the brush strokes shown on page 71 on an offcut of a similar type of watercolour paper to determine the amount of paint needed to produce the desired effect. Don't be in a hurry; think it through first. Begin with a weak Cobalt Blue to establish the main flow patterns. A quick downward "twitch" of the hake is all that is needed - don't over do it. Let the paint dry and lightly "twitch" again with a darker tone, made by adding a little Payne's Gray to the Cobalt Blue. Less is more, when painting a fall of water. Practise on a piece of watercolour paper first.

KEY POINTS

- 1. The sky and mountains need to be simply painted in pale values to achieve recession.
- 2. Build up the painting of the water gradually having a pause for thought. Remember "less is more".
- 3. Use masking fluid to profile your mountains. It will prevent the sky colours running down over the white of the paper.
- 4. Make the left hand rock group a feature and use the darker toned trees behind them to create counterchange.
- 5. Leave the white of the paper to represent white water.
- 6. Use a palette knife to create tree structure and to shape the rocks.

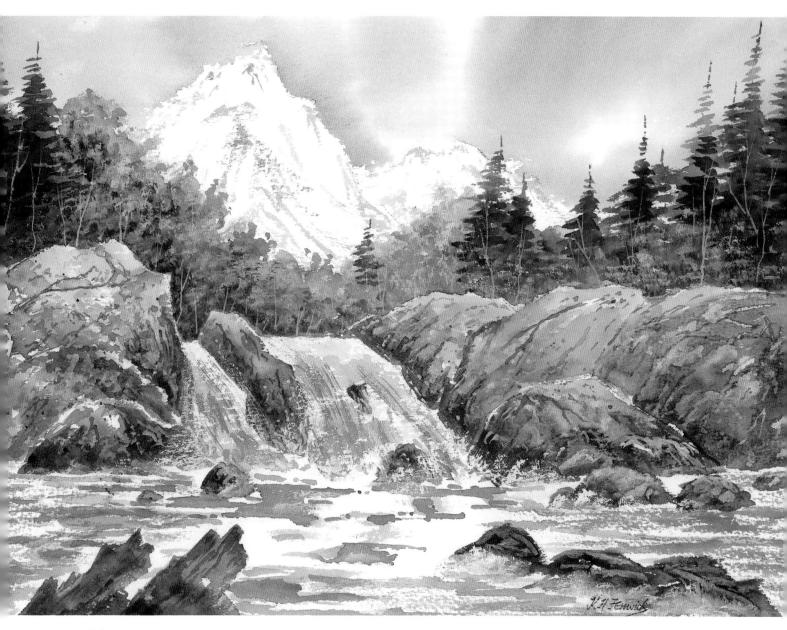

THE COMPLETED **PAINTING**

Bringing the painting together is an important stage. I normally prefer to critically examine all aspects of the painting spread over a few days before making the final changes that are usually required. The painting must appear as a unit when finished. With a little Burnt Sienna on a size 6 brush, I added colour to the different elements throughout the painting. Using a softened white water-soluble crayon, I deposited paint to represent splash back over the rocks by flicking upwards from the waterline. This is a useful technique. Similarly, in the case

of the rocks shown below, the softened water-soluble crayon can provide the effect I want. Note how the water reflects the sky colours and how the colour combinations used for the rocks are echoed throughout the painting. This is important to achieve UNITY in a painting.

PAINTING MOUNTAINS AND **ROCKS**

THERE ARE ALWAYS SEVERAL DIFFERENT APPROACHES TO PAINTING landscapes, including mountains or rocks. The techniques chosen will really depend on the structure of the mountain observed or the atmospheric aspect at the time. For example, in fog or mist, little detail can be seen and the answer may be simple washes to achieve the desired result. On a sunny day with light highlighting specific features, one's approach will be different, with more detail being painted and when rain falls the colours take on a different aspect. Some of the techniques I use are shown below.

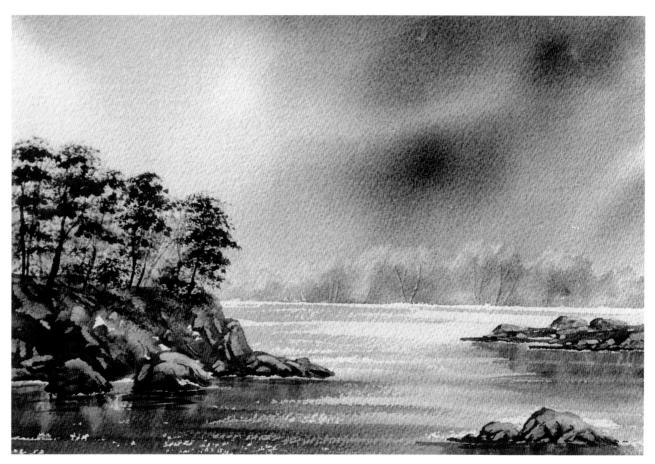

The rocks in this quick sketch were developed effectively by moving paint with the side of a palette knife to create their structure.

WASHES AND TISSUE

The mountains shown below were painted using a 11/2" hake brush and applying various washes from peak to ground level, following the structure of the mountain. Whilst still wet, a tissue was folded and pressed into a wedge. Working from the peaks downward the wedge was used to wipe off paint to create highlights and give the impression of structure.

WET IN WET

Here I have applied a Raw Sienna wash and dropped in a little Burnt Sienna, allowing the colours to blend together to create a warm under-painting.

This was followed by darker tonal values being added so a little Burnt Umber was brushed in and when dry, I added further detail.

When painting rocks it is important to use colours that are as near to nature as possible. I could have used Davy's grey and added a Payne's Gray/Alizarin Crimson mix. It depends on the region but the technique is the same.

washes with a 3/4" flat brush and when approximately one third dry, using a palette knife to move the paint to achieve a realistic looking rock. Practise this

technique with a palette knife; you will be amazed how easy

This group of rocks, typical of those to be found on a beach, were painted by applying several colours and tones and whilst the paint was still wet, with a tissue shaped to a wedge or point, paint was removed to reveal light areas. This is a very simple technique. A few cracks/fissures in the rock face were added using the rigger brush when the under-painting was dry.

snow.

WET IN WET AND PALETTE KNIFE

This rock was painted by applying the usual

it is.

PALETTE KNIFE

These crags were painted by initially applying several different coloured washes with a $^{3}/_{4}$ " flat brush and when approximately one third dry using the side or point of the palette knife to move the paint to produce the desired effect. How much side of the knife you press to the paper will depend on how narrow or wide you wish the finished marks to appear. This

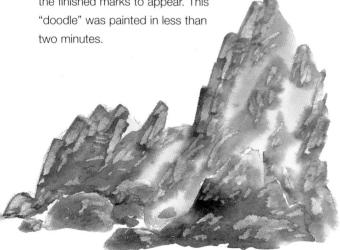

Painting snow-capped mountains requires a little finesse and

represents the snow. A Cerulean Blue wash represents the

Crimson mix the mountain structure projecting through the

shadows and the darker tones of a Payne's Gray/Alizarin

patience as they can so easily be overdone. There are

several examples in this book. The white of the paper

WET INTO WET AND TISSUE

SUMMER

Of green and stirring branches is alive

And musical with birds that sing and sport

In wantonness of spirit; while below

The squirrel, with raised paws and form erect,

Chirps merrily. Throngs of insects in the shade

Try their thin wings and dance in the warm beam

That wake them into life. Even the green trees

Partake the deep contentment; as they bend

William Cullen Bryant

Summer is the season of hazy, lazy days.

The countryside is in full bloom; hedgerows and meadows teeming with dog roses, meadow sweet, milkmaids, meadow cranesbill and hogwort to name but a few and the pastures are full of grazing cows and sheep. The lambs grow fat. Haymaking is in progress and the farmer works from dawn to dusk at this time of the year.

The cottage garden is very colourful with herbaceous borders being at their best and roses and sweet smelling honeysuckle climbing around the doors of the cottages.

Towards the end of summer, the corn is harvested and the moors become a blanket of purple heather.

There are ample subjects to inspire both the beginner and the experienced artist.

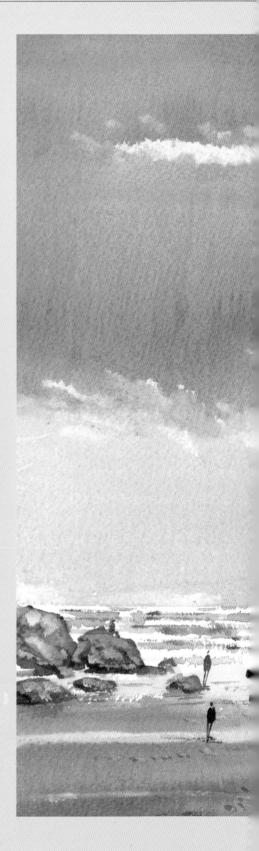

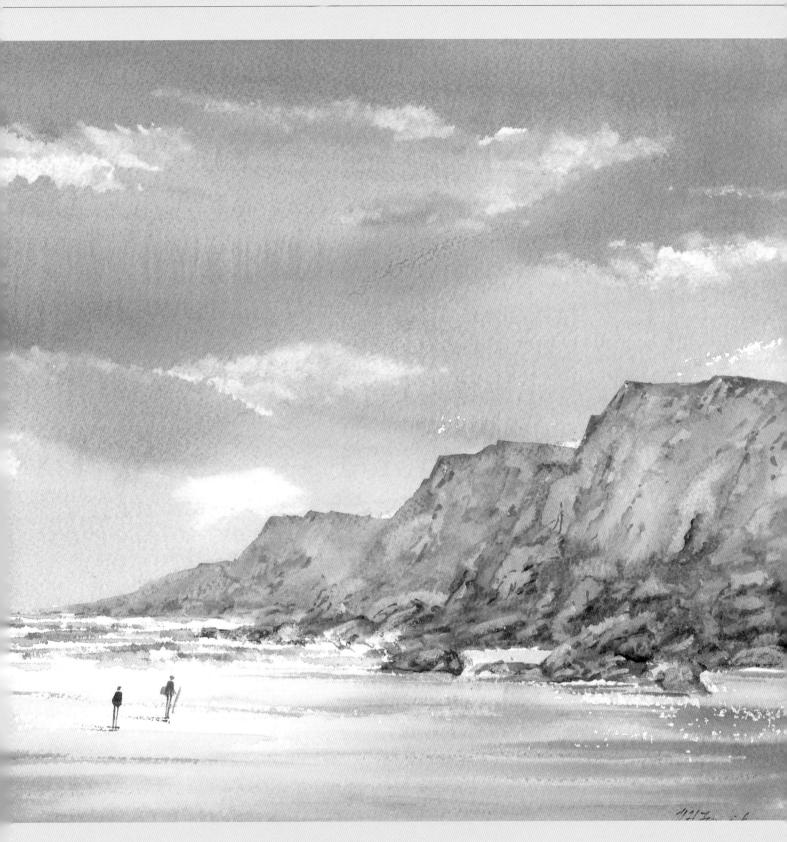

ABOVE: A Walk on the Beach

THE WALKERS - SIMPLE EXERCISE

This is an exercise I have included for the new beginner to watercolour painting. It makes a pleasing composition and is very simple to achieve. In fact, the painting can be regarded as complete at Stage 3, if the fence and figures are added and in addition, the path is painted in darker tones.

WHAT YOU WILL NEED

PAPER:

Bockingford 140lb rough

BRUSHES:

Winsor & Newton Sceptre Gold II series size 14 round, size 3 rigger, 11/2" hake, 3/4" round hog hair

COLOURS:

Payne's Gray, Cobalt Blue, Alizarin Crimson, Raw Sienna, Burnt Sienna, Cadmium Yellow Pale, Burnt Umber

SUPPORTIVE:

white acrylic paint

The outline drawing was completed with a dark brown water-soluble crayon.

The sky area was washed with a very pale Raw Sienna using the 11/2" hake brush. When the under-painting was less than one third dry a pale Cobalt Blue/Alizarin Crimson mix was brushed in. Note that the brush strokes are directed towards the distant path and figures. Using the side of the size 14 round brush loaded with a weak Payne's Gray/Cobalt Blue mix, make downwards strokes to paint the

outline of

the distant trees. Scratch out a few tree structures with a palette knife

Paint the distant right hand trees with the side of the size 14 round brush loaded with a Payne's Gray/Cobalt Blue mix. Paint the left hand side tree group using the same mix with some Sap Green added. A stiffer paint was used to paint this tree group. Paint in the tree structures using the rigger brush and mixes of Raw Sienna/Burnt Umber. (see pages 114/115 for techniques)

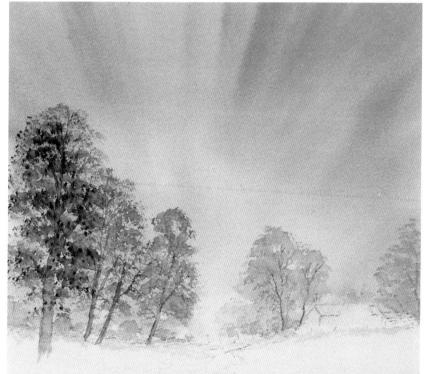

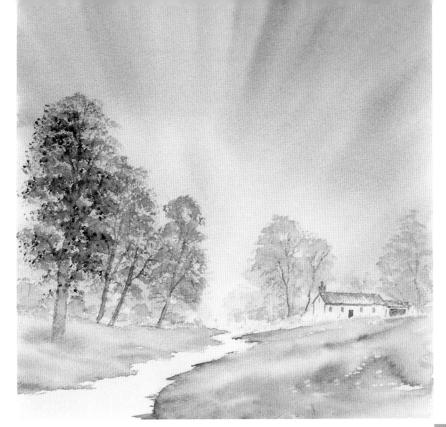

STAGE 3 COTTAGE AND

FOREGROUND

The roofs were painted using a mix of Burnt Sienna/Alizarin Crimson. The windows were painted using the rigger brush and Payne's Gray.

The foreground was painted using the $1^{1}/_{2}$ " hake brush. An initial Raw Sienna wash was applied and whilst still wet, darker tones of green, made from Cobalt Blue and Cadmium Yellow Pale, were brushed in. A Payne's Gray/Alizarin Crimson mix was used to give definition to the path and to add darker tones in the grass.

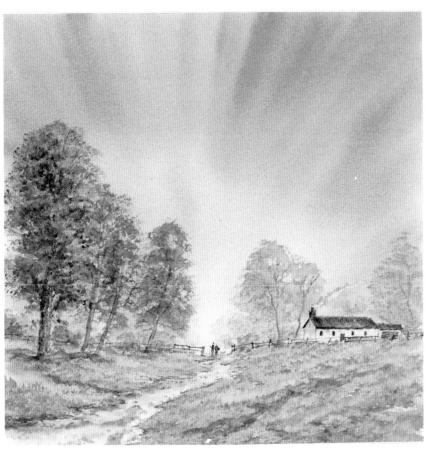

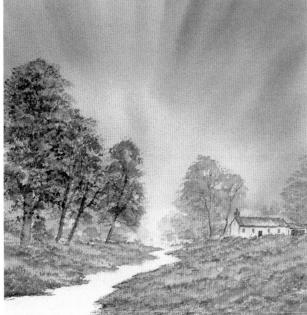

STAGE 4 FOREGROUND TEXTURE

A hog hair brush was used to stipple various tones of green into the foreground grass areas, giving the impression of rough grass growing.

FINAL STAGE

The roof was glazed with Raw Sienna, adding sparkle. The fence and figures were painted using the rigger brush. Texture was added to the path by wiggling the rigger brush loaded with a Payne's Gray/Alizarin Crimson mix.

Finally, the foreground was softened with lighter greens and smoke from the chimney added by over-painting Payne's Gray with a little white acrylic paint.

YOSEMITE FALLS - CLOSE UP

YOSEMITE FALLS is an exercise that cries out for the use of a palette knife to create the mountain structure.

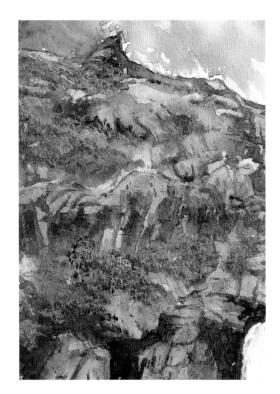

WHAT YOU WILL NEED

PAPER:

Winsor & Newton 300lb rough

BRUSHES:

Winsor & Newton Sceptre Gold II Series ³/₄" flat, size 3 rigger, 1 ¹/₂" hake, size 6 round, bristle brush

COLOURS:

Payne's Gray, Alizarin Crimson, Raw Sienna, Burnt Sienna, Cadmium Yellow Pale, Sap Green

SUPPORTIVE:

Palette knife, tissues, dark brown watersoluble crayon

MOUNTAIN STRUCTURE

Having established the composition, a simple drawing was completed using the dark brown water soluble crayon. It's then just a matter of splashing paint all over - that's a technical term!

With a 3/4" flat brush an overall Raw Sienna wash was applied to the mountain areas, followed by deposits of Burnt Sienna for warmth and dark values of Payne's Gray/Alizarin Crimson to add depth.

Think of the various mountain promontories as being parts of a jigsaw, painted separately, which as a whole establish the mountain.

When the paint is less than one third dry, use the palette knife to move paint to create the desired effect. This technique takes about five minutes.

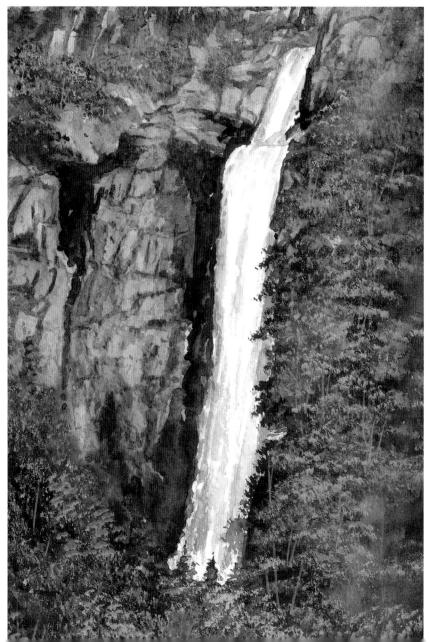

ATERFALL

waterfall was nted using quick t strokes with the re brush using the hnique shown on je 71.

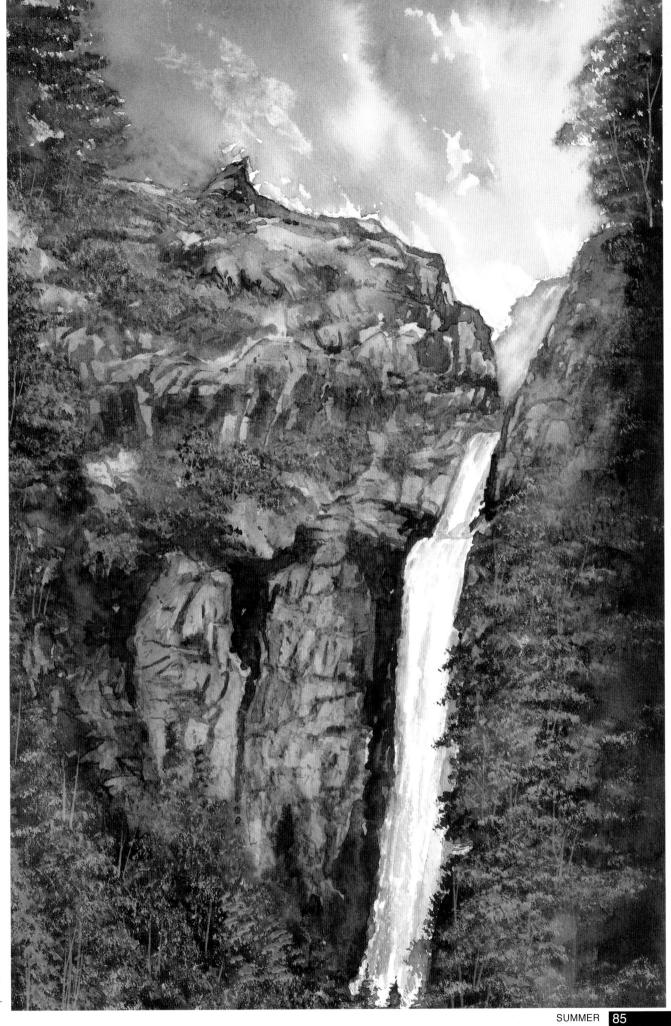

KY AND REES

atmospheric sky 3 painted applying a Payne's y/Raw Sienna mix r a Raw Sienna er-painting. Finally trees were painted ng the bristle brush.

COTSWOLD SPLENDOUR - PROJECT

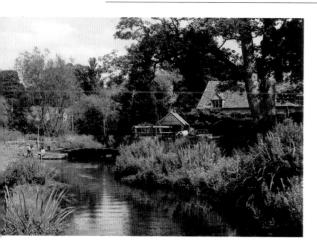

This pretty Cotswold hamlet displays a wide range of greens, providing an opportunity to practise colour mixing. It is typical of the region and is a popular touring area. When painting scenes such as this, with a mass of trees and rough river bank, it is so easy for the beginner to simply paint them as a mass, making it difficult to establish the different tree species or variations in the river bank. Paint each tree or bush as individuals that display their own structure, colour and form, yet when linked together, form the overall unified whole.

WHAT YOU WILL NEED

PAPER:

Winsor & Newton 300lb rough

BRUSHES:

Winsor & Newton Sceptre Gold II Series size 14 round, size 6 round, size 3 rigger, 3/4" flat, 11/2" hake

COLOURS:

Payne's Gray, French Ultramarine, Alizarin Crimson, Raw Sienna, Burnt Sienna, Burnt Umber, Cadmium Yellow Pale, Sap Green

SUPPORTIVE:

Masking fluid, natural sponge, 1/2" diameter oil painting brush

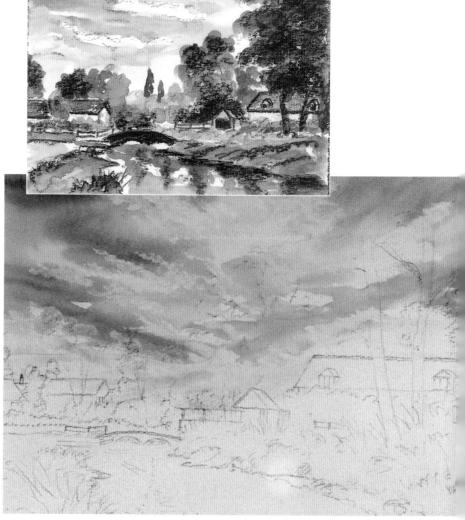

STAGE 1 DRAWING, SKY AND MASKING

Using a dark brown water-soluble crayon the outline was completed; care being taken to accurately portray the relationship between the various elements and the correct angle and linear perspective of the river. Masking fluid was applied to the tree structures, window frames, tufts of grass and the light effects on the water. See Stage 9 for clarity.

I have painted a simple yet interesting cloud structure by applying the usual Raw Sienna wash and brushing in French Ultramarine blue with the hake brush. An absorbent tissue was used to remove paint to produce the soft white clouds.

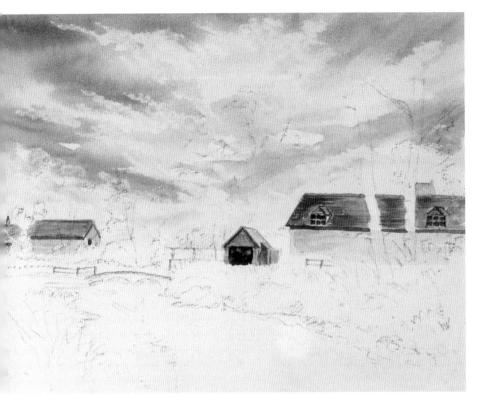

STAGE 2 BUILDINGS

With the 3/4" flat brush, paint the walls using Raw Sienna and the roofs of the buildings with a Burnt Sienna/Raw Sienna mix. Don't forget to paint shadows under the eaves. The windows and garage door were painted using a Payne's Gray/alizarin mix. Whilst still wet, dab the windows and door with a tissue shaped to a point to indicate light areas created by the effects of the light.

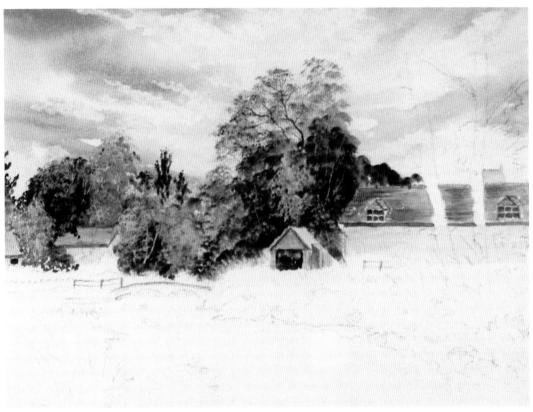

STAGE 3 TREE AND BUSH FOLIAGE

An old worn oil painter's brush is effective for stippling paint in various colours and values creating realistic foliage. Here, I have used my "unique" foliage brushes and various tones of Raw Sienna, Sap Green and Cadmium Yellow Pale.

STAGE 4 TREE STRUCTURES

The masking was removed from the tree structures. The technique used to paint these structures initially, is to apply a very pale Raw Sienna wash. When this wash is approximately one third dry, using the edge of the 3/4" flat brush loaded with Burnt Umber, move down the trunk depositing paint; by lifting the brush every half inch and touching lightly the paint will blend with the damp under-painting. Use a tissue to remove paint where required to lighten areas and control the flow. The rigger brush was used to paint the branches.

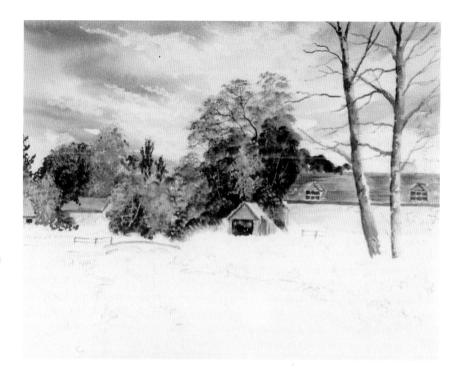

STAGE 5 PAINTING MIDDLE DISTANCE AND TREE FOLIAGE

Use several tones of a Cadmium yellow/Sap Green mix to paint the hedge and darker values for the main tree foliage. A sponge was used to block in and the oil painter's hog hair brush to soften the edges and to apply the light tones in the hedge.

STAGE 6 RIGHT HAND BANK

This needs to be built up gradually, leaving lighter values in appropriate areas. A pale Raw Sienna wash was applied overall, followed by various green values to indicate the distribution of the grass as it falls in layers to the water's edge.

The effect of the masking can easily be seen; how it repelled the washes.

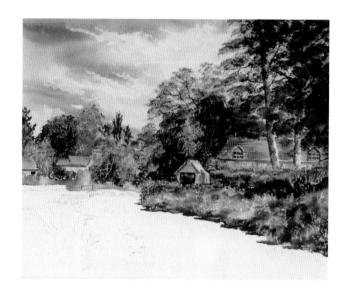

STAGE 7 LEFT HAND BANK AND BRIDGE

The left hand bank was painted using the size 14 round brush. Washes of Raw Sienna, a soft green made from Ultramarine blue/Cadmium yellow and Burnt Sienna were applied to selected areas as shown in the photograph. The bridge outline was painted using a dark Burnt Umber value. The stone wall on the left was painted by applying washes of Raw Sienna, Burnt Sienna and Payne's Gray/Alizarin Crimson and the palette knife used to

create structure. See page 100.

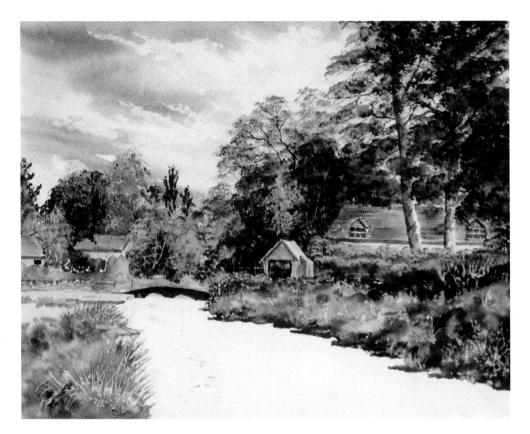

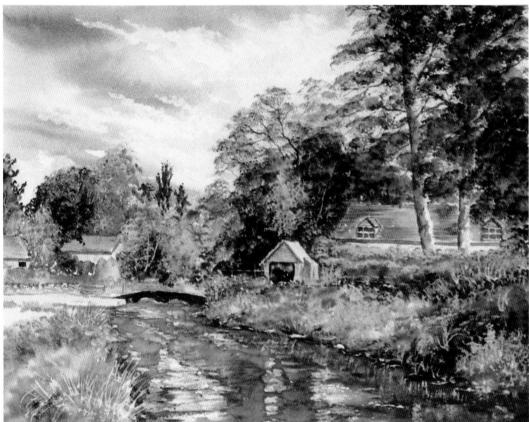

STAGE 8 WATER AND TEXTURE The water in this river is quite dark in value. I have used the 11/2" hake brush loaded with mixes of Raw Sienna/Burnt Sienna initially; overpainted with a Sap Green/Burnt

Umber glaze. More detail was stippled into the right hand bank and tufts of reed growing through the water were painted. Raw sienna/Burnt Sienna mixes were applied.

STAGE 9 REMOVING MASKING

The masking was removed revealing the distant fence, bridge outline, light effects on the water and tufts of grass. A putty eraser is ideal for removing masking - it seems to adhere to the masking, simplifying its removal and is sufficiently soft to prevent damage to the paper.

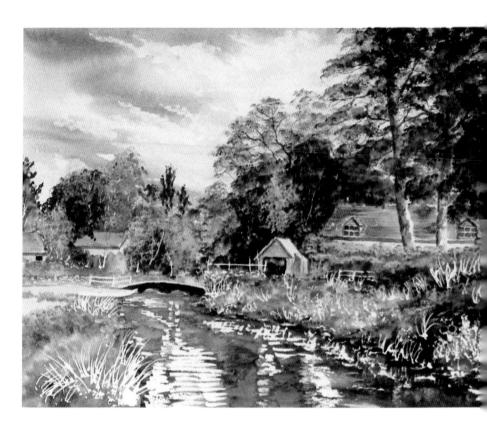

STAGE 10 BANK DETAILS

Darker tones were painted into the banks - particularly the right hand bank, indicating the pattern and angle or growth of the grasses and vegetation. A size 6 round brush was loaded with a Payne's Gray/Alizarin Crimson mix.

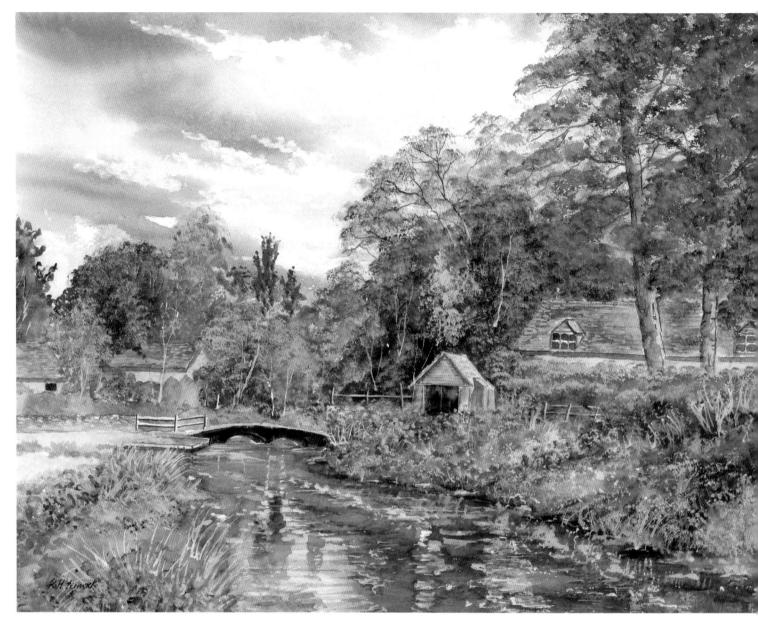

FINAL STAGE - WATER AND

HIGHLIGHTS

Touches of Ultramarine blue were applied to the surface of the river and a little Burnt Sienna/Raw Sienna brushed in, to add sparkle on the water.

White acrylic paint was added to the various mixes previously used, to add highlights in the tree foliage and vegetation on the riverbank.

KEY POINTS

- 1 Paint a simple but interesting sky.
- 2 Paint the tree masses shown, as being compiled of individual trees/bushes.
- 3 Add a variety of colours and tones to the foliage and in the vegetation on the riverbanks.
- 4 Build up the surface water gradually, by using washes and
- 5 Finally add highlights to make the painting sparkle.
- 6 Notice that colour harmony and unity has been achieved by painting similar colours in most areas of the painting.

PORTSOY SEASCAPE - CLOSE UP

This scene was painted at one of my favourite painting areas in north-east Scotland. I run painting holidays here. It's an exercise that lends itself to the use of the palette knife for creating the rocks. The palette knife can be a wonderful tool for the watercolourist.

WHAT YOU WILL NEED PAPER: Winsor & Newton 300lb rough BRUSHES: Winsor & Newton Sceptre Gold II Series size 14 round, size 3 rigger, 3/4" flat, 11/2" hake COLOURS: Payne's Gray, Ultramarine blue, Alizarin Crimson, Raw Sienna, Burnt Sienna, Burnt Umber, Sap Green SUPPORTIVE: White water-soluble crayon, palette knife, tissues

SKY. DISTANT CLIFFS. ROCKS

There's lots of detail in this landscape; the sky therefore needs to be simple. An Ultramarine wash was applied and a tissue used to remove paint to create the white clouds.

Pale yellow green washes were applied to the distant cliffs with Raw Sienna and Burnt Umber mixes painted on to the base of the cliffs. A palette knife was used to create the light values and fissures on the cliff face. A Raw Sienna wash was applied to the rocks followed by a Payne's Gray/Alizarin Crimson mix. When the paint was approximately one third dry the palette knife was used to move paint; an effective way to achieve a realistic vision of rocks.

WATER, CAUSEWAY, BOAT

The hake brush loaded with Ultramarine blue was used to paint the water. It is important to leave some white paper uncovered.

A Raw Sienna wash defined the causeway.

The boat and figures were added to add a little colour and interest to the landscape. Practise painting them: they are very easy, but don't forget there is always a reflection under boats.

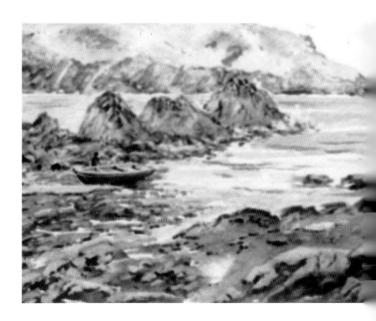

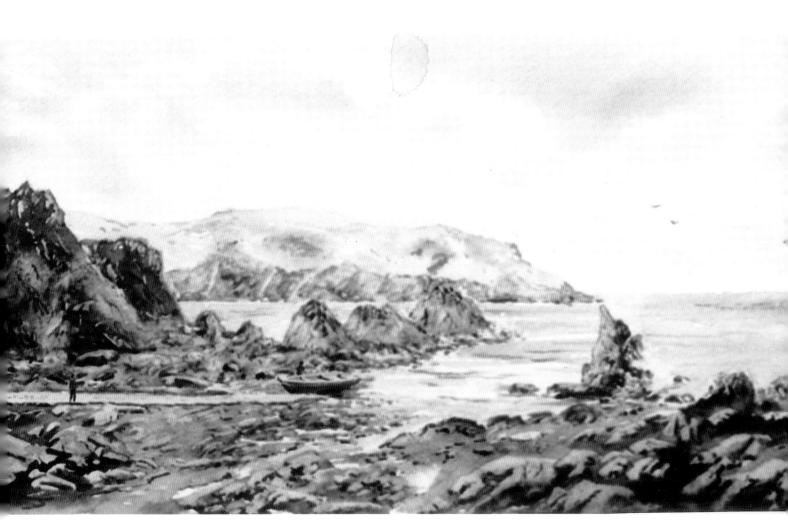

FOREGROUND ROCKS

This is where the palette knife comes into it's own; a few simple washes, in this case Raw Sienna, Sap Green, Burnt Sienna and darker values of a Payne's Gray/Alizarin Crimson mix and when approximately one third dry the paint is moved using the edge of a palette knife. The rocks were completed in under two minutes and yet I couldn't paint them as effectively with a brush. It's a wonderful technique - practise using the knife, the results will amaze you.

To indicate waves splashing against the rocks, I softened a white water-soluble crayon by dipping it in water and using its side deposited painted by flicking the crayon upwards. The sea birds were painted with the rigger brush.

PERSPECTIVE

- MADE SIMPLE

AS ARTISTS THERE ARE TWO TYPES OF PERSPECTIVE WITH WHICH WE NEED concern ourselves - linear perspective and aerial perspective.

LINEAR PERSPECTIVE

The first, linear perspective, is particularly important when painting buildings. The easiest example of linear perspective is a railway line or road that appears to vanish in the distance at some vanishing point. When painting buildings the same principle applies.

Each feature - the roof, windows, ground level etc is angled to a vanishing point that lies on the eye level.

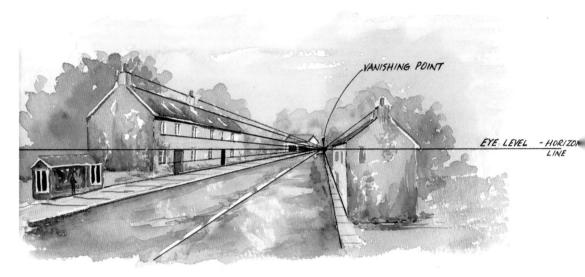

ONE POINT PERSPECTIVE

This occurs when looking face on at the gable end of the building as in the sketch above.

The base of the buildings will appear horizontal but the roof, sides etc of the building will appear angled to vanish in the distance at a vanishing point at eye level. For buildings to look real in a painting it's important to draw them correctly.

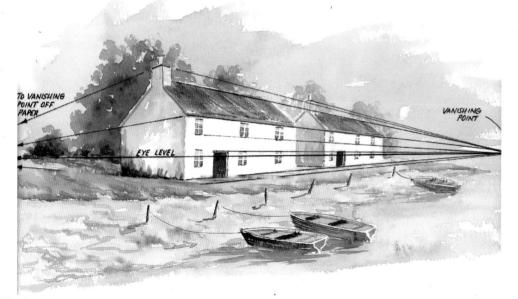

TWO POINT **PERSPECTIVE**

This occurs when the scene is viewed from the side rather than face on. There will be two vanishing points here, both on the eye level. In the actual painting, the vanishing points may be off the paper but the same principles apply. The base of the buildings, roof lines at front and rear will appear at different levels as will the chimney tops etc.

SIMPLIFYING

In practice all that is needed, is to cut an aperture in a piece of mount card and view the scene. Position elastic bands around the perimeter of the card and align them with the various angles of the building features.

It's simply a matter of laying this over your paper and drawing along the elastic bands to transfer the true angles to your painting

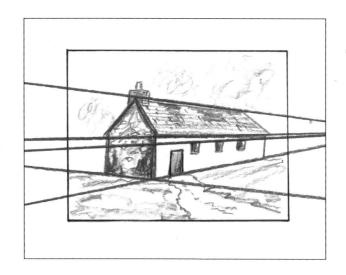

AERIAL PERSPECTIVE

This is of particular significance in order to achieve a sense of distance in a painting. This is known as recession. In this sketch of a Lakeland barn, in order to achieve recession the distant

mountains are painted in cool colours, little detail and light values. As the foreground is approached, warmer colours are used, more detail is painted and darker values are applied.

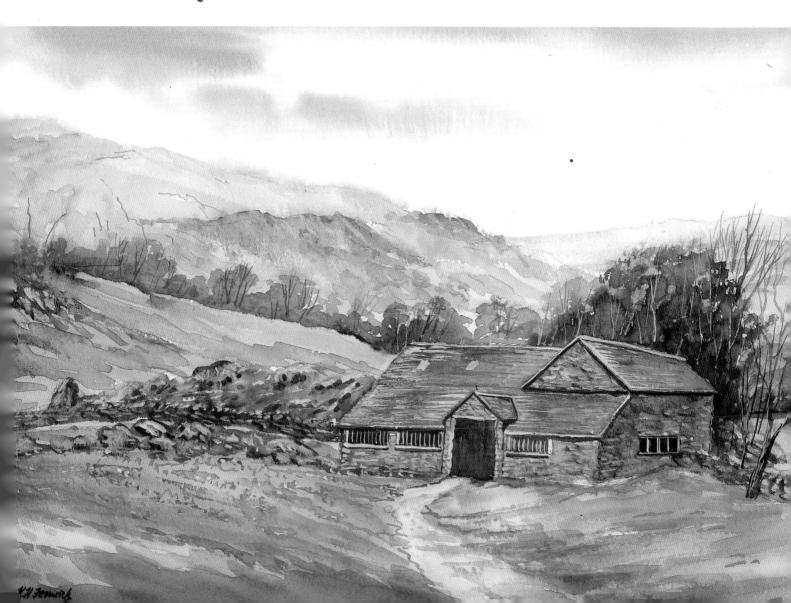

YEW TREE FARM, CONISTON - PROJECT

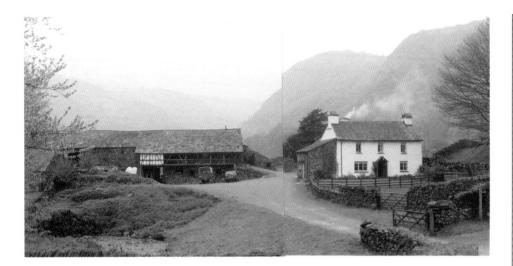

Yew Tree Farm is a popular painting spot in the English Lake District. To me it epitomises all that is best in the area. The contrast, between the white plastered farmhouse and the stonework is typical of the region. This painting has been included to provide practice in painting stonework.

The Lake District is memorable for its many stone walls which control the movement of sheep on the fells. Those walls are actually two walls, inclined inwards at an angle to meet at the top and heightened by placing coping stones which also deflect the rain, snow and frost from seeping into the middle of the wall and eventually damaging it. The walls are linked together by placing flat key stones between the two sides as building progresses. This method of construction is why these walls have stood for a hundred years or more. The shape of the stones used is dependent on the area. The stone waller may collect his stone from a river where it will be rounded in shape or if near a quarry, he may use slate which is long and flat. It is important therefore, when representing these walls, that the direction of the strokes used must correspond to the shape of the materials to be found in

The view shown was chosen from eight possible compositions. Tonal studies were quickly produced to determine the most interesting features. For example, when I stood further to the left, I could not observe the left hand barns that I find very attractive. If I had stood to the right, I would have been unable to see the beck. The composition chosen allowed me to include these features and see the gable end of the farmhouse. (Try not to view the buildings straight on - it's poor design).

The tonal study provided me with thinking time, established the lights and darks and became the plan for this painting.

WHAT YOU WILL NEED

PAPER:

Winsor & Newton 300lb rough

BRUSHES:

Winsor & Newton Sceptre Gold II Series size 14 round, size 6 round, size 3 rigger, 3/4" flat, 11/2" hake, size 6 round hog hair brush

COLOURS:

Payne's Gray, Cobalt Blue, Alizarin Crimson, Raw Sienna, Burnt Sienna, Burnt Umber, Sap Green

SUPPORTIVE:

White acrylic paint, palette knife, tissues (toilet roll) masking fluid

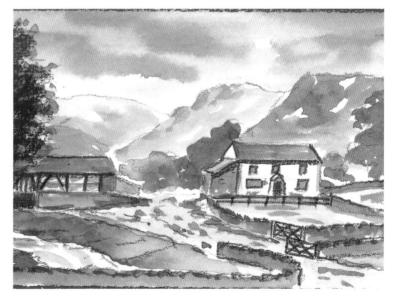

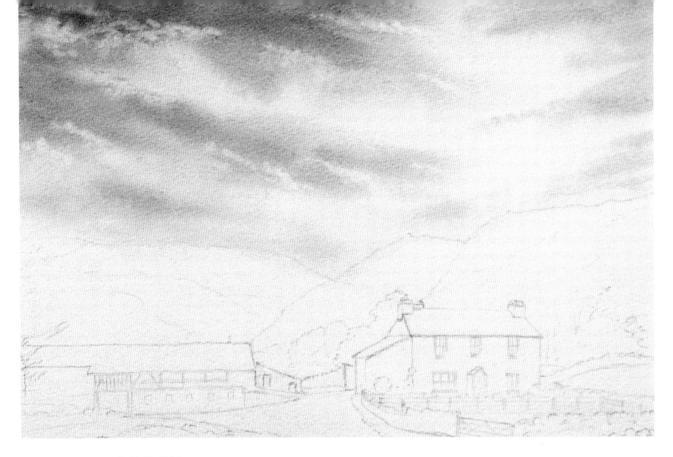

STAGE 1 DRAWING AND SKY

Take care with the drawing - it's quite tricky capturing the angle of the road. I suggest you draw in the buildings first and then the angle of the roadways. I always draw with a dark brown watersoluble crayon for if I make a mistake, I don't have the trouble of erasing

incorrect lines. With the water-soluble crayon, simply dampen the mistake with a brush and wipe off with a tissue - it's so much easier.

I painted the sky as usual with the 11/2" hake brush. Apply a pale raw sienna wash and when the shine has gone from the surface, brush in a Cobalt Blue/Alizarin Crimson mix. Use a minimum number of brush strokes to ensure freshness. The white clouds were created by dabbing with a tissue folded to a wedge.

STAGE 2 **DISTANT MOUNTAINS**

To ensure recession, I painted the distant mountains in a pale tone of Cobalt Blue/Alizarin Crimson and as I progressed forward, added some Burnt Sienna to the mix, to both darken the values and to add colour. A little Raw Sienna/Sap Green was painted in selected areas. The technique is to use the hake brush, the strokes from peak to ground level following the angle of the mountain structure. Whilst still wet, fold a tissue into a wedge and wipe downwards from the peak to create highlights on the mountain.

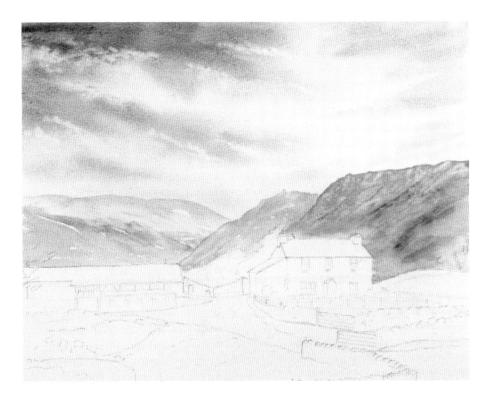

STAGE 3 GRASS AREA - DISTANT

TREES

The distant trees were simply painted, using a size 6 brush using a dabbing action - note the values. Mixes of Raw Sienna and Sap Green were used. The remaining grass areas were painted with the 11/2" hake and the application of Raw Sienna washes with a little Sap Green added to provide gradation of colour. To create interest in the riverbank, a size 14 round brush was used to brush in some darker values of Sap Green/Burnt Sienna whilst the under-painting was still wet, to achieve a natural, soft effect.

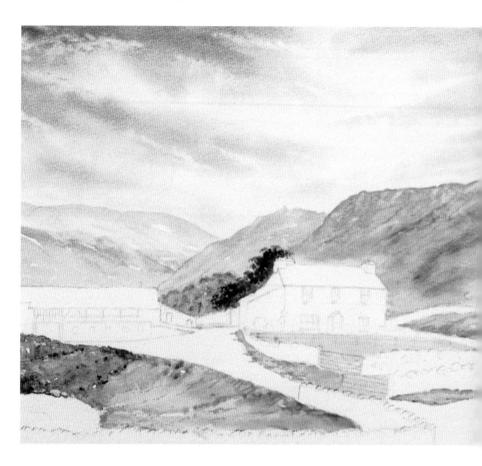

STAGE 4 BUILDINGS

To paint the roofs, the side of the size 14 round brush was used, loaded with a Cobalt Blue/Alizarin Crimson mix. Note the dry brush technique on the roof and the variation in values. Masking fluid was applied to preserve the window frames and the woodwork on the barn.

To paint the stonework is simplicity itself, (see page 100 for technique). Using a 3/4" flat brush, brush in variations of Raw Sienna, Burnt Sienna and a Payne's Gray/Alizarin Crimson mix. When the paint is approximately one third dry, move the paint, using the corner of a palette knife. This is the most realistic and simple way to produce stonework. Paint the windows using a Cobalt Blue/Payne's Gray mix - dab with a tissue shaped to a point to represent reflections in the glass. Remove the masking fluid.

STAGE 5 STONE WALLS

I'm going to use a technical term here! Just splash paint all over and move with a palette knife. It really does work and it's so effective and easy to do. I cannot paint stone walls as effectively with a brush.

Apply a Raw Sienna wash in this example, followed by Burnt Sienna and a Payne's Gray/Alizarin Crimson mix so that there are both light and dark values in the wall. Use the corner of a palette knife to move paint, almost restoring the whiteness of the paper very effective, see page 100 for technique.

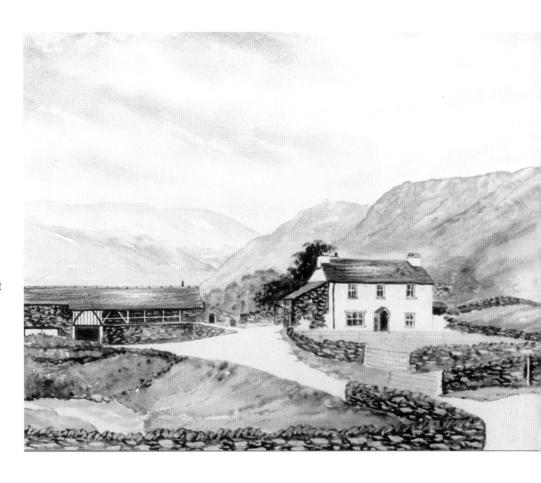

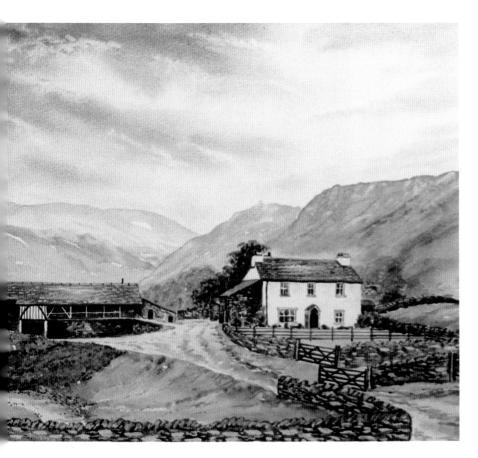

STAGE 6 FENCE, GATES AND PATH

Using the rigger brush, paint the fence and gates with a little Burnt Umber. The path is a pale Raw Sienna with a Payne's Gray/Alizarin Crimson mix for the shadows. Note, I have stippled in more detail to represent groups of low growing foliage on the riverbank and finally, painted in the water with pale tones of Cobalt Blue.

KEY POINTS

- 1 Paint a simple sky. Use a light touch with the hake and a minimum number of brush strokes.
- 2 Create a sense of distance (recession) by painting distant mountains in paler values.
- 3 Practise the techniques shown above for painting stoneworks
- 4 When painting grass areas, apply a wash and gradually add stiffer paint in different colours and values. The effect will look soft and natural looking as the colours blend together.
- 5 Add highlights to the tree foliage.
- 6 Indicate life by adding smoke from the chimney it's those little details that improve the painting.

Painting a Stone Wall

Painting a realistic stone wall can be easily achieved by applying several washes with the 1/2" flat brush; in this case, Raw Sienna, Burnt Sienna and a Payne's Gray/Alizarin Crimson mix.

When the paint is less than one third dry, use a palette knife to move paint to simulate stone work. Begin with the coping stones followed by the larger, main stones in the wall. Complete the structure by indicating smaller stones with the knife and making the wall look real and believable.

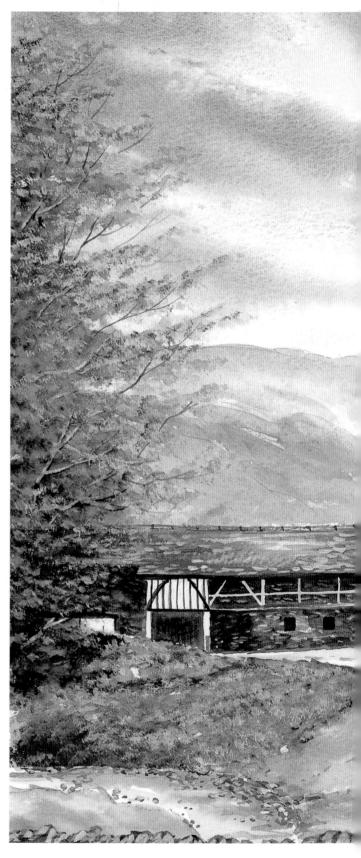

FINAL STAGE

Time to add the finishing touches. The tree on both sides of the painting were added. Note that the left hand tree is taller than the right hand group. Never make the trees the same height when positioned both sides of the painting, its poor design.

The trees were painted using the stippling technique. Don't forget

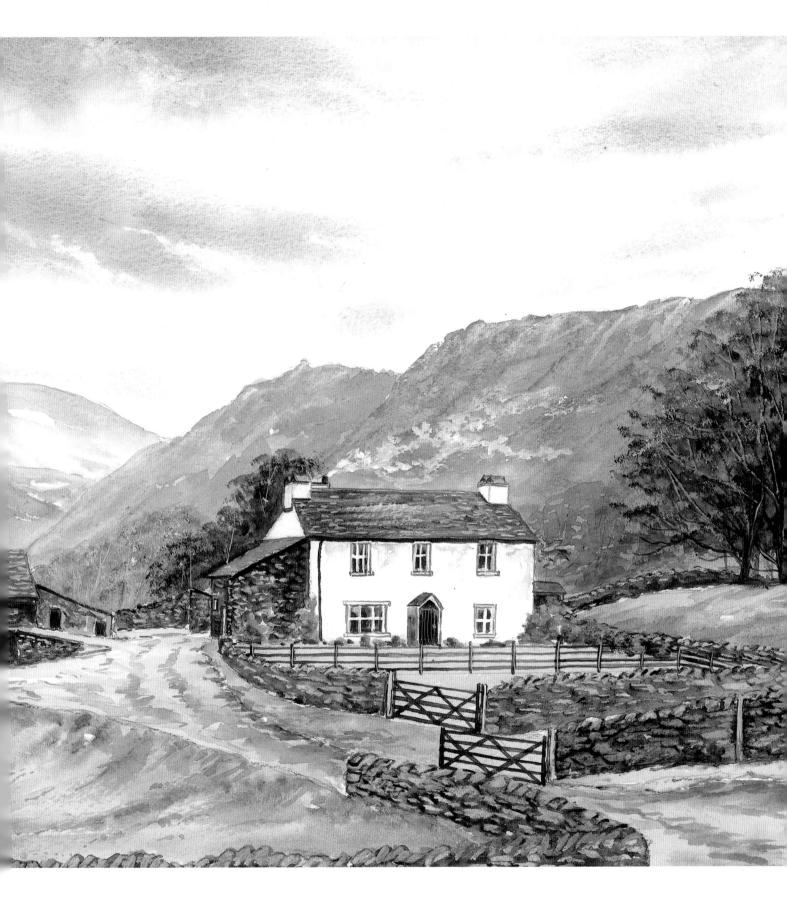

aint dark areas in the foliage. Trees are dark on the inside and er on the outside.

create highlights, add a little gouache or in this case acrylic te paint to the greens. Watercolour white will be absorbed, ache will be partially absorbed but acrylic paint will stay on the top and that's the effect I want.

Finally to indicate life, I have painted smoke from the chimney. For the smoke, apply a weak Payne's Gray and over-paint with acrylic white paint, using the size 6 round brush. I almost forgot to paint the windows in the barn.

LLYN MYMBYR, SNOWDONIA

- CLOSE UP

This is an evening scene painted just prior to darkness setting in. As the sun goes down behind the mountains, it lights up the sky in an orange-yellow glow, beautifully reflected in the surface of the lake.

SKY

Apply a Raw Sienna wash, followed by a stiffer mix of Payne's Gray/Cobalt Blue/Alizarin Crimson for the cloud shapes.

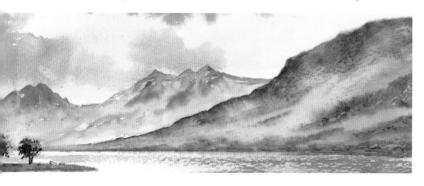

MOUNTAINS

Painted using the hake brush with lighter values for the distant mountains and darker values for the profile of the middle distant peaks.

A soft blue green was used made from Cobalt Blue/Cadmium Yellow Pale. The peaks were a Payne's Gray/Alizarin Crimson mix. A little Burnt Sienna was added selectively.

TREE GROUPING

The land jutting into the lake was painted and when dry the trees were painted using the 3/4" flat brush and a stippling action using mixes of Sap Green/Burnt Sienna. See page 115 for techniques.

FOREGROUND

Paint the land using the hake by applying a Cadmium yellow/Raw Sienna wash followed by additions of Sap Green/Payne's Gray.

The rocks were painted using the 3/4" flat brush – see pages 78/79.

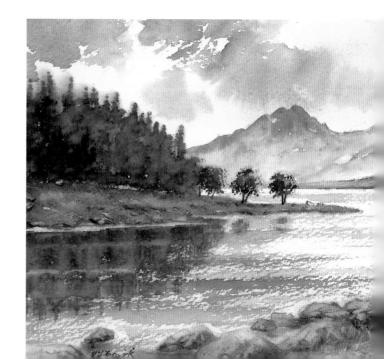

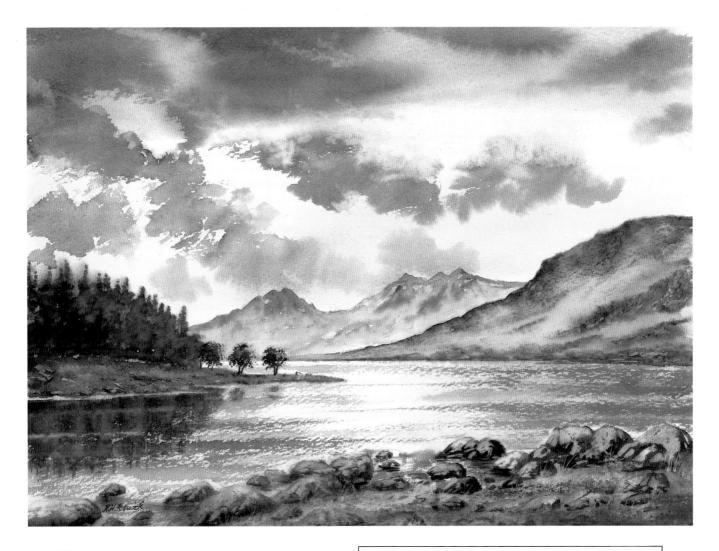

LAKE

With the side of the size 14 round brush, the water was painted using the sky colours - see page 71 for technique. The reflections were indicated by painting vertical strokes with the 3/4" flat brush.

CHANGING LIGHT

A Cobalt Blue glaze was applied to the top of the sky with the hake brush. A glaze is a small amount of paint and lots of water.

WHAT YOU WILL NEED

PAPER:

Bockingford 200lb extra rough

BRUSHES:

Winsor & Newton Sceptre Gold II Series size 14 round, 3/4" flat, $1^{1}/2$ " hake

COLOURS:

Payne's Gray, Cobalt Blue, Alizarin Crimson, Raw Sienna, Burnt Sienna, Cadmium Yellow Pale, Sap Green

SUPPORTING:

Palette knife

GLENCOE, SCOTTISH HIGHLANDS -

PROJECT

This is the view from the new visitor centre at Glencoe in the Scottish Highlands. I have included this scene to provide practice painting mountain structures. It is important to identify the main promontories and peaks, the gullies and fissures but don't attempt to copy the structure exactly - simplify, discarding small details that don't contribute significantly to the structure.

I find a small pair of binoculars useful for identifying areas of the mountain in shadow. If I paint what I see at the time, the mountain may look completely different in a changing light. I need to know whether the shadow area is a deep gully or simply a cloud shadow. I want the structure to be reasonably representational.

The photograph shows the view and the tonal study is the first stage in helping to determine the accuracy of the structure. It makes me question the specific features and determines the value patterns.

The large area of trees needs a sympathetic representation, always a difficult mass to paint. The best approach is to use a variety of values and colours and to indicate the structure of a few trees in the foreground.

The wild flowers were added for interest. I visit this area regularly but at the time the photograph was taken the flowers were not in bloom.

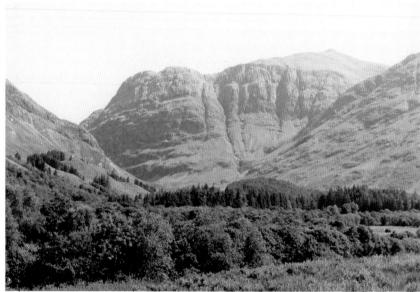

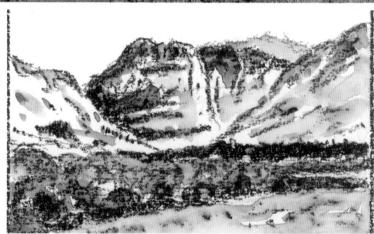

WHAT YOU WILL NEED

PAPER:

300lb Saunders Waterford Rough

BRUSHES:

Winsor & Newton Sceptre Gold II Series size 6 round, size 14 round, 3/4" flat, $1^{1/2}$ " hake, $^{1/2}$ " diameter hog hair

COLOURS:

Payne's Gray, Cobalt Blue, Alizarin Crimson, Raw Sienna, Cadmium Yellow Pale, Sap Green

SUPPORTIVE:

Dark brown water-soluble crayon, old toothbrush, 1" masking tape, palette knife

STAGE 1 DRAWING AND SKY

A water-soluble crayon was used to draw the main features. The sky was painted by brushing Cobalt Blue/Alizarin Crimson into a Raw Sienna under-painting, wet into wet using the $1^{1/2}$ " hake brush.

STAGE 2

DISTANT MOUNTAINS

This is the tricky part. Paint an area at a time - it can't be rushed. Begin with a Raw Sienna wash and using a size 14 round brush, paint in a Payne's Gray/Cobalt Blue mix to create the mountain structure, commencing with the main promontories and gullies. Establish their positions and paint the fissures around them. This task needs to be done with care - stand back and view your efforts before progressing to the next area.

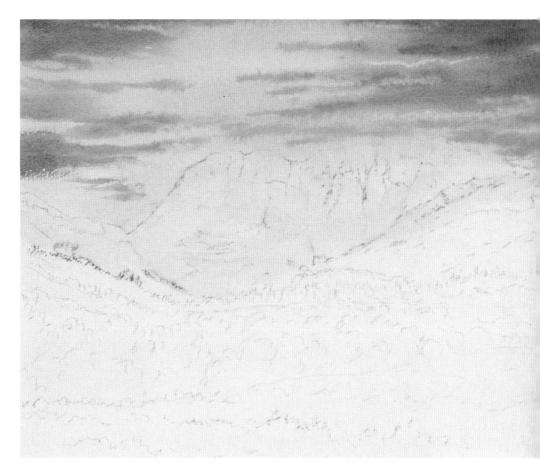

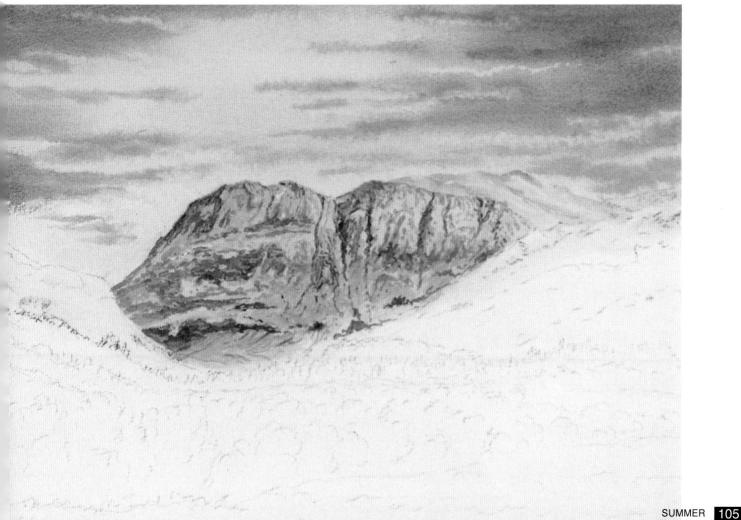

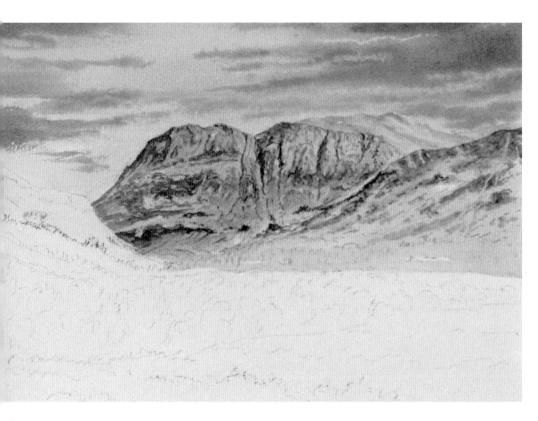

STAGE 3 FOREGROUND MOUNTAIN

Apply a weak wash of Raw Sienna/Sap Green and whilst still wet, paint in the promontories with a Cobalt Blue/Sap Green mix. Use a size 6 round brush to push the paint around, to soften the edges.

♦ STAGE 4 **MOUNTAIN, DISTANT TREES**

Paint the left hand mountain, adding a little Burnt Umber to the mix when painting the promontories, making up the structure of the mountain. When dry, paint the distant fir trees using the corner and edge of a $^{3}/_{4}$ " flat brush loaded with a Payne's Gray/Sap Green mix with a little Cobalt Blue added. See page 115 for techniques.

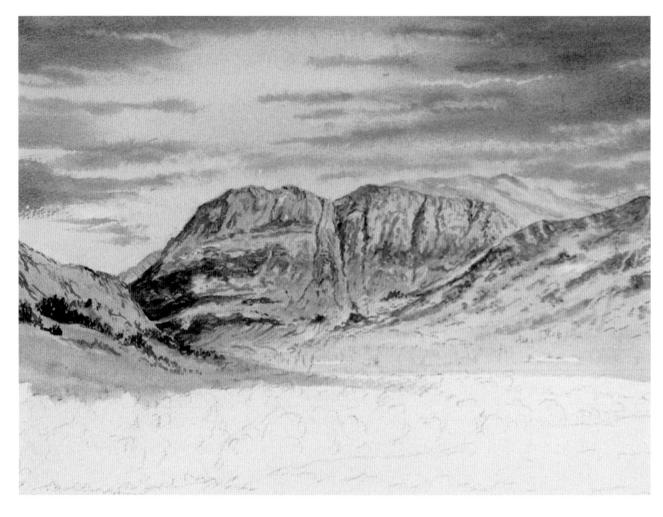

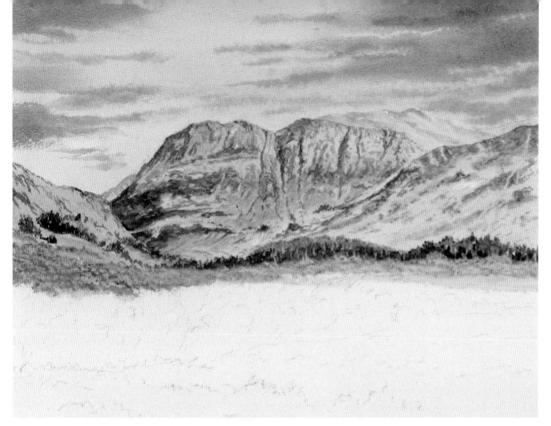

STAGE 5 MIDDLE DISTANCE TREES

Paint these with the edge of the 3/4" flat brush, using a stippling action and scratch out a few tree structures with your thumbnail, cocktail stick or palette knife. A useful tip is to stretch a piece of 1" masking tape across the paper to represent the base of the tree group. Bend the tape when positioning, to create an uneven effect. Simply remove the tape after painting the trees. The colours used were a mix of Sap Green and Raw Sienna.

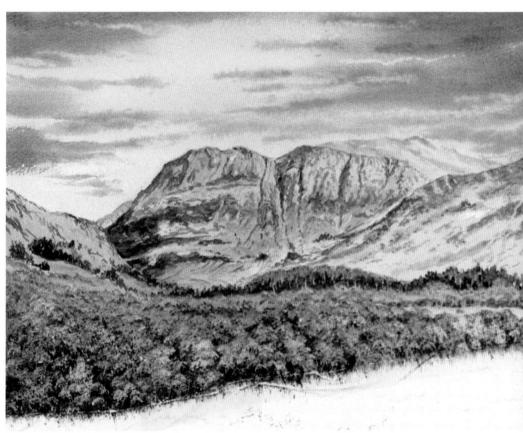

STAGE 6 TREE MASS

The masking tape I stretched across the paper can be easily seen in the photograph. This enables me to paint over the tape and on its removal, the top of the field has a clean line.

The trees were painted by stippling with a hog hair brush, using

combinations of Raw Sienna, Cadmium Yellow Pale and Sap Green. The dark shadows, important for depth, were a mix of Payne's Gray and Alizarin Crimson. Scratch in a few tree trunks with a palette knife.

KEY POINTS

- 1 Produce a value pattern it becomes the plan for your painting.
- 2 Paint a simple sky because there is so much detail elsewhere in this landscape.
- 3 Take time to draw the profile of the mountain correctly.
- 4 Use binoculars if necessary to determine the shape of the peaks, promontories, gullies and fissures in the mountain.
- 5 Determine the values, these lights and darks are important, particularly for the structure of the mountain to look real.
- 6 Don't rush the painting of the mountain structure; take your time - stand back and look before progressing further.
- 7 Detail a few tree structures at the front of the woodland.
- 8 Create an impression of rough texture in the foreground.

▶ STAGE 7 **FOREGROUND**

I want this area to look rough. Initially a Raw Sienna/Cadmium yellow wash was applied with the hake brush and when dry, darker values were stippled using the hog hair brush. Payne's Gray and Sap Green were added to the wash to create a variety of values. The hog hair brush gives the effect of rough grass. When completed and the paint was dry, I painted a few lighter values by adding a little white acrylic to Cadmium Yellow Pale.

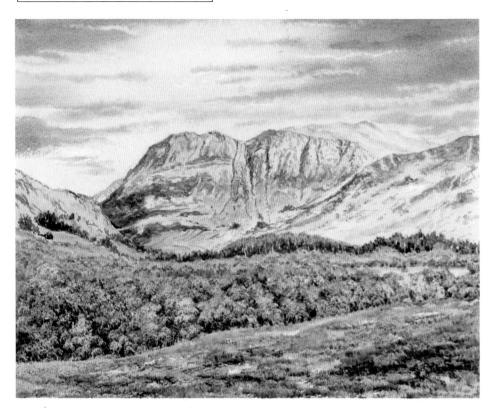

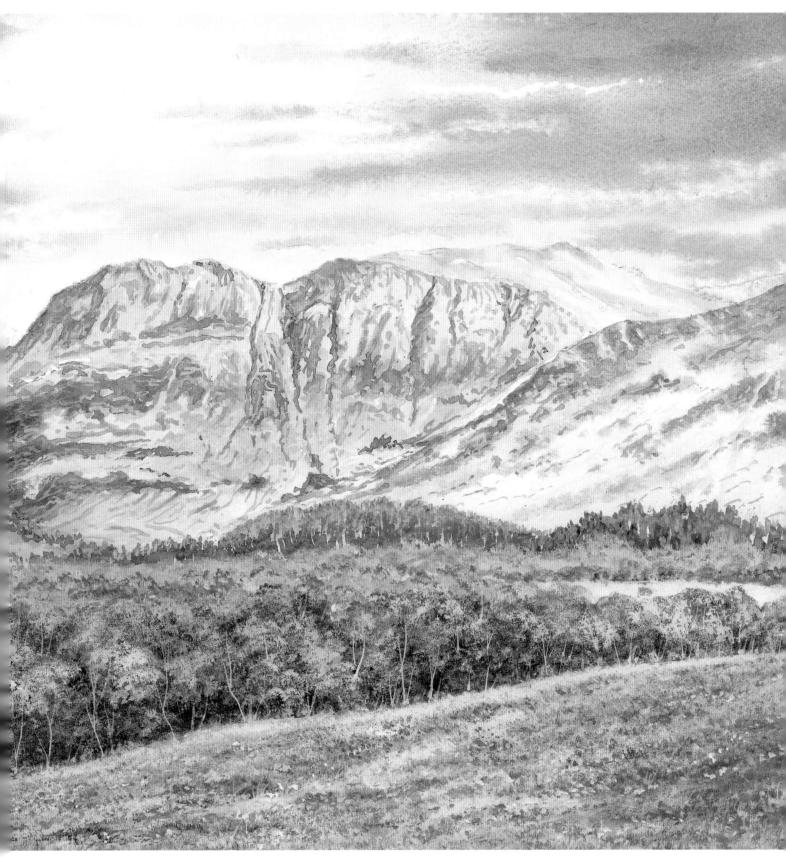

FINAL STAGE WILD FLOWERS

With the hog hair brush, I completed the painting by adding a few wild flowers. Reds, yellows and white were used here. The trees were masked with a sheet of newspaper and using

an old toothbrush dipped in paint a few impressions of flowers were spattered into the foreground by rubbing my thumb across the bristles.

LAKELAND FARM - CLOSE UP

This is a typical Lakeland farmstead situated at the side of the main road to Keswick. The farm has a round chimney, which in this region signifies its age.

It is a sheep rearing farm with the backdrop of the mountain know as "Blcnoathra" or locally nicknamed "Saddleback", due to its profile being shaped like a saddle.

WHAT YOU WILL NEED

PAPER:

Saunders Waterford 300lb rough

BRUSHES:

Winsor & Newton Sceptre Gold II Series size 14 round, size 3 rigger, 3/4" flat, $1^{1/2}$ " hake, size 6 round hog hair brush

COLOURS:

Payne's Gray, Cerulean Blue, Alizarin Crimson, Burnt Umber, Cadmium Yellow Pale, Sap Green, Raw Sienna

SUPPORTIVE:

Palette knife, white acrylic paint, tissues

SKY

The wet in wet sky was painted by brushing in Cerulean Blue/Alizarin Crimson over a Raw Sienna under-painting.

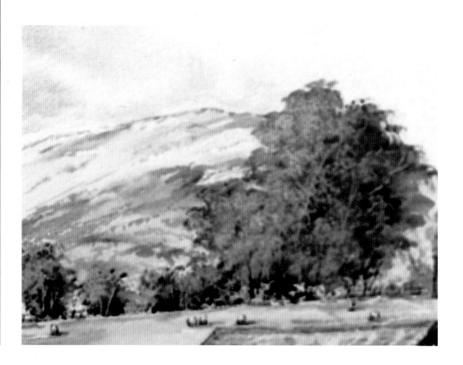

MOUNTAINS AND TREES

The mountain was painted wet into wet by painting various values of green into a Raw Sienna under-painting. I painted the tree grouping by applying downward strokes with the side of the size 14 round brush for the under-painting and when approximately one third dry, a lighter value was stippled to represent highlights on the foliage, with a hog hair brush. The tree structure was scratched in using a palette knife.

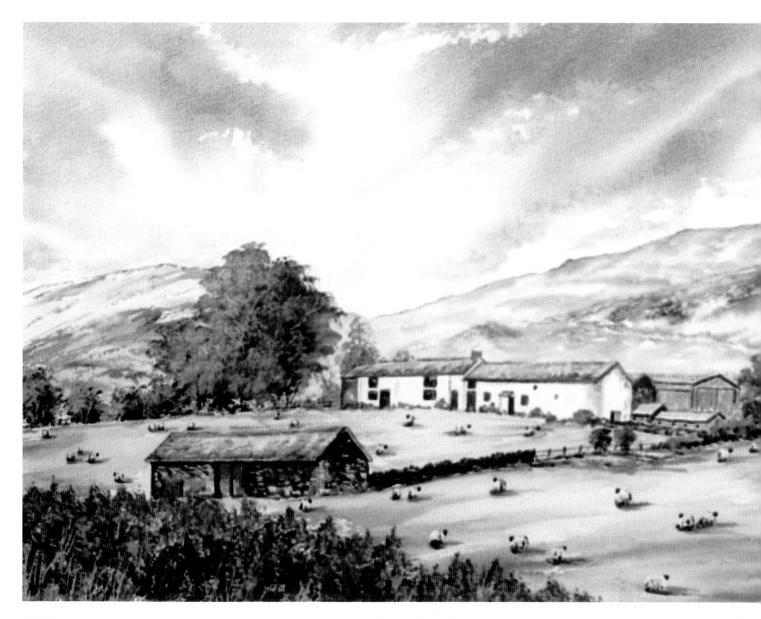

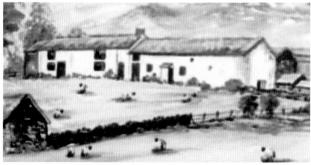

BARN AND FLOWERS

The stonework of the barn and wall was created by applying several washes, beginning with a Raw Sienna under-painting and adding Burnt Umber, followed by a Payne's Gray/alizarin mix. Whilst still wet, a palette knife was used to move paint, giving the impression of stonework. The rose bay willow herbs in the foreground, are to be found growing throughout the region adding colour to this landscape.

BUILDING

I used the $^{3}\!/_{\!4}\!\!{}^{"}$ flat brush to paint the farmhouse. In the Lake District, farmhouses are traditionally, white faced structures with green/grey roofs and are usually connected to stone built outbuildings or barns.

To paint the Lakeland sheep, which are often Herdwicks, Swaledales or Scottish blackface breed, simply paint horseshoes - see page 151. Those shown are Scottish blackface.

HOW TO PAINT TREES

Almost every landscape painting will include one or more trees. It is important, therefore, that they are painted reasonably accurately in terms of shape, size and value. Observe the direction of light and add highlights to your finished work.

Trees appear dark on the inside and light on the outside. The watercolourist is told to paint from light to dark, which is the opposite of trees in nature.

I refuse to be bound by old rules and paint my trees in the conventional way or by applying a dark underpainting, and when dry, building up the groups of light foliage. Finally, I paint the highlights by adding a little white acrylic paint or gouache to colour, ensuring the final highlights don't sink into the watercolour paper. The choice is yours.

When painting trees, study their structures; an ideal time to do this is in winter when the leaves have fallen. Their trunks have to be sufficiently sturdy to hold the boughs that lead from the trunk. The boughs hold the branches that in turn radiate thinner twigs that reach outwards to catch the light.

Tree trunks vary significantly in colour with tree type, weather conditions and season. A wet tree trunk will look completely different to one that is dry with sunlight shining on it. Their colours may vary from greys through browns to Burnt Siennas. When painting tree trunks, I find an effective technique is to wet the area initially with a pale wash and when approximately one third dry, add darker values and allow the colours to blend together. Whilst still wet, use an absorbent tissue to remove paint to represent highlights. This technique is very effective!

Whilst artists do not need to know the name of the tree they are painting, their structure and form must be represented accurately. It is obvious that a poplar tree is different to a palm tree, which is different to an oak tree and so on. Experiment painting trees with different brushes and techniques. For example, I know 17 ways to paint a tree. Over the following pages I will show you several techniques I use to represent them. In this book it is not my intention to attempt to impose a style of painting upon you, I couldn't even if I tried. You and only you will decide whether you wish to paint loosely or in detail. Your style will represent your handwriting in paint. Practise these techniques and you will soon be able to paint trees that look realistic.

PAINTING A SPECIMEN TREE

Stage 1 Commence by painting a base colour to help establish the shape

Stage 2 Apply darker tones to create depth. Paint in a few branches and the trunk that should look sufficiently sturdy to hold the boughs, branches and twigs.

Stage 3 Paint impressions of foliage and add highlights

COLOURS USED

For summer trees use mixes of Cadmium Yellow Pale, Raw Oienna, Oobalt Dluo, Cap Groon, Payno'o Gray, For autumn trees use mixes of Cadmium Yellow Pale, Raw Sienna, Cadmium orange, Burnt Sienna, Alizarin Crimson, Payne's Gray.

BRUSHES

Try a 3/4" flat or side of the size 14 round. Finish by stippling with a sponge or old oil painter's hog hair brush.

POPLAR trees tend to be tall and full leafed - vary their height in a painting.

Paint them using the edge of a 3/4" flat brush with the brush held almost at right angles to the paper. Use a stippling technique.

PALM trees are tall and graceful with rough trunks and open fronds growing from the top.

Paint the fronds by producing a thin curved line with a fan brush and then flicking downwards to create the open foliage.

WILLOWS are a varied species but most are painted as being of the weeping shape with graceful dropping lace-like foliage. Paint them with a fan brush or hake brush made of very soft hair.

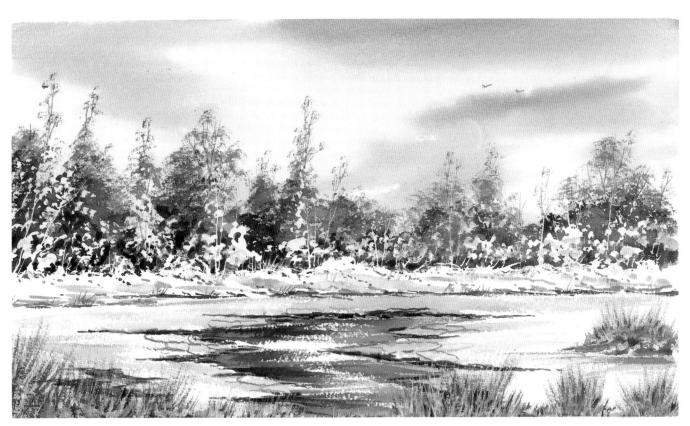

To paint the effects of snow on trees, initially apply a deposit of masking fluid. In this example, I have shaped a piece of tissue to a point, dipped it into masking fluid and stippled.

When the masking is dry, it can be

over-painted. When the over-painting is completely dry, remove the masking with a putty eraser and the trees appear to be laden with snow. It is as simple as that. Note that I have masked a few thin lines representing

tree structures: alternatively, these could have been painted in at the end, using a cocktail stick dipped in white acrylic paint.

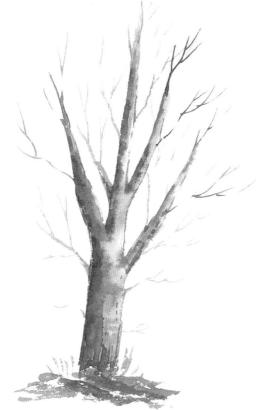

The tree structure was painted by applying a Raw Sienna wash and brushing in some Burnt Sienna and Burnt Umber whilst still wet. A size 6 round brush can be used either to move paint around or when clean and dry to soak up paint by absorption.

To create the texture on this beech tree a grey wash was applied and when approximately one third dry Burnt Sienna and Burnt Umber brushed in. When dry a rigger brush was used to add detail.

To achieve recession paint distant trees in cool colours and foreground trees in warmer colours in more detail.

This tree grouping was painted wet into wet. The background trees were painted using downward twitches with the side of the size 14 round brush, varying the values with cool colours for the distant trees and gradually warmer values for the middle distant trees.

A palette knife was used to scratch in some tree structures when the paint was approximately one third dry.

The specimen tree was painted by dipping a $^3/_4$ " flat brush into three colours at once and by using twisting, downward strokes of the brush. At the top of the tree, Raw Sienna was loaded on one side of the brush, Burnt Sienna on the other side and Burnt Umber along the edge. Press the brush on to the paper and turn it, changing sides as required to create variation/gradation in the foliage. At lower levels Raw Sienna, Cadmium yellow and Sap Green was used in the same manner.

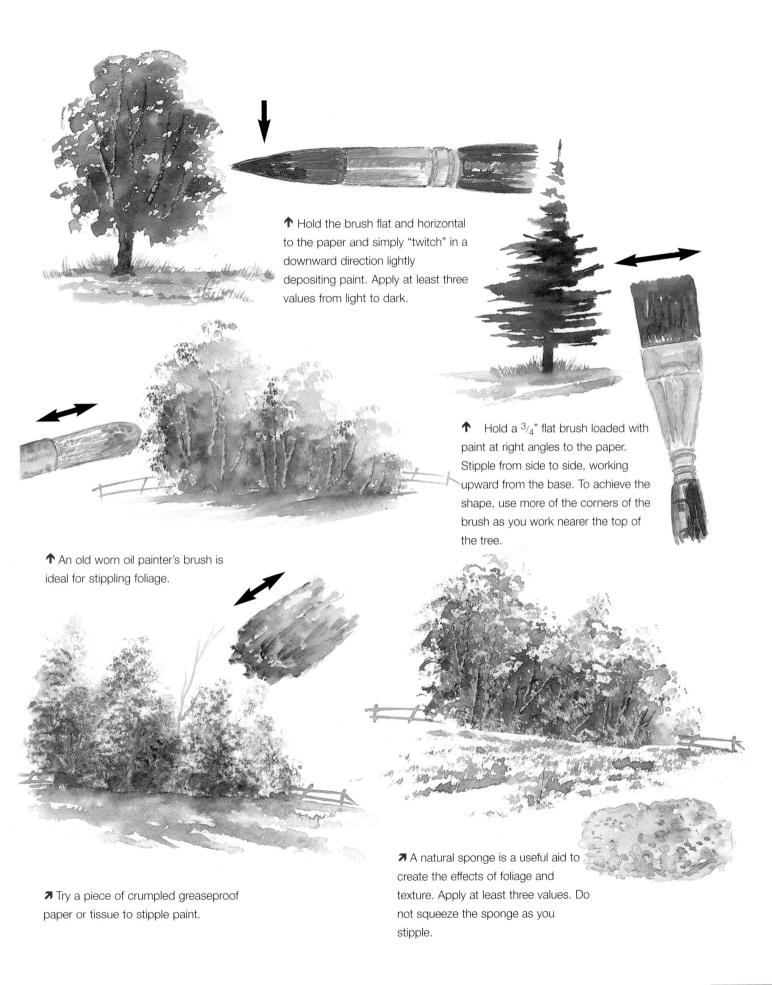

AUTUMN

Season of mists and mellow fruitfulness

Close bosom-friend of the maturing sun;

Conspiring with him how to load and bless

With fruit the vines that round the thatch-eves run;

To bend with apples the moss'd cottage-trees

And fill all fruit with ripeness to the core;

To swell the gourd and plump the hazel shells

With a sweet kernel; to set budding more,

And still more, later flowers for the bees,

Until they think warm days will never cease,

For Summer has o'er brimm'd their damming cells.

John Keats

Autumn – my favourite time of the year to paint. The summer greens evolve into a panorama of yellows, sienna and russet reds. The leaves fall to the ground creating a carpet of sparkling colour. It's the season of colour; the hips and haws in the hedgerow providing sustenance for the flocks of migrating birds that gather before departing to warmer climates, whilst the stay at home birds and visitors from colder areas grow fat on the surfeit of fat balls and nuts to be found in gardens everywhere. This source of food is vital to the birds as the weather becomes colder and their natural diet of berries and insects dwindles.

The mountain becks and rivers are full of water cascading over rocky beds. The sound of farmers ploughing can be clearly heard across the fields. Dampness and mist often cover the landscape and the days become shorter. The tourists have gone and the landscape is transformed into a sea of colour.

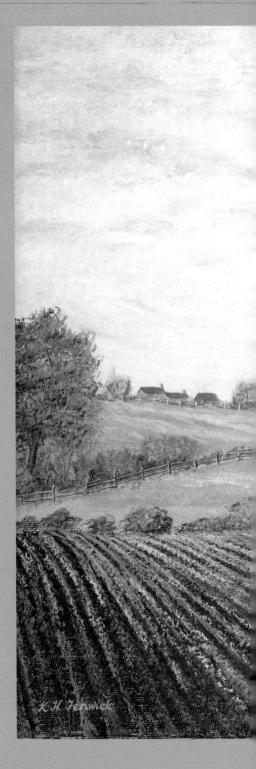

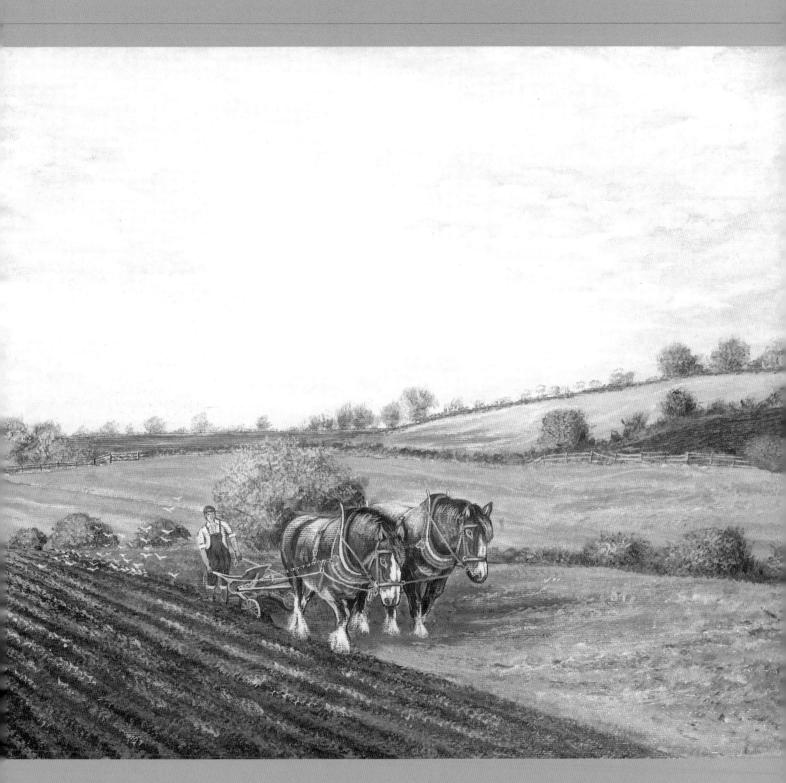

ABOVE: Autumn Ploughing

AUTUMN PASTURE - PROJECT

This is one of those exercises that provides an opportunity to demonstrate the three ingredients of a successful painting; in this case, an atmospheric sky, an interesting group of bushes in the middle distance and a colourful foreground with plenty of texture.

The tonal study was completed in order to establish the value relationships.

♦ STAGE 1 **SKY**

The initial stage is to fix the horizon line by positioning a piece of 1" masking tape across the paper. Note that the tape has been bent to create the horizon line that is not perfectly level, as would be the case in reality.

The sky was painted using the 11/2" hake brush and a Raw Sienna wash. When the shine had left the underpainting, the clouds were painted using an Ultramarine blue/Payne's Gray mix.

Create interesting cloud shapes by using a tissue to remove paint with a dabbing action to improve their structures.

WHAT YOU WILL NEED

PAPER:

Winsor & Newton 300lb rough

BRUSHES:

Winsor & Newton Sceptre Gold II Series size 14 round, size 3 rigger, 11/2" hake, size 6 round, hog hair

PAINTS:

Payne's Gray, Ultramarine blue, Alizarin Crimson, Raw Sienna, Burnt Sienna, Cadmium Yellow Pale, Sap Green

SUPPORTIVE:

Masking tape, acrylic white, tissues

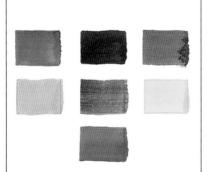

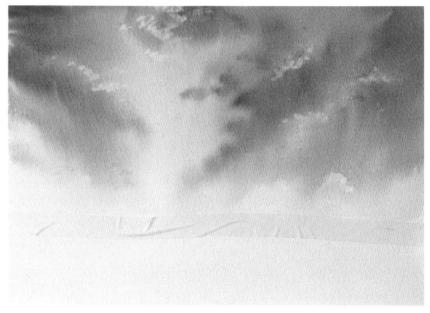

→ STAGE 2 BUSHES

Use an old, round hog hair brush to stipple in the form of the bushes. Make them differing heights and use a variety of colours mixed from Cadmium Yellow Pale, Cerulean Bluo, Raw Sienna, Burnt Sienna, Alizarin Crimson and Payne's Gray. First, practise your colour mixes on an off-cut watercolour paper. Work from light to dark; quite wet, allowing the colours to blend together. Paint in the fence and gate. In order to lead the viewer's eye into the distance, paint a few distant bushes beyond the gate.

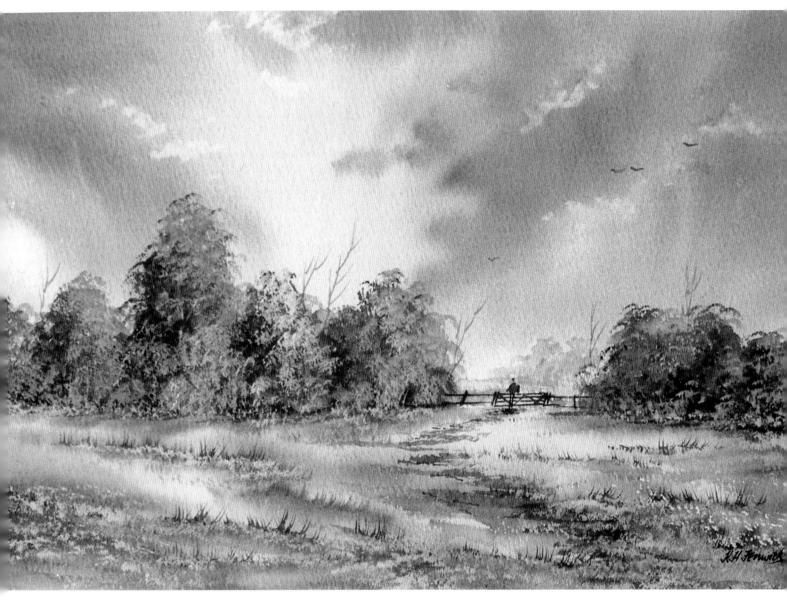

STAGE 3 BUSHES AND FOREGROUND

Carefully remove the masking tape. Add more detail to the bushes, in particular, highlights created by adding a little white acrylic paint to the mixes, ensuring that the highlights

remain on the top of the paper, rather than sink in and lose the necessary sparkle.

The foreground needs to be sensitively painted by initially applying a weak Raw Sienna wash over the whole of the foreground. Brush a little Burnt Sienna in and a Payne's Gray/Alizarin Crimson mix to represent shadows. When the under-painting is dry, use the edge of the hake brush to touch the paper, lightly depositing paint and flicking upwards to create the Impression of stubble. Add darker tones to shape the path.

When the paint is dry use an old worn hog hair brush to stipple in soft green colour, representing low growing plants. Finally add the figure and a few birds.

MOUNTAIN MAJESTY - PROJECT

I have created this landscape from my imagination to provide experience in painting snow-capped mountain scenery and the use of a palette knife for forming realistic rocks. Although it may appear daunting to the less experienced, hopefully the stage-by-stage will show how easy it can be – it's just a series of bits linked together like a jigsaw to create a unified whole.

The value pattern helps to establish the mountain structure. Scenes like this can be easily overdone, so take care in determining the position of the main features – peaks and promontories, gullies, fissures and shadow patterns. Don't make all the peaks the same height and shape.

WHAT YOU WILL NEED

PAPER:

Saunders Waterford 300lb rough

BRUSHES:

Winsor & Newton Sceptre Gold II series size 14 round, size 6 round, size 3 rigger, 11/2" hake

COLOURS:

Payne's Gray, Cobalt Blue, Alizarin Crimson, Raw Sienna, Burnt Sienna, Sap Green

SUPPORTIVE:

Masking fluid, palette knife, white acrylic

It is important to contrast the mountains with the sky to ensure the

STAGE 1 DRAWING AND MASKING

An outline drawing was prepared

using a water-soluble crayon and

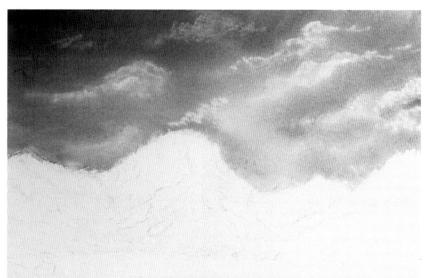

areas to be preserved on the mountains masked.

The rocks were also masked.

snow-capped mountains, which are the main feature of this landscape were clearly defined. Various values of Cobalt Blue were brushed in over a Raw Sienna under-painting to create a wet-in-wet sky. To darken values, a little Payne's Gray was added to the Cobalt Blue. Tissues were used whilst the paint was still wet to create some white clouds. The hake brush is ideal for painting skies.

STAGE 3 UNDER-PAINTING

Using both the point and side of the size 14 round brush, the structure of the main mountains was painted. Begin with Cobalt Blue to define the main shapes and follow with some Burnt Sienna and a Payne's Gray/Alizarin Crimson mix. It is obvious from the artwork where these colours were placed. Take care not to overdo it – paint a little at a time. Stand back and view it until you're reasonably happy with the overall structure.

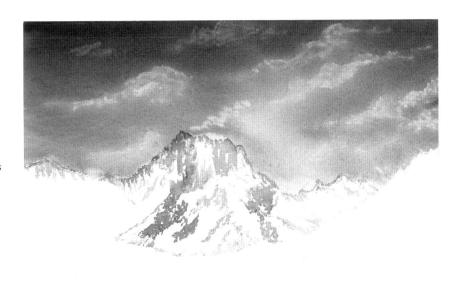

STAGE 4 ADDING DETAIL

Using the same approach, complete the structure of the mountain range. Now is the time to add darker values to give more definition to the mountain. Darker values make the covering of snow more distinctive. I used a size 6 brush to paint the darker values. Notice also that I have brushed in a little Raw Sienna and at the base of the mountain a pale Cobalt Blue to represent cloud shadows over the snow.

STAGE 5 ROCKS AND MIDDLE DISTANT TREES

You will enjoy painting the rocks. The technique is so simple. Using 3/4" flat brush wash in Raw Sienna. This shape of brush is very helpful when painting rocks. Add some Burnt Sienna in selected areas and follow this with a

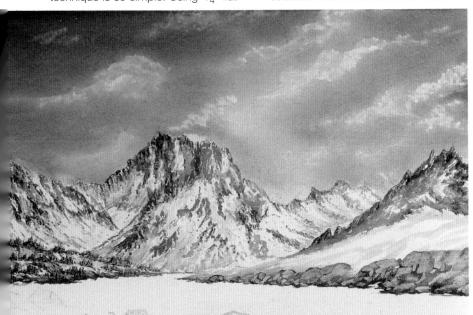

Payne's Gray/Alizarin Crimson mix. At this stage the rock group will appear as a soft wet-in-wet texture, with each colour clearly showing. When the under-painting is approximately one third dry, using the side of the palette knife, move the paint around to create the rock structure. Try this technique you will be amazed at the result and it's so easy to achieve. See pages 78/79 for technique. The fir trees were painted by stippling with the edge of the 3/4" flat brush.

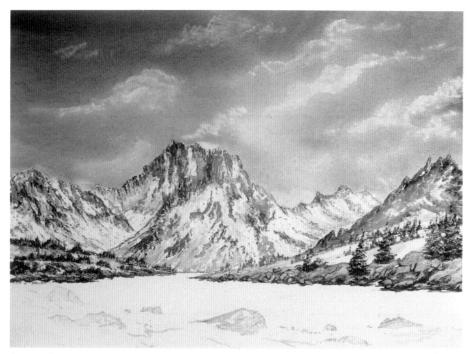

STAGE 6 FIR TREES

These were painted using the edge of the $^{3}/_{4}$ " flat brush, held almost horizontal and whilst stippling, rock the brush from side to side to follow their shape, working from their base upwards.The full width of the brush will

be in contact with the paper at ground level and the corner of the brush only, as the top of the tree is reached.

The impression of snow was stippled using a little acrylic white paint.

The foreground was painted with broad sweeps of the hake brush using various values of Raw Sienna/Burnt Sienna and darker values by adding a little Payne's Gray to the mix.

The masking was removed from the rocks and they were painted following the procedure described on page 79. A rigger brush loaded with a Payne's Gray/Burnt Sienna mix was used to emphasise their shadows and features. Don't forget to paint shadows under the rocks. The effects of snow in the foreground was

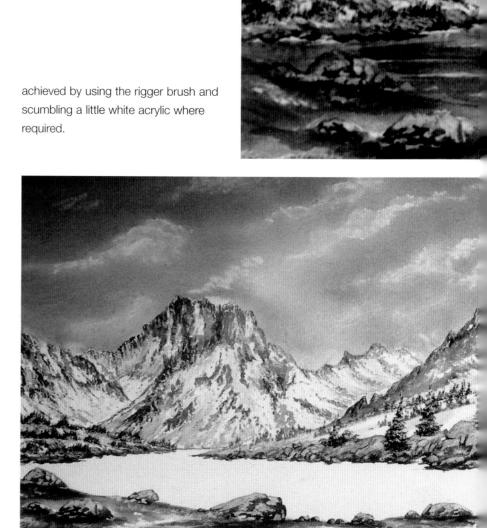

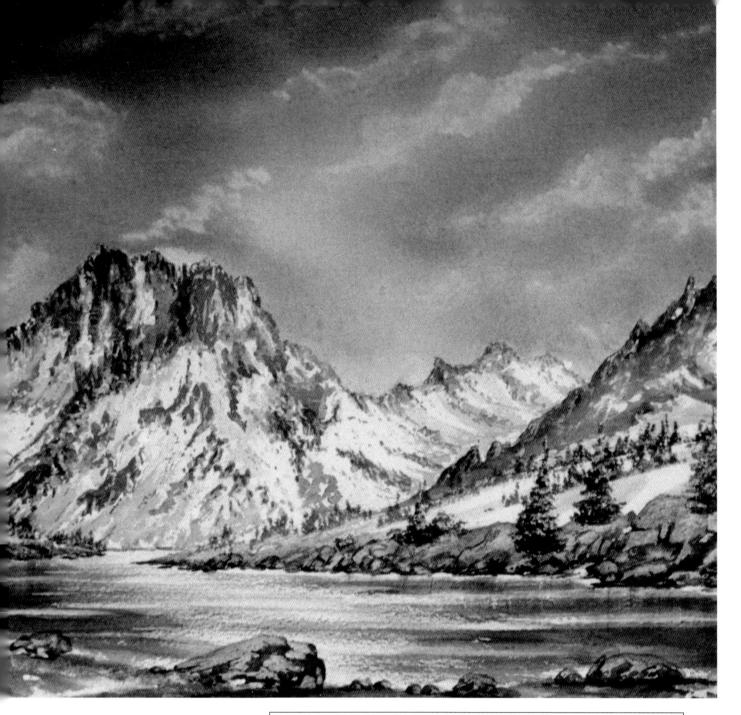

FINAL STAGES WATER

The side of the size 14 round brush was used to paint the water with the sky colours, to ensure harmony. Use a light touch, working from the outsides inwards. Create the light areas in the centre by leaving parts of the paper uncovered.

Shape a tissue to a fine wedge and whilst the paint is still wet, wipe out a few horizontal wind lines.

Finally, when the paint is dry, gently paint a pale Raw Sienna wash across the water to represent light from the sky.

KEY POINTS

- 1 Paint an atmospheric sky to counterchange with the snow-capped peaks.
- 2 Take time in painting your mountain structures, don't overdo it leave ample snow covered areas.
- 3 Shape the peaks don't make them all the same height.
- 4 Think of the surface of your paper as consisting of peaks and valleys. Move your brush quickly across the peaks of the paper, leaving the valleys uncovered to represent sparkle on the water.
- 5 Use a palette knife to create realistic shaped rocks.
- 6 Transfer the cloud colours on to the surface of the water.

AUTUMN FLOW - PROJECT

WHAT YOU WILL NEED

PAPER:

300lb Winsor & Newton rough

BRUSHES:

Winsor & Newton Sceptre Gold II Series 3 /₄" flat, size 6 round, size 3 rigger, 1 /₂" hake, 1/2" round hog hair

COLOURS:

Payne's Gray, Cobalt Blue, Alizarin Crimson, Raw Sienna, Burnt Sienna, Cadmium Yellow Pale

SUPPORTIVE:

Dark brown water-soluble crayon, masking fluid, tissues, palette knife

This type of landscape can be discovered in abundance in the English Lake District in autumn. The water tumbles down from the mountains to form these mountain becks, the sound of which can soothe the mind of any artist.

Painting this type of landscape is my idea of heaven. In producing this painting, I have used some unconventional techniques. The tonal study becomes the plan for the painting.

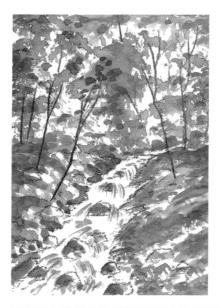

STAGE 1 OUTLINE DRAWING/MASKING

A dark brown water-soluble crayon was used to draw a simple outline; emphasis being placed on the position, size and shape of the rocks. A crumpled tissue was dipped in masking fluid and stippled on the paper to represent areas of foliage and fallen leaves to be preserved. Using an old size 6 round brush, masking was applied to the rocks and areas of water to be preserved as well as a line around the perimeter of the beck. The masking was allowed to dry completely.

STAGE 2 POURING PAINT

Three liquid washes were prepared using - Raw Sienna, Burnt Sienna and Payne's Gray/Alizarin Crimson.

Initially the Raw Sienna was poured from top to bottom. This was followed by Burnt Sienna to the bottom half of the right hand side and to the left hand side of the foliage area. Finally the Payne's Gray/Alizarin Crimson was applied to the left hand side.

The board was tilted allowing the washes to flow down and blend together. The masking applied to the perimeter of the beck prevented the washes from running over the areas of paper preserved for the beck.

Using the palette knife, a few tree structures were scratched in. The paint was allowed to dry.

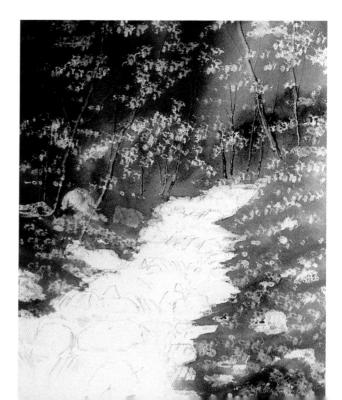

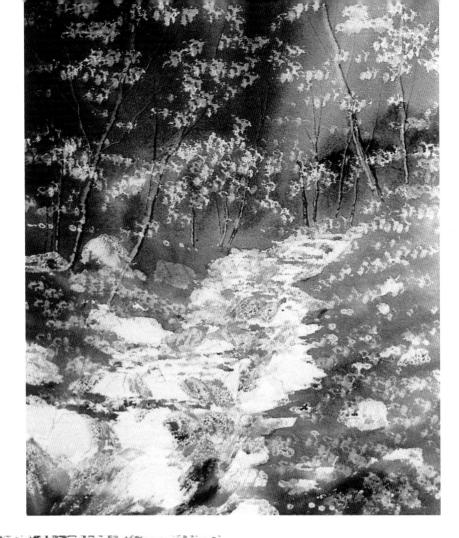

STAGE 3 WATER

With the $1^{1}/_{2}$ " hake brush, the techniques described on page 71 were followed. A Payne's Gray/Cobalt Blue mix was used, the masking repelling the paint. Angle your brush strokes to vary the direction of water flow. Allow to dry.

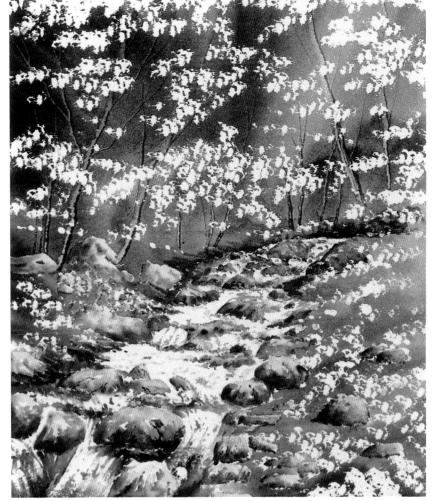

STAGE 4 ROCKS

Remove the masking from the rocks and the water. Using the ${}^{3}/_{4}$ " flat brush apply washes of Raw Sienna to the rocks, followed by deposits of Burnt Sienna using the corner of the brush allow the paint to blend together. Paint a few rocks at a time - timing is important to allow the two washes to blend. When dry, add the shadows using a size 6 round brush and a Payne's Gray/Alizarin Crimson mix. Paint shadows under the rocks to improve the representation of the mountain beck.

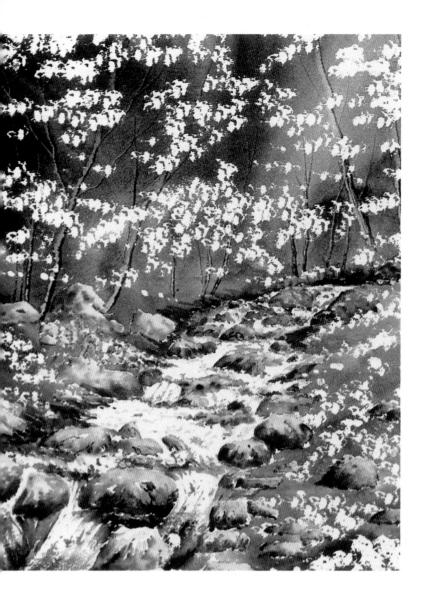

STAGE 5 REMOVE MASKING

Remove the masking from the tree foliage and the areas of foreground leaves.

STAGE 6 FOLIAGE

Using Cadmlurn Yellow Palc, Burnt Sienna, Alizarin Crimson and a size 6 round brush, colour the foliage. Begin with a Cadmium Yellow Pale wash and add a hint of other colours to allow the paint to blend together representing multicoloured leaves. Emphasise the tree structures with a little Burnt Umber using the rigger brush.

KEY POINTS

- 1 Draw the outline with a water-soluble crayon it will wash out as the paint is applied.
- 2 Use a crumpled tissue to apply masking fluid.
- 3 Use the technique described on page 71 to paint the water
- 4 Apply several colours and values to the rocks attempt to make them look realistic.
- 5 Transfer the colours in the foliage to the foreground.
- 6 Paint some darker values where the land meets the water, providing contrast.

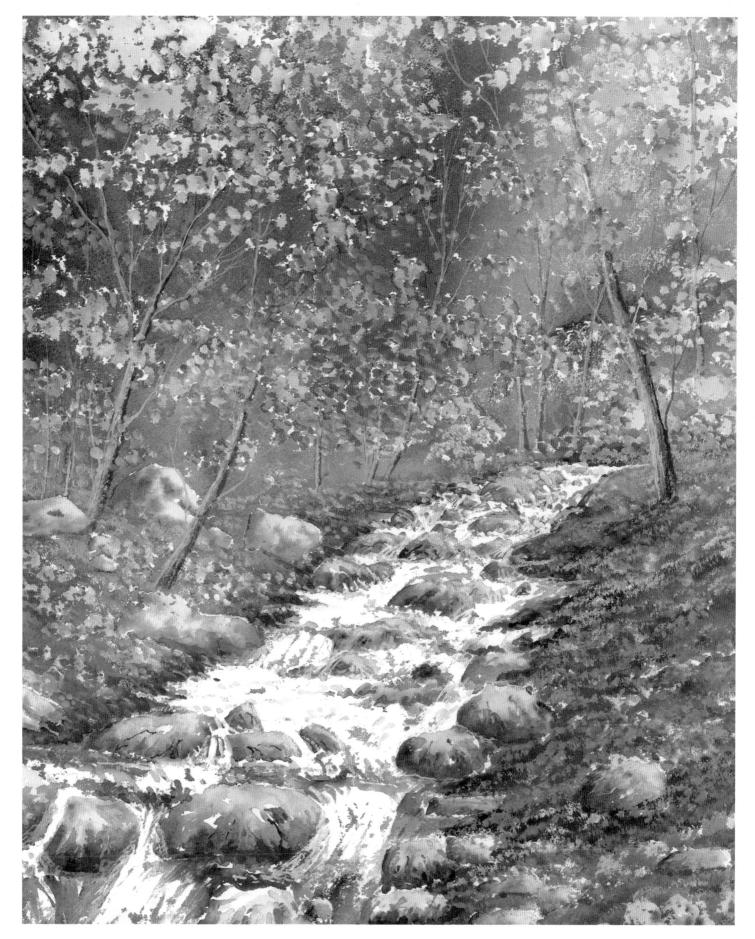

FINAL STAGE **ADDING DETAIL** Complete the foreground by stippling in a range of greens, yellows and siennas. Stipple in the foreground with a hog hair brush bringing texture and realism to this area.

ON LAKELAND FELLS — PROJECTS

WHAT YOU WILL NEED

PAPER:

Winsor & Newton 300lb rough

BRUSHES:

Winsor & Newton Sceptre Gold II Series size 14 round, size 6 round, 3/4" flat, $1^{1}/_{2}$ " hake, $1/_{2}$ " hog hair

COLOURS:

Payne's Gray, Cobalt Blue, Alizarin Crimson, Raw Sienna, Burnt Sienna, Sap Green

SUPPORTIVE:

Masking fluid, white acrylic paint, tissues

I have included this project to provide experience in painting the subtle colours in a mountain landscape, in this case the mountain, "Pike o' Stickle" in the English Lake District, and to describe how a realistic foreground is

Here the softness and variation in a mountain structure is captured and also the roughness and detail of a Lakeland foreground. The value study establishes the lights and darks.

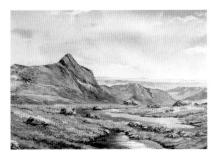

STAGE 1 DRAWING, MASKING, SKY Care was taken whilst drawing the outline using a water-soluble crayon. It's important to capture the mountain profile as accurately as possible, as mountaineers and walkers can be very critical. Artistic licence allows the repositioning of a few rocks, to improve the composition but representing "Pike o' Stickle" must be accurate.

Masking fluid was applied to create highlights on the mountains and light on the rocks.

The sky was painted using the hake

brush, as it is ideal to cover large areas of paper quickly, to avoid hard edges occurring. An initial wash of Raw Sienna was applied, followed by varying tones of Cobalt Blue - darker tones being applied to the top right to balance the main mountain structure on the left. A tissue was used to wipe out a few white clouds. A sky needs to be painted in less than three minutes to avoid hard edges occuring.

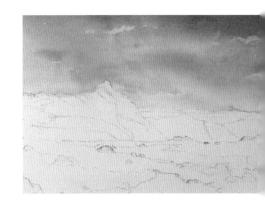

STAGE 2 FOUNDATION FOR

MOUNTAIN

Here I have used two brushes - the hake for sweeping washes and the 3/4" flat brush for shaping the peaks. Using the hake brush, a Raw Sienna wash was applied to the whole of the mountain and a Raw Sienna/Cap Green mix applied whilst still wet to selected areas. Finally, prior to the paint becoming more than one third dry, the 3/4" flat was loaded with a Payne's Gray/Alizarin Crimson mix and used to shape the peaks and add darker values to the mountain.

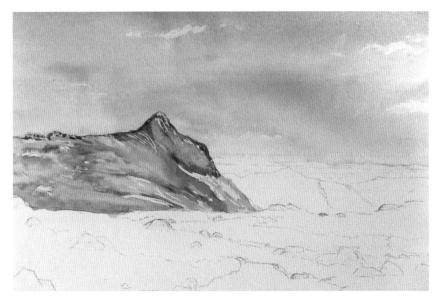

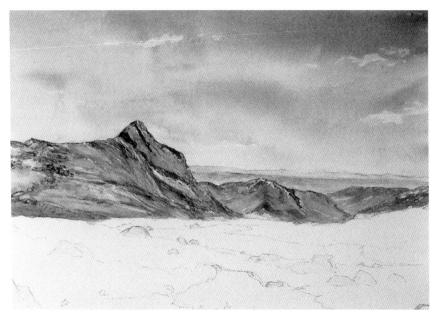

STAGE 3 COMPLETING THE

MOUNTAINS

The distant mountain ranges were painted using pale values of Cobalt Blue in the far distance with a hint of the Payne's Gray/Alizarin Crimson mix here and there. The middle distant mountains were painted by applying a Raw Sienna under-painting, followed by various tonal values of Payne's Gray/Alizarin Crimson. The masking was removed using a putty eraser and detail added using a size 6 round brush.

On the left of "Pike o' Stickle", there is a group of rocks that lead to the top edge. A Payne's Gray/Alizarin Crimson was applied and allowed to soften the under-painting. A palette knife was used to move paint to represent the variety of shapes and sizes of rocks leading to the edge. The result of the foregoing process is a subtle blending of colour and a realistic representation of the feature - "Pike o' Stickle".

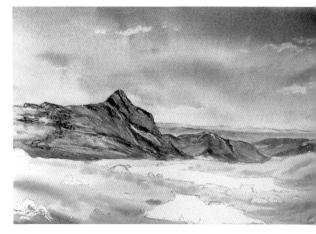

STAGE 4 FOREGROUND WASHES Using the hake brush, a weak Raw Sienna wash was applied to the whole of the foreground, followed by the application of Burnt Sienna to selected areas.

STAGE 5 APPLYING DARKER

VALUES

The edge of the hake brush is useful for painting rough grasses and texture. The loaded brush is simply tapped across the paper to deposit paint, rather like a stippling action. The edge of the brush is held at an angle approximately 30 degrees to the paper and by patting down on the paper the required effects are created. Just dance across the paper in this manner, having loaded the brush with less wet colours - greens, browns and sienna; all being made from Sap Green, Raw Sienna and Burnt Sienna remembering to use a light touch.

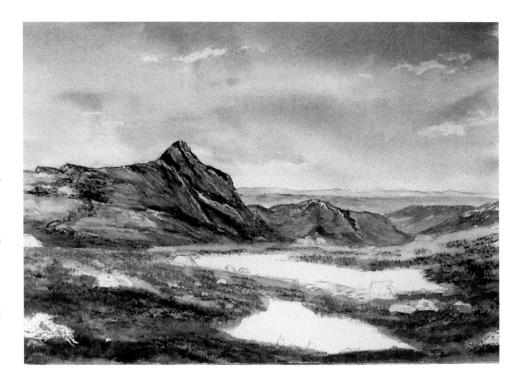

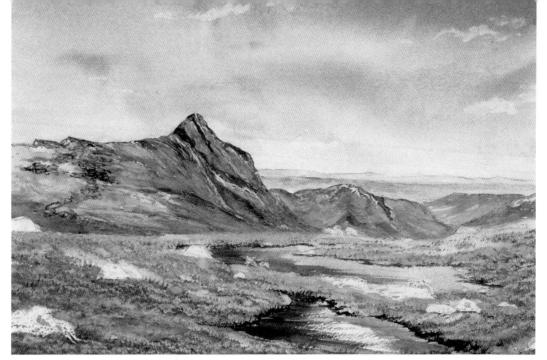

STAGE 6 FOREGROUND

Using an oil painter's hog hair brush, the impression of rough texture was created by stippling with a little white acrylic/Raw Sienna mix, creating lighter areas of rough texture. The water was painted by using the side of the size 14 round brush, loaded with Cobalt Blue. A little Payne's Gray was added for the darker tones. The sparkle on the water was created by leaving the white of the paper uncovered - dry brush effect.

STAGE 7 ROCKS

The rocks were painted using dark values of a Payne's Gray/Burnt Sienna mix and when dry the masking was removed. The size 6 round brush being used to add detail to the rocks.

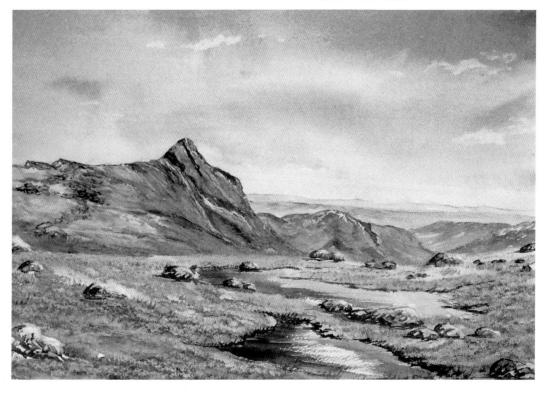

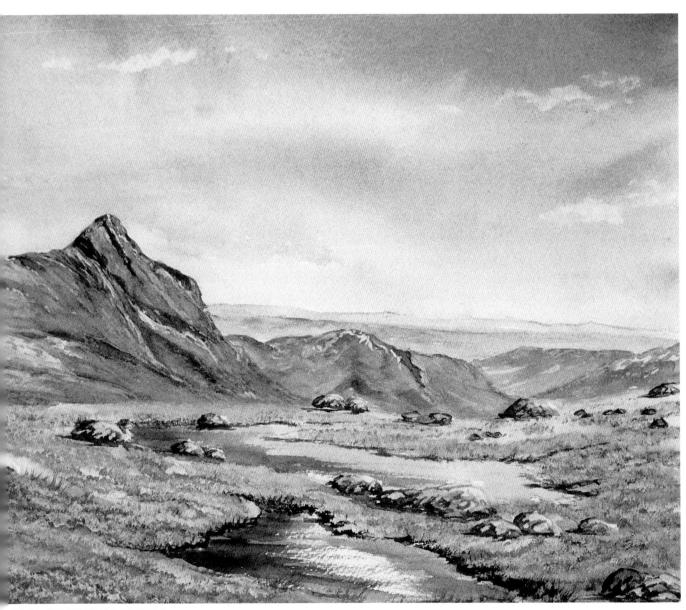

FINAL STAGE FINAL DETAILS

Darker values were added to represent shadows over the foreground and to edge the banks of the small areas of water. Note the tufts of grass growing over the rocks - painted by fanning the size 14 round brush and flicking in

an upward direction. The rocks weren't placed there yesterday: there will be vegetation growing around their base. It's these small, yet important details, which separate the professional from the amateur painter.

KEY POINTS

- 1 Paint a simple sky. Remember the "Golden Rule" - a detailed foreground requires a simple sky.
- 2 When painting the mountain structures, apply the washes and glazes wet into wet to allow the colours to blend together, creating soft texture.
- 3 Use an old bristle brush to create texture in the foreground.
- 4 Add small details like the tufts of grass growing around the rocks for realism.

THE COUNTRY LANE - CLOSE UP

This landscape has been included to provide experience in the painting of foreground texture. There are many techniques that I could have used to achieve the effect of rough grasses, wild plants, fallen leaves and the variation and gradation to be found on such roadside banks. I could have used a sponge, spattered paint, stippled or dabbed with a small brush or even a combination of all these techniques. The scene is typical of a country lane to be found virtually anywhere in the United Kingdom.

I was attracted to this landscape because the track vanishes into the distance, beyond a stone building with red doors and roof, providing the focal point in this painting. This is one of those exceptions where although the focal point is just off centre, I feel it still works. The viewing points were very limited, due to the narrowness of the lane and the steep banks and it was important to select a viewpoint where I could observe the track passing the building and out of the painting.

WHAT YOU WILL NEED

PAPER:

Winsor & Newton 300lb rough

BRUSHES:

Winsor & Newton Sceptre Gold II Series size 14 round, size 6 round, size 3 rigger, 11/2" hake

COLOURS:

Payne's Gray, Cobalt Blue, Alizarin Crimson, Raw Sienna, Burnt Sienna, Cadmium Yellow Pale, Sap Green

SUPPORTIVE:

Masking fluid, cocktail stick, old oil painter's brush, natural sponge

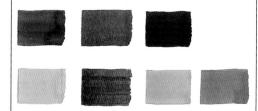

SKY

Because of the amount of detail in this landscape the sky needs to be painted simply. Using the hake brush a Raw Sienna wash was applied and Cobalt Blue brushed in - the brush strokes being directed towards the focal point, which is the building.

PINE TREE

This was a lovely shape, which helped to balance the right hand tree group. I applied a soft green initially, to represent the foliage and over-painted whilst still wet, using a Payne's Gray/Sap Green mix to create depth. After the foliage had been painted, the tree trunk and branches were added. using the rigger brush and Burnt Umber.

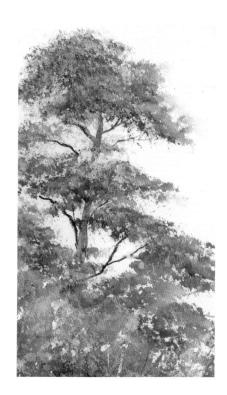

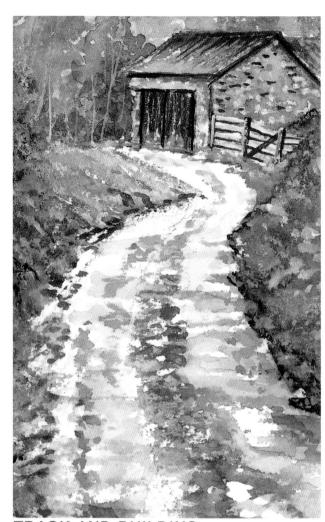

TRACK AND BUILDING

The track curved nicely up to the building and continued out of the painting. This was a well rutted track and I wanted to indicate this roughness in the painting. I have left much of the paper uncovered as the track needed to appear light in tone to provide counter-change with the banks that were painted a darker value. Using the size 14 round brush, Raw Sienna was washed in. When dry I used the side of the rigger brush loaded with a Payne's Gray/Alizarin Crimson mix to paint the texture on the track. The building was built of stone and depicted by applying a Raw Sienna under-painting and adding Payne's Gray and Burnt Sienna to emphasise a few of the stone shapes. An Alizarin Crimson/Burnt Sienna mix was used to paint the roof and doors.

TREES

The tree structures were painted with the rigger brush. When dry, a sponge was used to stipple various values of a Burnt Sienna/Raw Sienna mix. When dry the ivy growing up the trunks was painted by adding a light green followed by a darker value to indicate the depth of shadow.

Take care to ensure that the twigs on the trees are finely painted. There's nothing worse than thick lines at the tops of trees. It's a good idea when painting the twigs, to immediately dab their ends with a tissue to lighten their value to replicate nature where the light catches them.

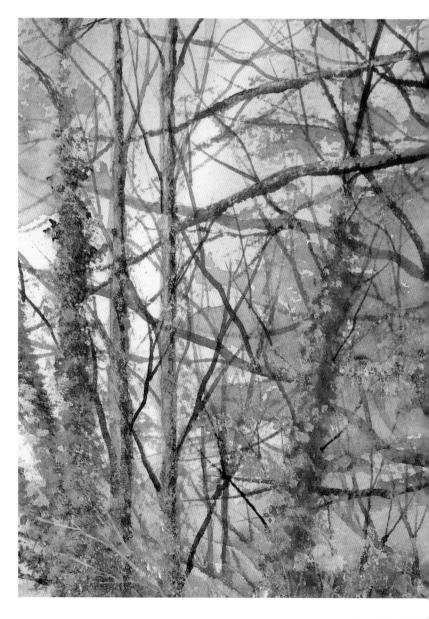

LEFT HAND BANK

This was to be painted in darker values but I needed to indicate a few light coloured leaves and rough texture here and there as would be apparent in reality. The best way to achieve this was to apply masking fluid by stippling with an old worn oil painter's brush. When dry various tones of Raw Sienna and Burnt Sienna were applied.

A Payne's Gray/Alizarin Crimson mix was used to create the darker values representing depth in the bank.

To illustrate the thin tree structures in the distance, I scratched these out with a cocktail stick. When the paint was completely dry the masking was removed with a putty eraser and soft greens, yellows and ciennas were painted over the preserved white of the paper to represent the colours of the leaves etc.

It is important that the bank is a darker tone than the opposite bank.

KEY POINTS

- 1 Paint a simple atmospheric sky as background.
- 2 Take care when painting the right hand trees. Make sure that the branches and especially the twigs aren't painted too thick.
- 3 Use a damp sponge to stipple on the foliage. Try this on an off cut of paper until you are satisfied that the paint is being deposited to your liking - not too dense and remember don't squeeze the sponge as you stipple.
- 4 Make sure the left hand pine tree is a pleasing shape to balance the relatively leafless tree grouping on the right.
- 5 The track, although well rutted, must appear light, to lead the viewer's eye into and out of the painting.
- 6 The banks are main features. Follow the stages described in the text - make them look real.

RIGHT HAND BANK

Masking fluid was applied with a rigger brush to represent new growth. Leafy growth on the bank was replicated by stippling masking fluid on to the area with an old worn oil painter's brush. When dry the hedgerow and bank were painted. The masking was removed and a size 6 round brush used to paint soft green, yellows and sienna to represent rough texture.

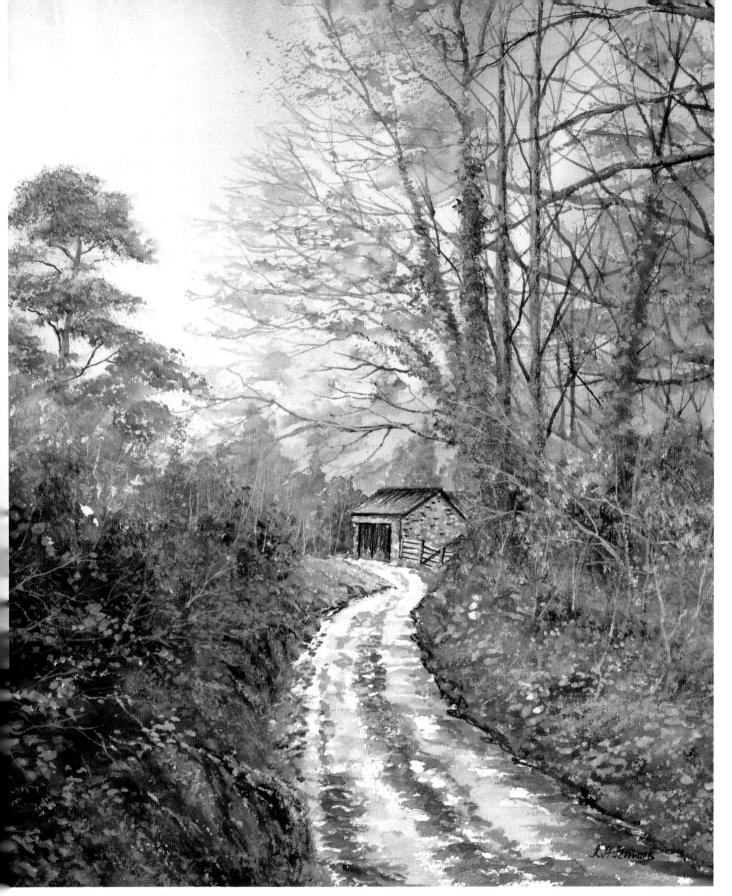

FINAL DETAILS

Using the rigger brush, the fence and gate at the side of the building were painted. A few light coloured leaves were added using the rigger brush and the mixes already on the palette with a little white acrylic added to lighten the values. The edges of the track were given more definition using darker values.

My normal practice at this stage, is to look at the painting over a few days and make any improvements that I feel are necessary.

AUTUMN GLOW - PROJECT

This landscape is typical of woodland scenes to be found virtually anywhere. This scene is by the side of Derwent Water, near Keswick in the English Lake District.

The tonal study was the commencement and plan for the painting.

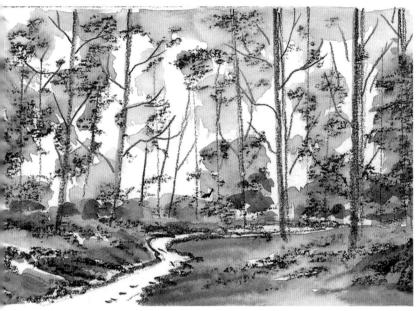

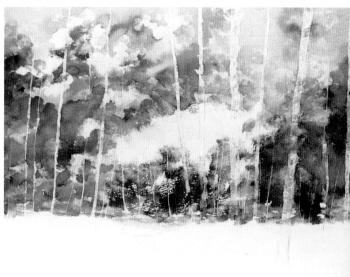

WHAT YOU WILL NEED

PAPER:

Winsor & Newton 140lb rough

BRUSHES:

Winsor & Newton Sceptre Gold II series size 14 round, size 6 round, size 3 rigger, 3/4" flat and 11/2" hake

COLOURS:

Payne's Gray, Cobalt Blue, Alizarin Crimson, Raw Sienna, Burnt Sienna, Cadmium Yellow Pale, Cadmium orange

SUPPORTIVE:

Masking fluid, acrylic white

STAGE 1 BACKGROUND

The trees structures were masked. A crumpled piece of tissue was dipped in masking fluid and areas for the light coloured foliage were stippled in. When dry, using the hake brush, washes of Cobalt Blue, Alizarin Crimson and Raw Sienna were washed in to create the background.

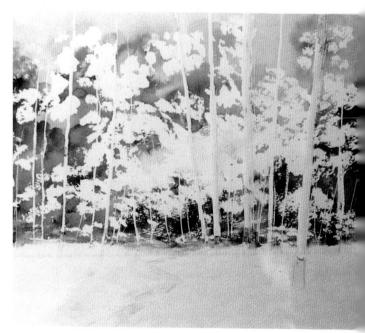

STAGE 2 REMOVE MASKING

When perfectly dry, the masking fluid was removed using a putty eraser to reveal the white of the paper.

STAGE 3 PAINTING THE FOLIAGE

Using the side of the size 14 round brush loaded with various tones of Cadmium yellow, the white of the paper was covered. A little Burnt Sienna was added to the mix in order to paint a little richer colour here and there.

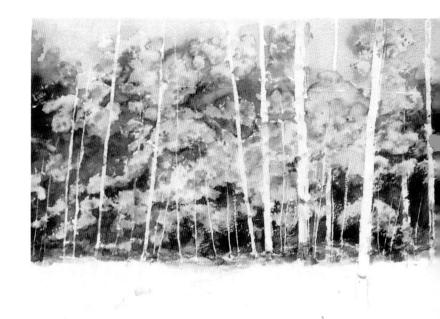

STAGE 4 FOREGROUND

Masking fluid was applied to the foreground path and selected areas of the foreground. Washes of Raw Sienna, Burnt Sienna and Cobalt Blue were applied to the foreground to create colour variation.

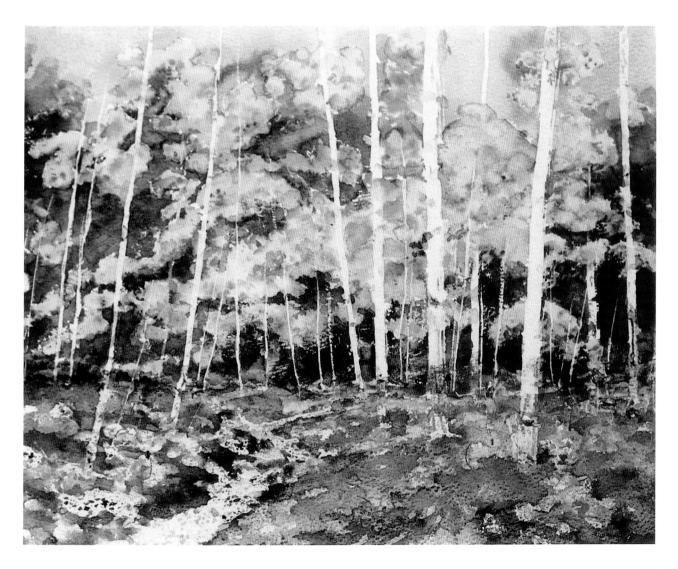

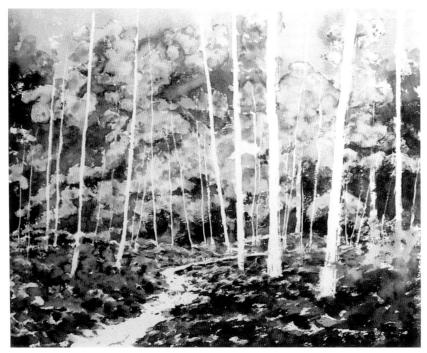

STAGE 5 DEPTH IN FOREGROUND More depth was added to the foreground by applying mixes of Payne's Gray/Alizarin Crimson/Burnt Sienna.

STAGE 6 TREE STRUCTURES

To paint the trunks Raw Sienna was applied with the 3/4" flat brush. As the paint dried, Burnt Sienna and a Payne's Gray/Alizarin Crimson mix were applied, using a size 6 round brush to create the textured look. The rigger brush was used to paint the branches.

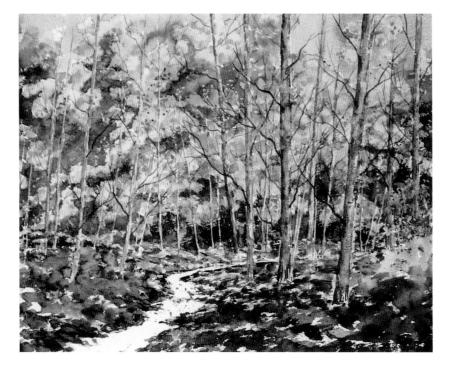

FINAL STAGE FOREGROUND DETAIL To paint the impressions of rough foreground, the masking was removed and various mixes made from Cadmium Yellow Pale, Raw Sienna and Cadmium orange were stippled using an old hog hair brush.

The path was given its definition by brushing in a Payne's Gray/Alizarin Crimson mix using the rigger brush.

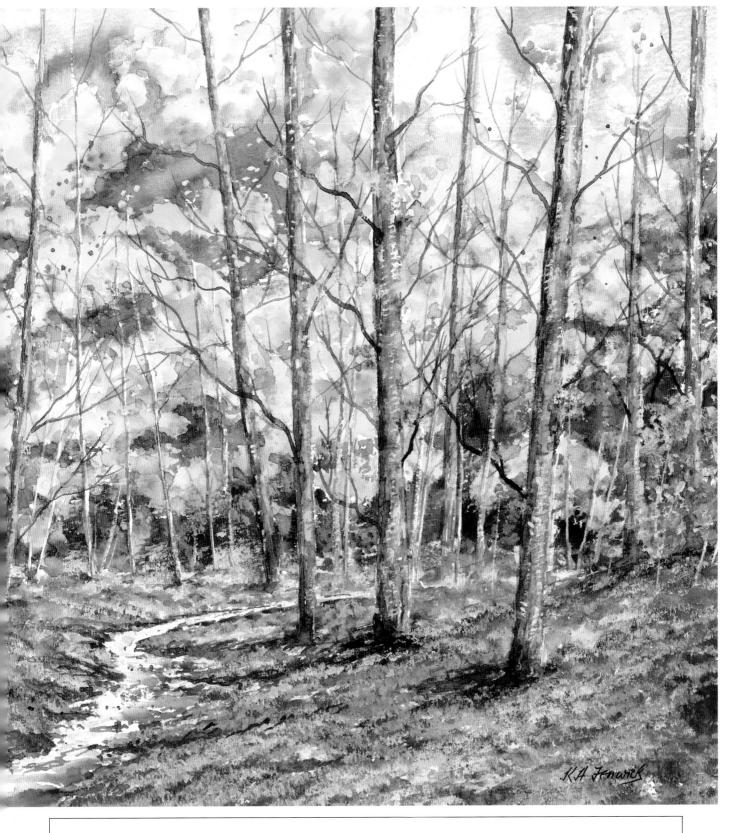

KEY POINTS

- 1 Use a piece of crumpled tissue or greaseproof paper to apply the masking for the foliage.
- 2 Timing is important when painting the tree structures. Apply an initial wash to wet the paper and experience will tell you when to apply further colours to enable them to fuse together as required. If you apply further values when the under-painting is too wet, the whole appearance will lack detail, because the
- colours run together as a mass.
- 3 Build up the foreground gradually; stand back and look. Decide where lighter values are needed and where darker values are necessary to create shadows and depth. It is foolhardy to rush at this stage - spend three minutes thinking for every minute spent painting.

WINTER

Out of the bosom of the air

Out of the cloud-folds of her garments shaken,

Over the woodlands brown and bare,

Over the harvest-fields forsaken,

Silent and soft, and slow

Descends the snow

Henry Wadsworth Longfellow

Winter is one of my favourite times of the year to paint. The fields are ploughed ready for the next generation of seeds.

Pheasants can be seen in all their glory scratching for food. Winter visitors such as red wings and fieldfares flock the countryside. The trees are bare, except for those with a coat of ivy for the evergreens that provide shelter for the wildlife.

With food more difficult to find, the local fox can often be seen searching and the pheasant and partridge grace the bare landscape. The sheep are sporting their winter coats and are brought nearer to the farms in case of prolonged snow and frost.

There's nothing more beautiful than a snow-covered landscape on a crisp sunny day. Snow, hated by many, provides the artist with a whole new world of inspiring compositions to paint. The fast-flowing river or mountain stream, the partially frozen lake, the frost and snow on winter trees and the snow-capped mountain all provide the landscape artist with wonderful painting opportunities.

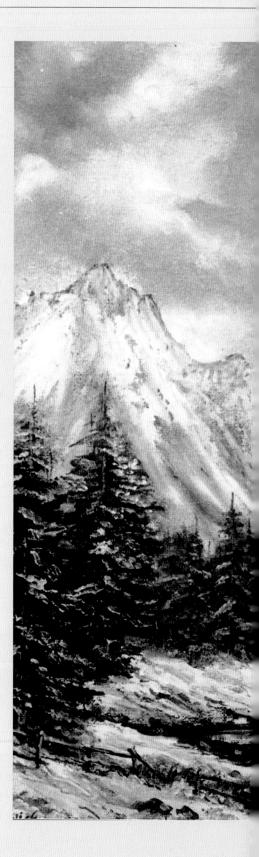

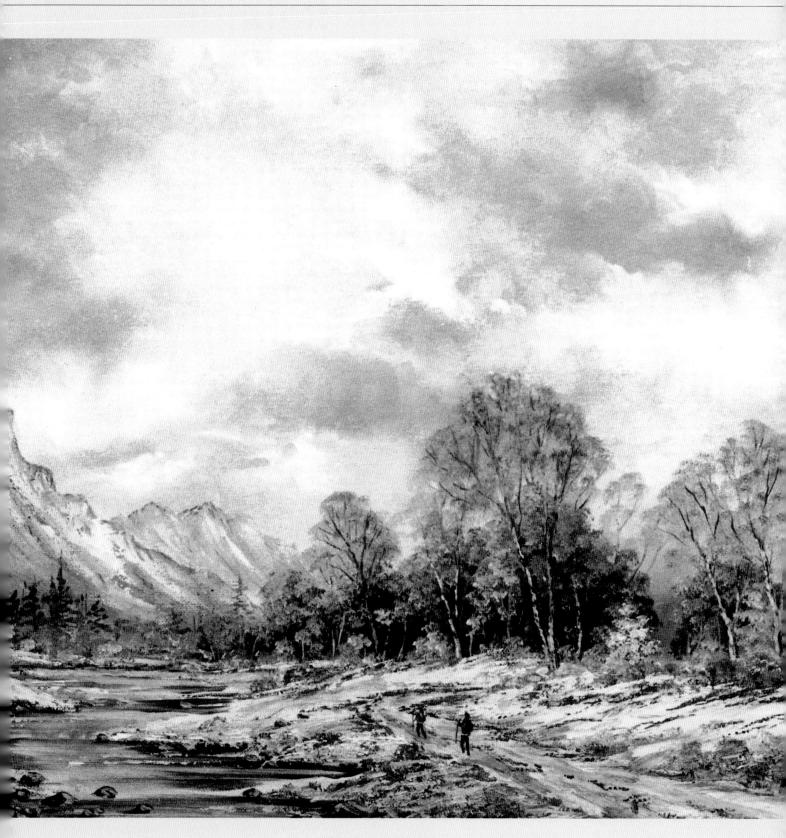

ABOVE: A Walk on the Wild Side

THE SKIERS - SIMPLE EXERCISE

I have kept this one very simple so you can have some fun using the wet-in-wet technique. The tonal value study helps clarify ones approach.

WHAT YOU WILL NEED

PAPER:

Bockingford 200lb extra rough

BRUSHES:

Winsor & Newton Sceptre Gold II Series size 14 round, 3/4" flat, size 2 rigger, $1^{1}/_{2}$ " hake, $^{1}/_{2}$ " round hog hair

COLOURS:

Payne's Gray, Cerulean Blue, Burnt Sienna, Sap Green

SUPPORTIVE:

1" masking tape, white acrylic or gouache

STAGE 1 SKY AND BACKGROUND TREES

Position a piece of 1" masking tape across the paper to represent the horizon. Bend the tape as shown to provide an uneven shaped far distant horizon on the right and a mid distant horizon for the land base of the middle distant tree group. Using the 11/2" hake brush wet the whole of the sky area with clean water and brush in the Payne's Gray/Cerulean Blue clouds with light downward strokes. Add a few darker clouds on the right of the painting. When the under-painting is approximately one third dry, brush in the impression of distant trees, using a stiffer, less wet mix of Payne's Gray/Cerulean Blue and dry.

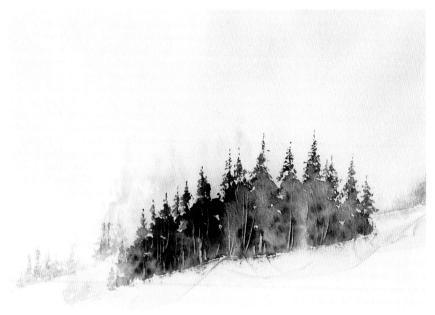

STAGE 2 MIDDLE DISTANT TREE GROUPING

With a 3/4" flat brush, paint in the tree shapes with fairly wet paint mixes, using combinations of Sap Green/Payne's Gray/Burnt Sienna to create variation. When approximately one third dry, shape the trees, using stiffer paint. The result will be combination of light and dark values displaying splashes of colour.

STAGE 3 CREATING SNOW ON

FOLIAGE

Add a little snow to the foliage by stippling some white acrylic or gouache paint with an old hog hair brush. You will find this technique effective but don't overdo it.

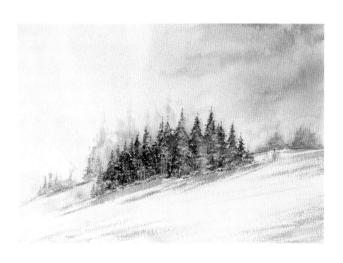

STAGE 4 FOREGROUND

Using the side of the size 14 round brush, dry brush a little pale value Payne's Gray/Cerulean Blue into the foreground to represent shadows over the snow. Leave lots of the paper uncovered - less means more. If you overdo it the effect will be lost.

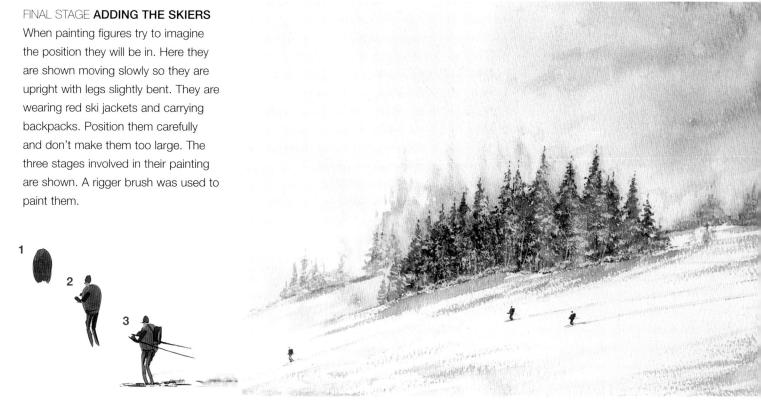

FRIARS CRAG - CLOSE UP

A short walk from Keswick in the English Lake District brings me to Friars Crag, one of the finest viewpoints in Britain. The view across Derwent Water was one of John Ruskin's favourites and his memorial still stands by the craq.

Friars Crag is so called because it is said the friars would wait there to embark on a pilgrimage to St Herbert who lived on the island in the lake, known as St Herbert's Island.

I have included this landscape as an exercise in painting rain clouds.

WHAT YOU WILL NEED

PAPER:

140lb Winsor & Newton Rough

BRUSHES:

Winsor & Newton Sceptre Gold II Series size 14 round, size 3 rigger, 3/4" flat, 11/2" hake

COLOURS:

Payne's Gray, Cobalt Blue, Alizarin Crimson, Raw Sienna, Burnt Sienna, Burnt Umber, Sap Green

SUPPORTIVE:

Masking fluid, dark brown and white water-soluble crayons, 1" masking tape, palette knife

MOUNTAINS

Position a piece of 1" masking tape across the paper; the top of the tape representing the water line. Mixes of Cobalt Blue/Alizarin Crimson were used along with the size 14 round brush to paint the distant mountains. Sap Green was added to the mix in order to paint the trees at the water's edge. This was achieved by employing a dabbing action with the point of the brush.

SKY

Rain clouds (nimbus clouds) are really very simple to represent. Having initially drawn the scene, using a dark brown water-soluble crayon, the sky area was washed with a pale Raw Sienna and a little Cobalt Blue washed in to provide variation. Whilst the under-painting was still very wet, a mix of Payne's Gray/Cobalt Blue was painted in a line roughly across the centre of the sky and a thicker mix of

Payne's Gray/Burnt Sienna painted in a line across the top of the sky.

It's simply a matter of lifting up the board almost vertical and allowing the paint to run down to represent rain clouds. When the paint has run sufficiently to achieve the desired effect, lie the board flat and let the paint dry naturally.

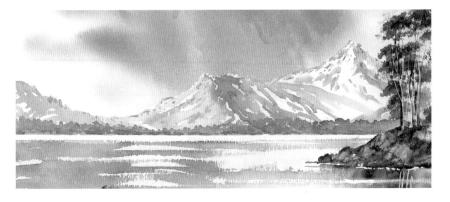

FRIARS CRAG AND **TREES**

Friars Crag was painted by applying a Raw Sienna wash, adding a little Burnt Sienna and finally painting in a Payne's Gray/Alizarin Crimson mix where the rocks were to be painted.

When approximately one third dry, a palette knife was used to move paint to create the rock structures.

Masking fluid was applied to represent light on the tree structures and reflections in the still water. Using the rigger brush darker tree structures were indicated, by using Burnt Umber paint.

With a hog hair brush, several tones of Sap Green, varying from light to dark were stippled to create foliage on the pine trees. A little Burnt Sienna was added to the mix to paint the bushes.

An impression of rough grass was painted on the crag. When dry the masking was removed from the tree trunks and Raw Sienna washes applied.

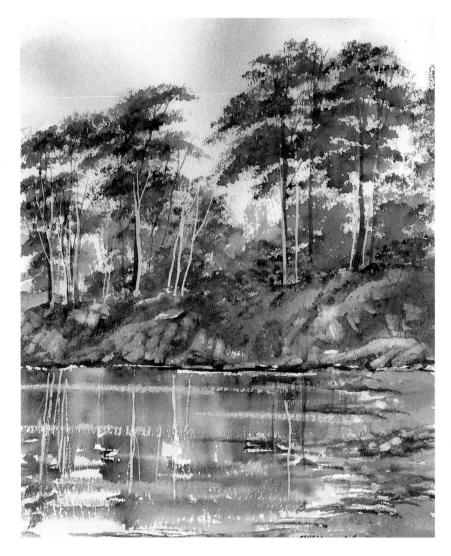

PROJECTING LAND AND FOREGROUND

Raw sienna washes over-painted with splashes of Burnt Sienna were used to paint the land areas. When approximately one third dry, the palette knife was used to move paint to create

the small rock groupings. The larger rocks were painted using the 3/4" flat brush and mixes of Raw Sienna/Burnt Umber and again knifed to create structure.

KEY POINTS

- 1 When painting rain clouds it is essential to paint a fairly stiff paint over a very wet underpainting or the colour will dilute to such an extent the result will be insipid.
- 2 The mountains must be painted in light values to achieve recession.
- 3 Leave lots of white paper uncovered when painting the water to represent light radiating from the sky.
- 4 Paint the rocks irregular shapes and sizes, positioning them unevenly
- 5 When painting reflections, use several colours, drawing the paint downwards using vertical strokes.

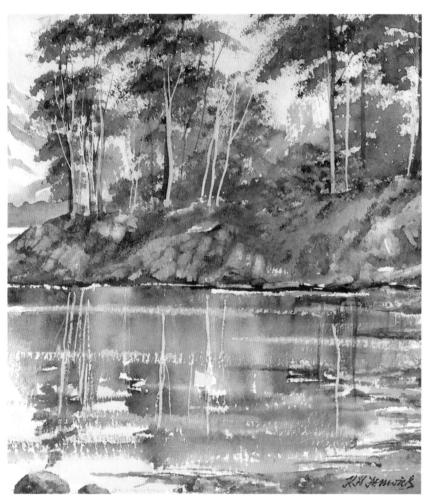

REFLECTIONS

Whilst the water is still wet drag Raw Sienna, Burnt Sienna and Sap Green down using the 3/4" flat brush. Use vertical strokes and at the end of the stroke stipple with the corner of the brush to obtain a ragged edge to represent the tops of the trees. Again, whilst the paint is still wet, either use a tissue pressed to a wedge to remove

paint creating wind lines or should the paint have dried, draw horizontal lines With a white water-soluble crayon for the same effect. Remove the masking to represent the reflections cast by the tree structures.

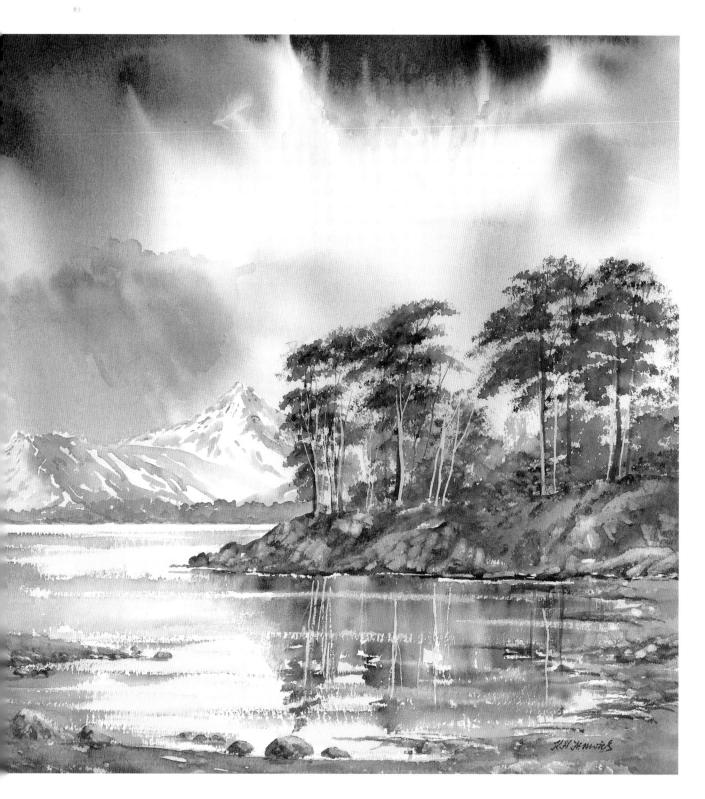

WATER

The lake is calm. To paint the water, brush the side of the size 14 round brush across the paper, working inwards from both sides, leaving areas of the white paper uncovered. A Payne's Gray/Cobalt Blue mix was used and whilst still wet, the tree

reflections were added. Observe how darker tones were painted between the land projection and the foreground on the left of the painting. Finally, paint a weak Raw Sienna over the white of the paper to add sparkle.

MOUNTAIN VIEW - CLOSE UP

This scene was one of two forty minute sketches, demonstrated to an art society. It is an imaginary landscape made up from a number of elements filed away in my memory and recalled like a jigsaw to create this composition.

As always, the tonal study is the staring point and the plan for the sketch. To emphasise the snow capped peaks a dramatic sky was required.

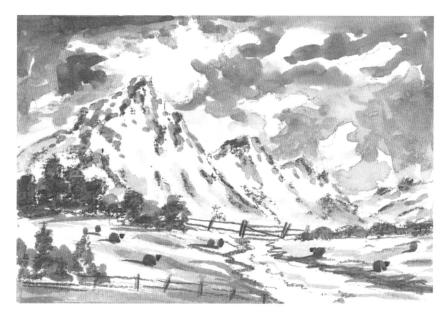

WHAT YOU WILL NEED

PAPER:

300lb Winsor & Newton rough

BRUSHES:

Winsor & Newton Sceptre Gold II Series size 14 round, size 6 round, size 3 rigger, $\frac{3}{4}$ " flat, $\frac{1}{2}$ " hake

COLOURS:

Payne's Gray, Cerulean Blue, Alizarin Crimson, Raw Sienna, Burnt Sienna, Sap Green

SUPPORTIVE:

White acrylic or gouache paint, palette knife, tissues

SKY

For speed and resulting freshness the 1¹/₂" hake brush is ideal, having the facility to hold large washes and the apply them quickly. By dabbing, brushing and twisting the brush in different directions, atmospheric skies like this one, can be simply and speedily painted.

The hake was used to apply a pale Raw Sienna wash, followed by stiffer mixes of Payne's Gray, Cerulean Blue and Alizarin Crimson. Areas of Raw Sienna were left untouched and finally an absorbent tissue was used to remove paint to create the cloud structures. The paper was almost vertical, encouraging the paint to run, creating interesting sky features. The sky was dried using a hair dryer. The sky was painted in less than four minutes using the minimum of brush strokes.

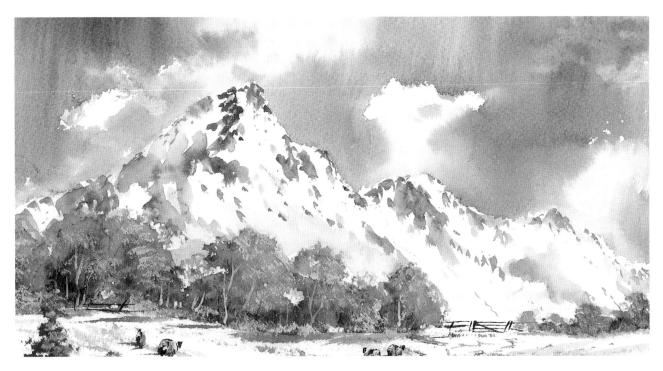

MOUNTAINS

The sky was painted working around the profile of the mountains. An occasional dab with a tissue, ensured the paint didn't run in to the mountain areas. The size 14 round brush was used to shape the mountains by working downwards from the peaks,

applying paint with the point of the brush and then spreading it with quick flicks, using the side of the brush. A few quick dabs to deposit paint, followed by a few flicks to spread it and a few small dots of paint here and there and the mountains are

completed. Finally a little pale Raw Sienna was brushed upwards from the base of the mountains. A Payne's Gray/Cerulean Blue mix was used to paint the promontories projecting through the snow.

The distant trees were painted using downward strokes with the side of the size 14 round brush. Mixes of Payne's Gray/Cerulean Blue/Burnt Sienna were used. A palette knife was used to scratch in some tree structures. A 3/4" flat brush was used to paint the foreground trees using the above mix with some Sap Green being added.

KEY POINTS

- 1 Paint the sky wet in wet.
- 2 Dab brush and twist the hake brush to create the atmospheric sky.
- 3 Use absorbent tissues to remove paint.
- 4 Use a palette knife to scratch out tree structures.
- 5 Don't make the fences square.
- 6 Transfer the sky colours to the foreground to maintain colour harmony.
- 7 Add some sheep to add life and improve the composition.

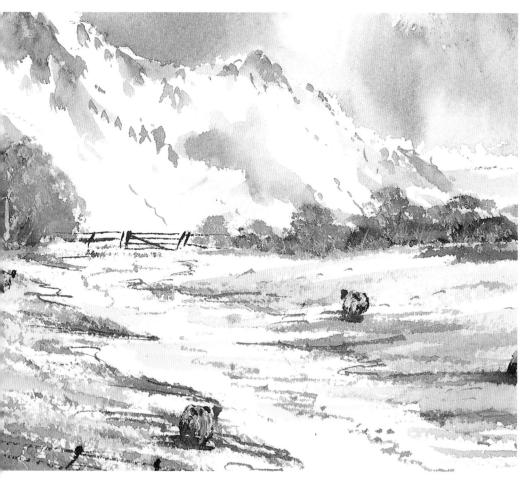

FOREGROUND

The edge of the hake brush was used to shape the path and add texture to the foreground. A Payne's Gray/Alizarin Crimson mix was used, followed by a hint of Raw Sienna to add warmth to the snow.

FENCE AND SHEEP

Fences are simply painted using the rigger brush. It is important that the spacing between posts is approximately twice the height of the fence. Square fences are not real. Keep them a simple two or three bar and don't make the fence posts

angles, you will find they look better. To paint sheep simply paint horseshoes - extend the horseshoe to the left or right to make their body larger and add a triangle for the head. Follow the stages shown.

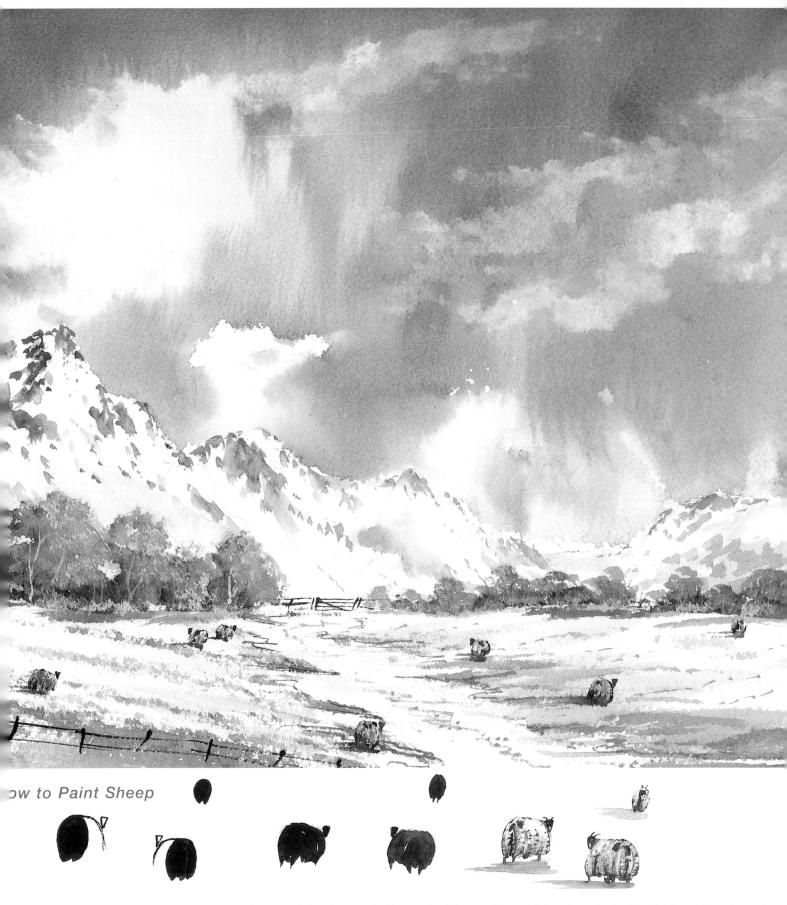

Stage 1 Paint horseshoes to represent the body of the sheep, larger horseshoes in the foreground and smaller ones in the distance, using Payne's Gray/Burnt Umber mix.

Stage 2 If the sheep is looking to the right add another horseshoe to the right and a triangle for the head; if looking to the left add a horseshoe to the left and a triangle for the head.

Stage 3 When the paint is dry, add the white paint and give it a mark. Legs are optional depending on the conditions - if the sheep is standing in snow or long grass the legs will obviously not be visible. Paint shadows beneath the animal and add horns if needed.

WINTER AT COCKLEY BECK

- CLOSE UP

The river Duddon rises in the area of Wrynose Pass in the English Lake District and flows westwards to Cockley Beck. It is one of my favourite painting spots. It flows through one of the prettiest dales in Cumbria and Birk's Bridge is much painted and photographed. Long before the days of motorised transport, these packhorse bridges were used as meeting places to re-distribute loads to be transported by pack horse to the different dales or valleys in the region.

Crossing over the bridge, to the right, is the beginning of the high ascent known as Hard Knott Pass. In winter it can appear cold and foreboding.

As always, the tonal study or value pattern becomes the plan for the painting.

WHAT YOU WILL NEED

PAPER:

Winsor & Newton 300lb rough

BRUSHES:

Winsor & Newton Sceptre Gold II Series size 14 round, size 6 round, size 3 rigger, 11/2" hake

COLOURS:

Payne's Gray, Cobalt Blue, Cerulean Blue, Raw Sienna, Burnt Umber

SUPPORTIVE:

White water-soluble crayon, tissues

TREES

The tree structures were painted with the rigger brush using Burnt Umber. Press the brush against the paper at the base of the tree, gradually releasing the pressure as the brush is worked upwards to the thin tips of the branches. Using the side of the size 14 round brush, held almost flat against the paper, the impression of foliage was painted by making half inch twitches down the paper from top to bottom.

Finally a little white acrylic paint was stippled, for the snow.

SKY

This wet in wet sky is very simple. I used cobalt and Cerulean Blue over an under-painting of Raw Sienna. Tissues were used to create a few white clouds and to control the flow of paint by softening edges and soaking up wet areas.

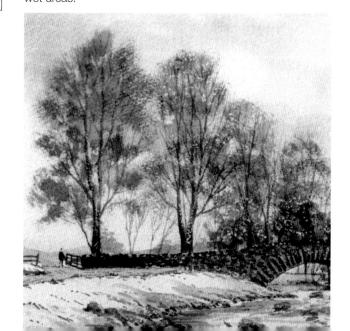

BRIDGE

Take care to ensure the bridge is correctly drawn. The arch must not be too steep and remember to show some of the inside of the arch in shadow. Never paint a bridge that is viewed face on.

An initial Raw Sienna wash was painted and when dry a sized 6 round loaded with various tones of Burnt Umber was used to indicate stonework.

LEFT BANK

Snow is rarely pure white. I have transferred cloud colours reflecting from the sky on to the bank and also a few strokes of Raw Sienna to link the snow with the rocks. The rocks were painted in dark values of Burnt Sienna/Burnt Umber and when dry I added white highlights using a white water-soluble crayon. I have blended the white into the rocks using a size 6 round brush dipped in clean water.

This is a further technique for painting rocks. I could have used any colour rather than clean water to tint the rocks to represent their regional colour

KEY POINTS

- 1 Paint a simple wet in wet sky.
- 2 Take care in drawing the bridge accurately note the arch is not in the centre of the bridge. Don't make the arch too high and show some of the underneath of the arch.
- 3 Shape the riverbank it must not look like a road with parallel edges.
- 4 Vary the size and shape of the rocks, not forgetting to place them randomly.
- 5 Add the figure and sheep to indicate life in the landscape.

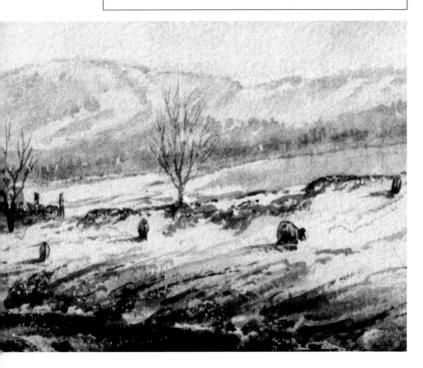

DISTANT MOUNTAINS AND SHEEP

The distant snow covered mountains were painted using the side of the size 14 brush and a Cerulean Blue/Cobalt Blue mix. Take care to leave the white paper uncovered to represent snow. At the base of the mountain a pale Burnt Umber was painted representing the distant woodland.

Characteristic of the region a few sheep were added.

RIVER

The size 14 round brush was used to paint the fast flowing water. The brush strokes are easily seen in the photograph. Colours used, were a Cerulean Blue/Cobalt Blue mix with a little Payne's Gray added for reflections at the edge of the riverbanks.

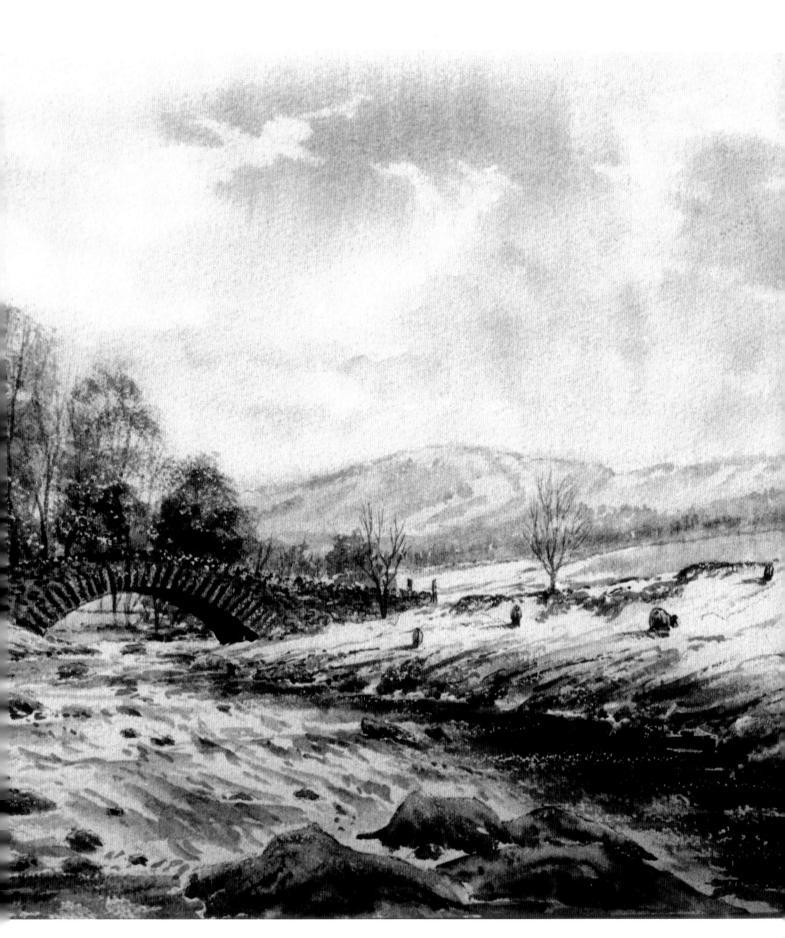

HEADING FOR A FALL - CLOSE UP

I have included this landscape as a simple exercise for you to complete. The secret here is the establishment of correct value patterns. The background must appear cold and misty, with the large trees in contrast.

I don't normally like to paint trees on both sides of a painting but in this case I think it works. I produced several value patterns but prefer this one. I'm sure you will enjoy painting this landscape.

OUTLINE DRAWING

Very little drawing was done. The horizon was established as was the foreground and the distant tree position indicated by simply placing a dot with the dark brown water-soluble crayon. A rough outline of the larger trees was drawn.

DISTANT TREES

When the paint was dry, masking tape was carefully removed. The distant trees were painted using the corner of a 3/4" flat brush loaded with a weak Payne's Gray.

MIDDLE DISTANT TREES

To create the effect of uneven, drifted snow at the base of the trees, a piece of 1" masking tape was positioned across the paper. A mix of Payne's Gray/Cerulean Blue was used. The smaller trees in the centre were painted in a middle value. When dry the two specimen trees were painted using darker values with a Payne's Gray/Cerulean Blue/Sap Green mix. The 3/4" flat brush was used to paint the trees. When the paint was dry the masking tape and the masking fluid were removed resulting in the effect of snow-laden trees.

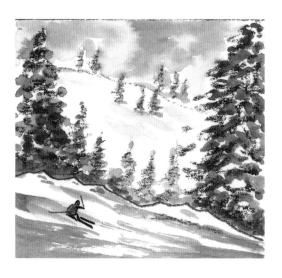

MASKING

A piece of tissue was crumpled to almost a point for control and then dipped into masking fluid. The larger trees were masked to create the effects of heavy snow on the foliage. To achieve this effect, I stippled with the tissue and flicked the tissue downwards at the end of each stipple to create a ragged look.

SKY

A piece of 1" masking was positioned across the horizon line and using the 11/2" hake brush loaded with a weak Payne's Gray/Alizarin Crimson mix, the sky was painted. I applied a few quick downward strokes of the hake to create the misty background.

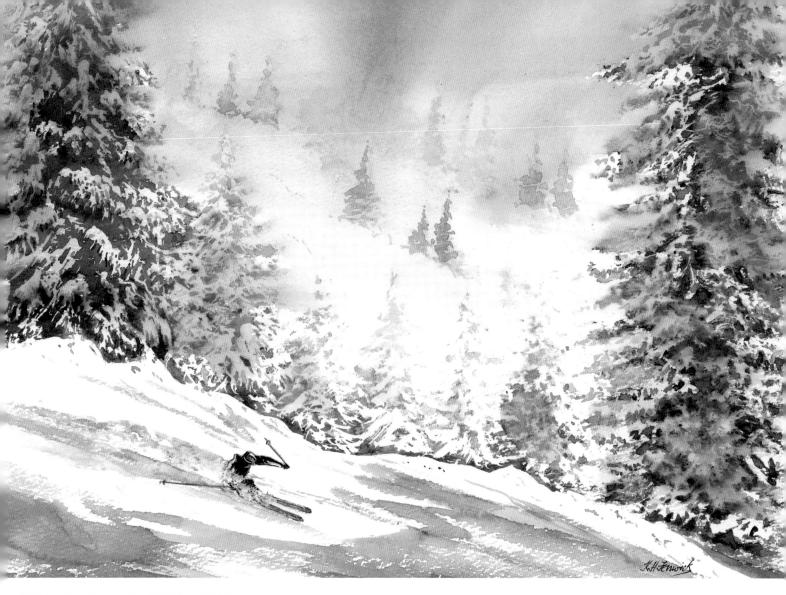

WHAT YOU WILL NEED

PAPER:

Winsor & Newton 140lb rough

BRUSHES:

Winsor & Newton Sceptre Gold II Series size 14 round, 3/4" flat, size 3 rigger, 11/2" hake

COLOURS:

Payne's Gray, Cerulean Blue, Alizarin Crimson, Sap Green

SUPPORTIVE:

Masking fluid 1" masking tape, dark brown watersoluble crayon, tissue

FOREGROUND AND SKIER

The side of a size 14 round brush was used to create some shadows on the foreground snow using Payne's Gray. Finally, the skier was painted with the rigger brush. Don't spoil your painting at this stage. First, practise painting the figure on an off cut of watercolour paper as the size and shape of the skier is important.

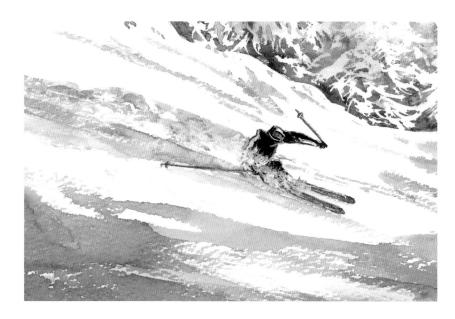

SNOWFALL - CLOSE UP

"Snowfall" has been painted to provide practice in painting snowflakes falling over a snowcapped mountain range backed by a colourful atmospheric sky. Snow paintings don't have to be without colour!

WHAT YOU WILL NEED

PAPER:

Bockingford 200lb extra rough

BRUSHES:

Winsor & Newton Sceptre Gold II series size 14 round, size 3 rigger, 3/4" flat, 1¹/2" hake

COLOURS:

Payne's Gray, Cobalt Blue, Alizarin Crimson, Raw Sienna

SUPPORTIVE:

masking fluid, old toothbrush, white acrylic paint

SKY AND SNOWFALL

My aim in this sketch was to paint a colourful atmospheric sky to provide a backdrop for the falling snowflakes.

Using the hake brush a Raw Sienna was initially applied and whilst still wet, mixes of Payne's Gray/Cobalt Blue and Alizarin Crimson were quickly brushed in a downward direction, leaving gaps for the Raw Sienna under-painting to shine through.

A useful tip is to apply a thin line of masking fluid around the profile of the mountains prior to painting the sky. This prevents the sky colours running down over the area that needs to be preserved white. The snowflakes were painted last, after the rest of the

painting was finished.

In this sketch, I have dipped an old toothbrush in to a thin coat of watery white acrylic paint and running my thumb over the bristles of the brush directed the spatter as and where required. First practise on an unwanted piece of paper until the spatter is the correct size. If you don't have a trial run your efforts may ruin your sketch as the spattered deposits may be too large.

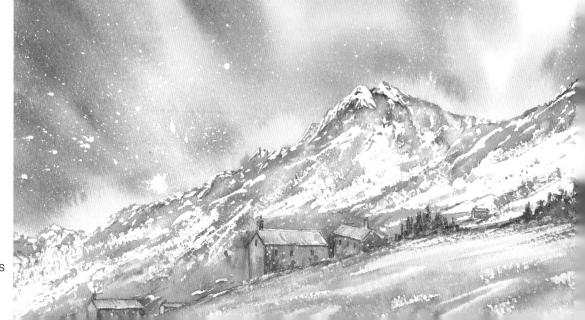

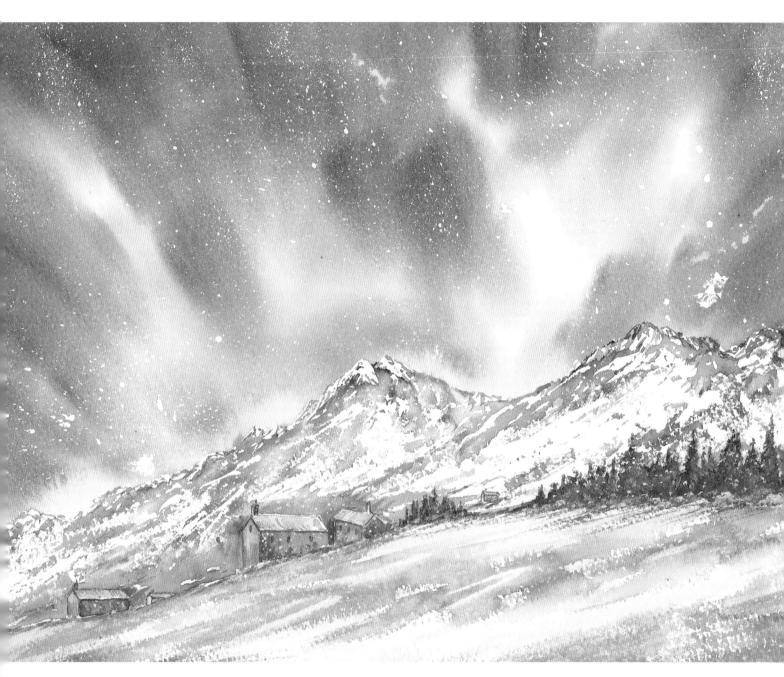

MOUNTAINS

The masking was removed from the mountain profile and using mixes of Payne's Gray/Cobalt Blue/Alizarin Crimson the mountain shadows and promontorics were painted. Lighter tones were added using the side of the size 14 round brush with the detail being painted in darker tones using the rigger brush. It's important to leave lots of the white paper uncovered so don't overdo the colour.

BUILDING AND FOREGROUND

The buildings and middle distant trees were painted using a 3/4" flat brush. The rigger was used to paint the details of the buildings.

The sky colours were utilised to paint shadows over the foreground using quick strokes with the side of the size 14 round brush. Attempt to create an open texture or dry brush effect. This is a simple exercise for you to try.

WINTER SCENE - CLOSE UP

This winter scene is made up like a jigsaw from my imagination, drawing from images stored in my mind, encountered on painting trips in the past. It embraces good design principles. The eye is led into the painting via the mountain beck. The dark water balances the left hand peak. Linear perspective has been adopted when drawing the beck, which vanishes into the distance. The sky has been kept simple (golden rule) so as not to detract from the mountain peaks. The beck has been painted in dark tones to contrast with the snow. The foreground trees help to balance the mountain peaks and the large rock on the left balances the tree trunks. Note the variation and gradation in the snow. The middle distant tree grouping counter-changes with the snow covered land. Use your imagination to produce a similar composition; it's all part of being an artist - you can do it. The tonal study shown was the basis for this painting.

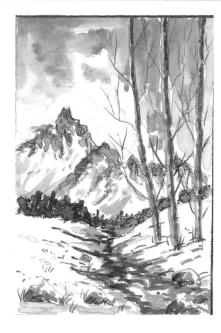

WHAT YOU WILL NEED

PAPER:

300lb Saunders Waterford rough

BRUSHES:

Winsor & Newton Sceptre Gold II series size 14 round, ³/₄" flat, size 3 rigger, $1^{1/2}$ " hake

COLOURS:

Payne's Gray, Ultramarine blue, Alizarin Crimson, Raw Sienna, Burnt Sienna, Burnt Umber, Sap Green

SUPPORTIVE:

Masking fluid, palette knife, tissues

SKY

Very simply painted with the hake brush by applying an Ultramarine blue wash and removing paint with a tissue whilst wet to create the white fluffy clouds.

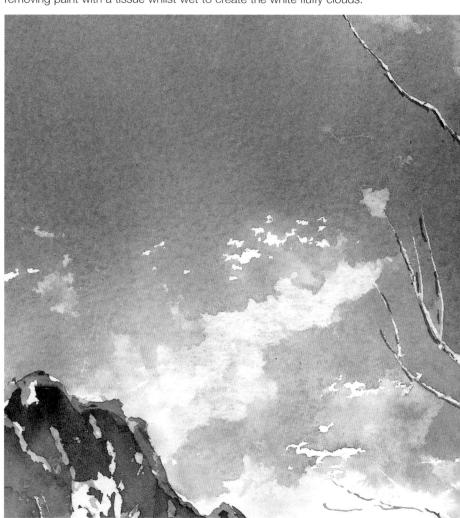

MOUNTAINS

Build these up gradually using both the point and the side of the size 14 round brush. The colours I used were mixes of Payne's Gray/Alizarin Crimson/Ultramarine blue for the main shapes with a little Raw Sienna and purple (Payne's Gray/Alizarin Crimson) brushed upwards with the side of the brush. Stand back occasionally and look at your effort to ensure that it is not over-worked. Leave the white of the paper to represent the snow.

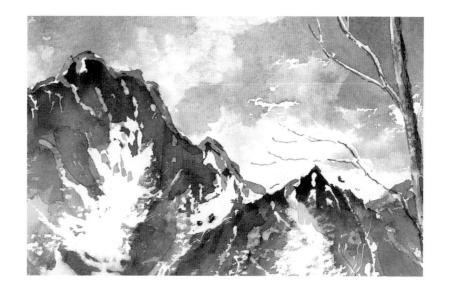

MIDDLE DISTANCE **TREES**

Painted with the 3/4" flat brush using mixes of Payne's Gray/Alizarin Crimson, Raw Sienna, Burnt Sienna and Sap Green. The full face and corner of the brush was used to deposit paint and the edge of the brush to paint the tree tops. The tree structures were scratched in with a palette knife.

ROCKS

The rocks were painted by applying a Raw Sienna under-painting to shape the rocks, followed by Burnt Sienna and Payne's Gray/Alizarin Crimson mixes into selected areas. A palette knife was used to create the rock formation. The result when using the knife is so realistic it's worth practising. A single- sided razor blade can also be used for this technique. See page 79 for technique.

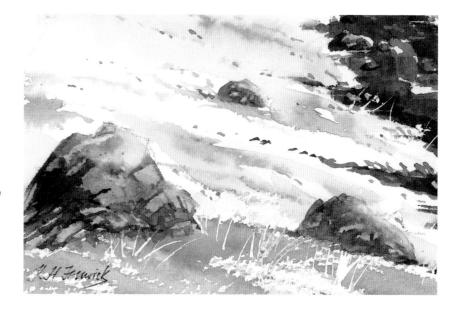

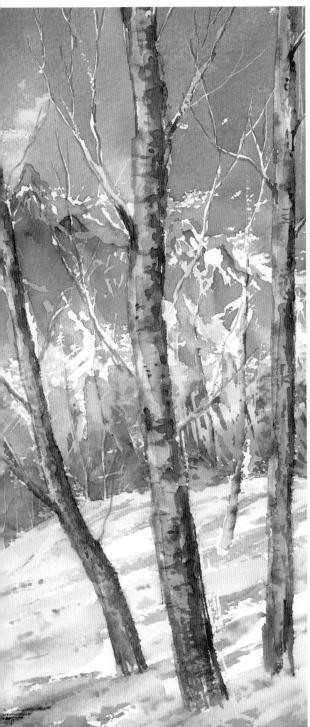

STUBBLE

To create the effect of frost-coated stubble, masking fluid was applied with a rigger brush and after overpainting, the masking was removed.

TREE STRUCTURES

These were masked at the drawing stage and over-painted. The masking was removed and paint applied using the 3/4" flat brush in the following manner; initially a Raw Sienna wash was applied and whilst still wet patches of Burnt Sienna were introduced to selected areas. Whilst still moist, darker tones of a Payne's Gray/Burnt Sienna mix were applied with a rigger brush to create the texture of bark.

KEY POINTS

- 1 Keep the sky simple yet colourful.
- 2 Don't overdo the mountain and take your time.
- 3 Shape the rocks, vary their size, shape and spacing - make them look real.
- 4 Add a little colour to the snow.
- 5 Indicate some stubble visible here and there for realism.

FOREGROUND

Snow isn't absolutely white; add some colour to represent reflecting objects. Using the side of the round brush a range of already mixed colours was brushed in.

MOUNTAIN BECK

Very quickly painted, using the 3/4" flat brush working from the distance to the foreground using horizontal strokes. A dark value Payne's Gray/Sap Green mix was used. Finally the rigger brush loaded with white acrylic paint was used to add a few ripples on the water.

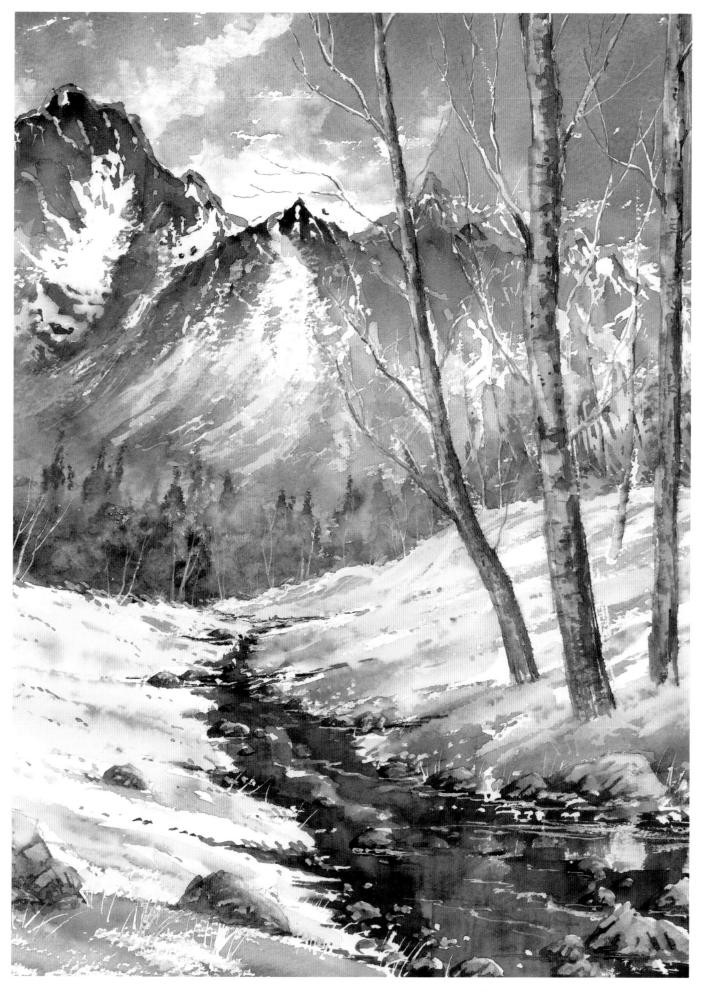

SNOW AT WATENDLATH - CLOSE UP

Watendlath is a small hamlet near Keswick in the English Lake District that epitomises the character of the area. Sir Hugh Walpole wrote several books, The Herries Chronicles, basing the lead character Rogue Herries and his woman, Judith Paris there. The hamlet is an artists' haven, with old barns, several farmsteads/cottages, a packhorse bridge and a tarn that runs out into a beck that flows through the valley and eventually into Derwent Water. It is a beautiful, peaceful place with a myriad of painting opportunities and must leave a lasting impression on all those who visit this unique hamlet.

DRAWING

The drawing was completed using a dark brown water-soluble crayon. Note the linear perspective of the left hand barn and the shape of the beck that leads the eye into the painting under the famous packhorse bridge.

SKY

A wet in wet sky was painted using Raw Sienna, Cobalt Blue, Payne's Gray and Alizarin Crimson.

Tissues were used to remove paint creating the effect of white clouds and also to soften the edges.

DISTANT HILLS

Using sweeps with the side of the size 14 round brush the distant hills were painted, leaving areas of white paper uncovered to represent snow.

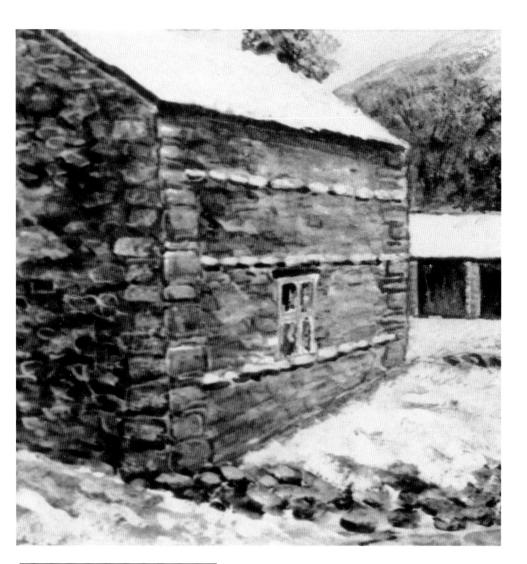

BARN

Washes of Raw Sienna, Burnt Sienna and a mix of Payne's Gray/Alizarin Crimson were applied and when one third dry the effect of stonework was knifed in with a palette knife. To add definition to the stonework when the under-painting was dry, a rigger brush was used loaded with a Payne's Gray/Alizarin Crimson mix to paint around selected stones to represent shadows giving the rough stones a realistic look. The window was painted using a Payne's Gray/Alizarin Crimson mix and immediately dabbed with a tissue shaped to a point to represent reflections on the glass. The roof was the white of the paper left uncovered with shadow painted under the eaves.

To represent snow lying on the three rows of protruding stones and to paint the window frame I used a rigger brush loaded with white acrylic paint.

YOU WILL NEED

PAPER:

Bockingford 200lb extra rough

BRUSHES:

Winsor & Newton Sceptre Gold II Series size 14 round, size 3 rigger, 3/4" flat, 1¹/₂" hake, ³/₄" round bristle

COLOURS:

Payne's Gray, Cobalt Blue, Alizarin Crimson, Raw Sienna, Burnt Sienna, Sap Green

SUPPORTIVE:

Palette knife, white acrylic paint

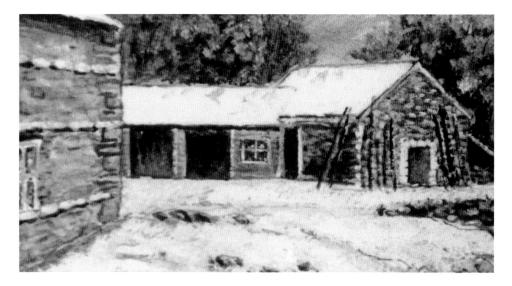

WOODSTORE / OUTBUILDINGS

The same technique and colours described above were used. The trees behind the building were painted by stippling with a round hog hair brush. Snow was added to the foliage using a little white acrylic.

PACKHORSE BRIDGE

Identical techniques used to paint the buildings were used for the bridge. The palette knife is an ideal tool to move paint and create the effect of stonework.

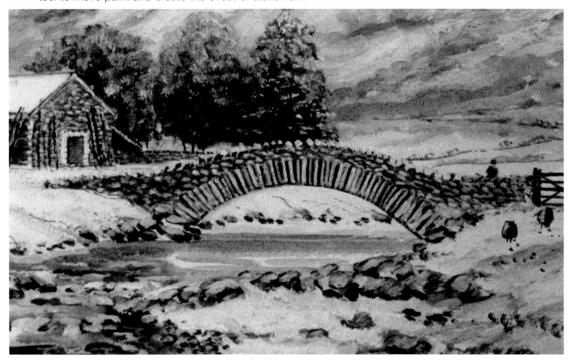

WATER AND ROCKS

The rocks were painted using the 3/4" flat brush, its shape being ideal to paint large and small rocks. Raw Sienna, Burnt Sienna and Payne's Gray were the colours chosen for the rocks and whilst still wet a tissue shaped to a point was wiped across the top of each rock to restore the white of the paper to represent snow.

The water can be painted quickly using the techniques shown on page 71 using the minimum of brush strokes with the hake.

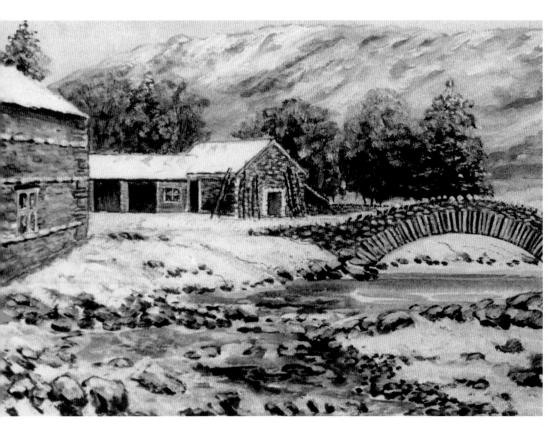

KEY POINTS

- 1 Leave the white of the paper uncovered to represent snow.
- 2 Snow is never perfectly white paint in some sky colour to represent shadow.
- 3 Vary the colours and shapes of the
- 4 Use the minimum brush strokes to paint the water to achieve a fresh look - don't overwork it.
- 5 Make the rocks different sizes and shapes - don't space them evenly.

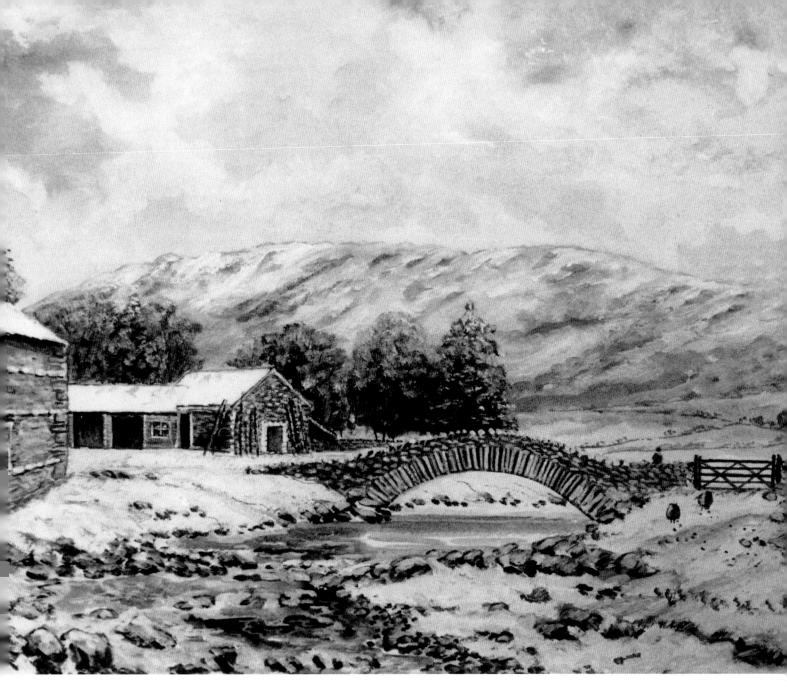

FOREGROUND BANK AND PATH

The white of the paper represents the snow. Shadows in the snow reflected from the sky were painted using the side of the size 14 round brush - just a hint of the sky colours here and there.

The path was painted by applying the usual washes and knifing in the flat stones. Io add interest the figure on the bridge and a few sheep were included.

ADDING DETAIL

My approach is to look at a painting critically over a few days and to make any necessary changes that may be as simple as a splash of colour here and there to promote harmony or to add some darker shadows values in the water or highlights somewhere on the stonework.

WOODLAND WALK - PROJECT

This is an area of Thurstaston Hill, only a few miles from my home. It is popular with walkers and picturesque at all times of the year.

STAGE 1 BACKGROUND

Masking fluid was applied to the tree structures. Using the hake brush, a soft Cobalt Blue wash for the sky was followed by washes of Raw Sienna, Burnt Sienna, Sap Green and Cobalt Blue for the background foliage.

STAGE 2 FOLIAGE

Using the same colours but stiffer paint, more detailed impressions of foliage were stippled using an old hog hair brush.

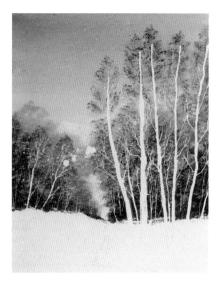

STAGE 3 REMOVING MASKING

A putty eraser is ideal for removing masking fluid. It seems to bond with the masking and it is also gentle on the paper.

STAGE 4 ADDING DETAIL

The texture on the trunks was painted by applying a Raw Sienna wash and when approximately one third dry, brushing in Burnt Sienna, followed by Payne's Gray for the shadows.

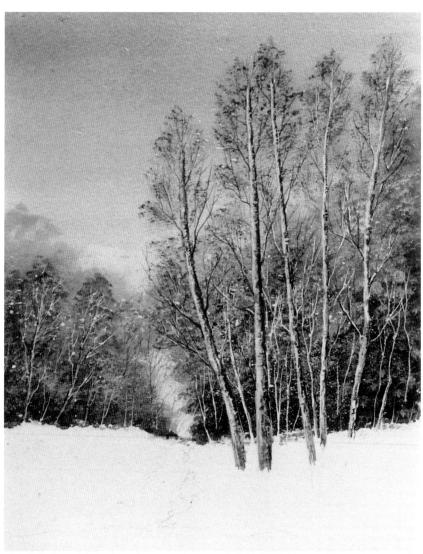

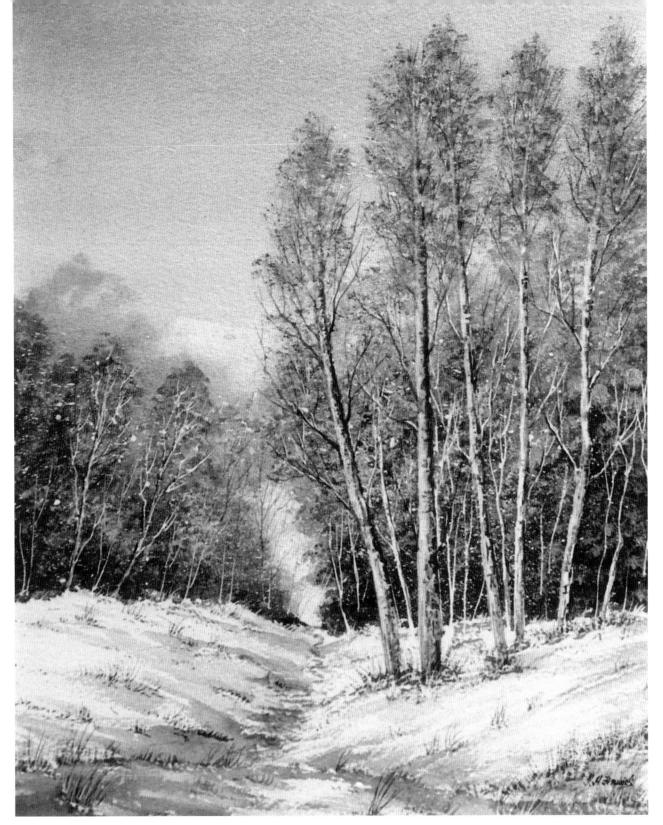

WHAT YOU WILL NEED

PAPER:

300lb Winsor & Newton rough

BRUSHES:

Winsor & Newton Sceptre Gold II Series size 3 rigger, size 14 round, $1^{1}/_{2}$ " hake, hog hair brush

COLOURS:

Cobalt Blue, Raw Sienna, Burnt Sienna, Sap Green

SUPPORTIVE:

Masking fluid

FINAL STAGE FOREGROUND

Using the side of the size 14 round brush a Cobalt Blue/Alizarin Crimson mix was applied working outwards from the path to represent shadows over the snow. Similarly, splashes of Raw Sienna were applied to harmonise the painting. Tufts of grass were painted with the rigger brush.

WILDERNESS - PROJECT

Painting a challenging foreground is possibly the most difficult task for the less experienced artist. The result is usually a few simple washes, displaying little texture and contributing almost nothing to the success of the painting. "Wilderness" is a landscape created entirely from my imagination, collated from a range of features encountered on my travels. It is a good example, allowing me to demonstrate my approach to painting a challenging foreground.

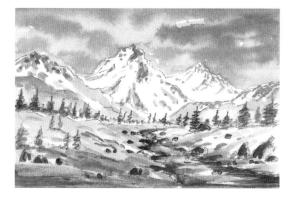

STAGE 1 DRAWING, MASKING, SKY

The basic outline was drawn using a dark brown watersoluble crayon. Masking fluid was applied to the foreground rocks and those in the mountain stream.

Although there is plenty of detail in the foreground, I wanted to paint a warm sky, enabling me to transfer these sky colours into the foreground.

The sky was painted using the now well-established techniques. Washes of Raw Sienna were applied in the centre, surrounded by washes of Cobalt Blue; the two colours blending together and a mixture of Cobalt Blue/Alizarin Crimson used for the cloud formations.

WHAT YOU WILL NEED

PAPER:

Saunders Waterford 300lb rough

BRUSHES:

Winsor & Newton Sceptre Gold II Series size 14 round, size 6 round, $\frac{3}{4}$ " flat, $\frac{11}{2}$ " hake, $\frac{1}{2}$ " round oil painter's brush

COLOURS:

Payne's Gray, Cobalt Blue, Alizarin Crimson, Raw Sienna, Burnt Sienna, Sap Green

SUPPORTIVE:

Masking fluid, dark brown water-soluble crayon

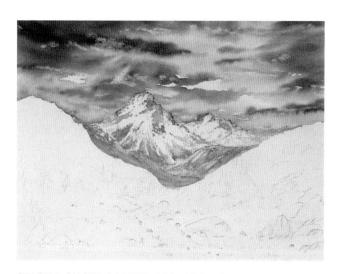

STAGE 2 SNOW-CAPPED MOUNTAINS

These need to be sensitively painted. Using the size 14 round brush loaded with a Cobalt Blue/Alizarin Crimson mix, I painted the main shadows/promontories, taking care to leave lots of white paper uncovered. When approximately one third dry, details were added using the rigger brush. It is important to pause and stand back after each succession of deposits to determine where further deposits need to be made.

STAGE 3 RIGHT MIDDLE DISTANCE

Following the structure of the mountain sweeping stokes with the hake brush were made.

Begin with a Raw Sienna wash followed by Sap Green to selected areas. Using the 3/4" flat brush, a Payne's Gray/Alizarin Crimson mix was applied to the areas where the rocks were located. When this area was approximately one third dry, I used the palette knife to move paint to create the rock formation.

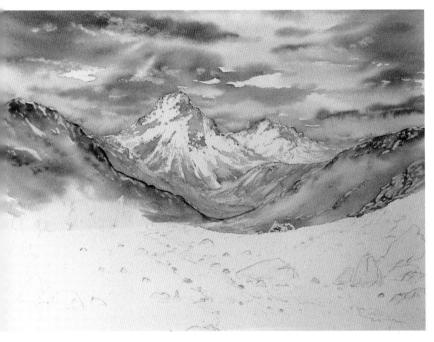

STAGE 4 LEFT MIDDLE DISTANCE

Following the process described above I completed the left hand mountain. Note that this was painted taller and a different shape to the mountain on the right.

It is important, when painting an actual mountain range, to select a viewpoint where the mountains display differing profiles and heights; it helps to create more interest in the painting.

STAGE 5 FOREGROUND WASHES AND TREES

Apply several pale washes for the underpainting of the foreground. On the left foreground, Raw Sienna was covered by Sap Green and allowed to dry. The right foreground was Raw Sienna covered with a Payne's Gray/Burnt Sienna mix and allowed to dry.

The distant trees were painted small and n paler tones to those on the right bank to create a sense of distance, so import in this painting.

The trees and their shadows were painted using a 3/4" flat brush loaded with mixes of Sap Green and Cobalt Blue. Note that the masking on the rocks has repelled the paint.

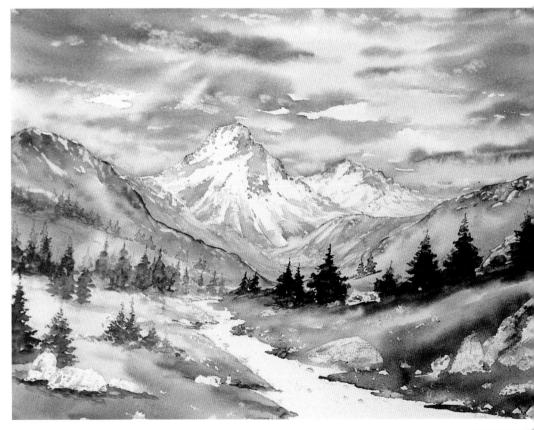

STAGE 6 APPLYING DARKER **VALUES**

Using the side of the size 14 round brush, darker tones of Payne's Gray/Alizarin Crimson were used to create depth in the foreground. Note that light areas were left uncovered between brush strokes.

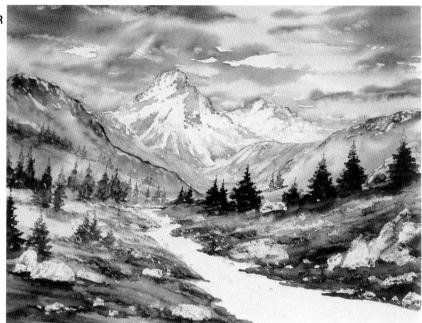

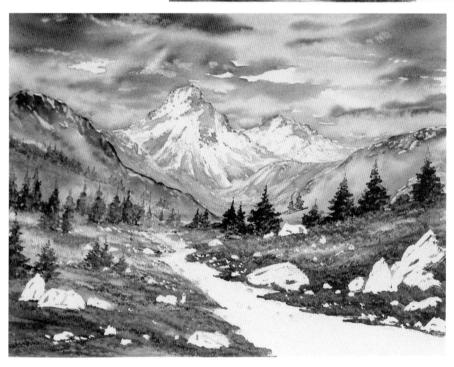

STAGE 7 CREATING TEXTURE

The aim here is to create the effect of heather and low growing vegetation to represent rough moorland. The most effective technique to achieve this is to stipple paint with an oil painter's brush. To simulate heather, I have used an Alizarin Crimson/Cobalt Blue mix, following on whilst still wet with a little white acrylic paint added to the mixture to produce highlights. The same approach was used to paint rough vegetation using Raw Sienna/Sap Green mixes with a little white acrylic paint added.

When completely dry, the masking was removed from all the rocks except those in the mountain stream.

KEY POINTS

- 1 Paint a warm atmospheric sky using the techniques described in the text.
- 2 Take care when painting snow capped mountains - don't overdo it; remember, little is more.
- 3 Paint the trees in different sizes and values don't forget the need for recession.
- 4 Build up the foreground in stages follow the techniques described in the text.
- 5 Paint the rocks using the wet into wet technique.

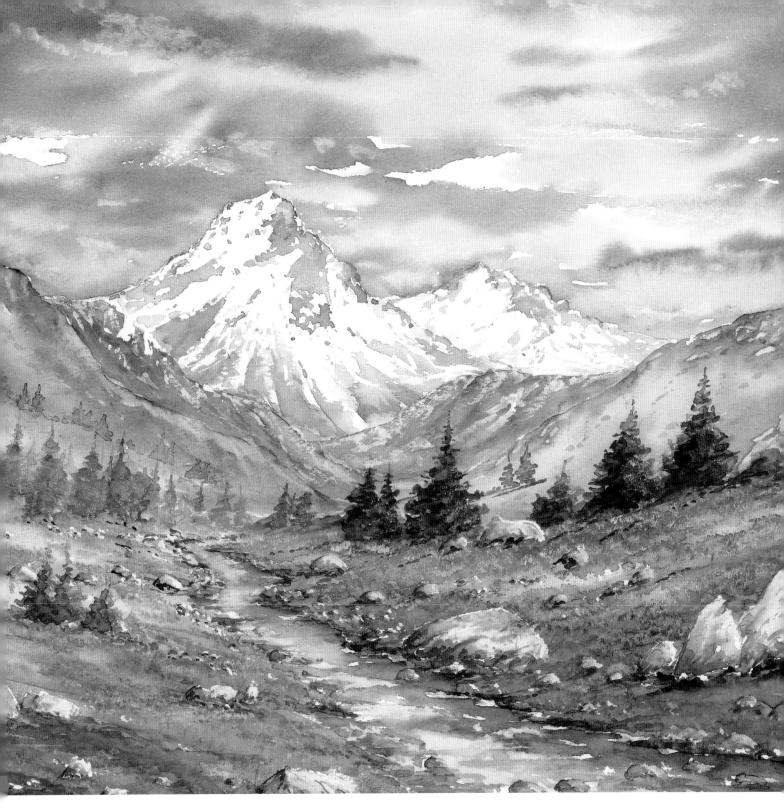

FINAL STAGE ROCKS, WATER, GLAZING

My intention here is to transfer some sky colour over the foreground. Using light touches with the side of a soft size 14 round brush, sky colours were glazed over the foreground. This harmonises the painting, producing a warm glow.

The water was painted using the hake brush; the shadows being indicated with a Payne's Gray/Alizarin Crimson mix. It is important to leave lots of paper uncovered. When dry a little Raw Sienna was painted into selected areas.

The masking was removed from the rocks in the mountain

stream and all of the rocks were painted a few at a time by applying an initial pale Raw Sienna wash and when approximatoly one third dry brushing in Burnt Sienna and a Payne's Gray/Burnt Sienna mix. The paint blends together wet into wet. Use a size 6 round brush to move the paint around to create the required effect. Use this approach to complete all the rocks. Finally, the profile of the left hand mountain was softened by washing out a little colour. This is a good example for practising painting foregrounds.

THE WAY FORWARD

If you have systematically worked through this book and practised all the techniques and exercises, you should by now be able to paint most elements in the landscape with confidence.

Don't attempt to copy the landscapes exactly, change colours, add additional features; make them your own. Remember that practice make perfect. Painting isn't a gift, it's more perspiration than inspiration. As your confidence grows, you will find that your failures become fewer and if something doesn't quite work out, you can remove paint (just wet the area and remove the paint with a tissue) then repaint that element to your satisfaction.

So what is the next stage? By joining one or more art societies you will have the opportunity to make friends with like-minded people. All art societies hold at least one exhibition annually. I know one such society that holds an exhibition every two months, so you will have the opportunity to exhibit your work and hopefully make a little money to cover the cost of your materials.

Most societies provide a list of visiting demonstrators, enabling you to observe other artists' working approaches and if you're fortunate you may be able to watch a professional artist at work.

When I first began painting, there were no teaching videos available, and few art and craft shows, so I was unable to see other artists at work. The colleges did not teach landscape painting skills, preferring to concentrate more on the history of art and life drawing. Today there are numerous videos available for purchase, enabling you to sit in the comfort of your home and watch an artist at work. I have made twenty such videos.

There are numerous major art and

craft exhibitions worldwide. A visit to these exhibitions will provide you with the opportunity to speak with professional artists; to see them demonstrate techniques and obtain practical advice from them. Eventually you will develop your own style of painting that can be recognised as your handwriting in paint.

As your confidence grows, you will be able to exhibit your paintings with other artists. When you see them exhibited and sell your first painting the pleasure experienced cannot be described. Eventually, if you are ambitious, you will want to hold your own one-man exhibition. You will find that most professional artists began by exhibiting in their local library or in the waiting room at the local doctor's surgery, or in the foyer of a theatre or sports centre; any venue at all where their work can be seen by the public. Your next problem will be acquiring display boards. Local authorities often have stocks of these that can be hired. as do local schools, colleges and art societies. Don't be afraid to approach them and ask if they can oblige. Your local library will have held exhibitions on the premises and should be able to advise you on sources for hire.

Programmes and publicity posters can be cheaply produced on the local photocopier in black and white or colour as required. If your progress results in your ability to produce a quality painting you may wish to approach a recognised art shop with gallery attached or even a major gallory in your aroa. They will want to see examples of your work and may insist that you exhibit with other artists to begin with. Don't forget to enquire about your contribution towards costs. Such galleries often produce quality catalogues and require a percentage

of the selling price of the painting as well as a contribution towards mail shots and advertising; so do clarify the extent of the charges and don't be caught out.

If you like the idea of selling your paintings on the Internet, there are

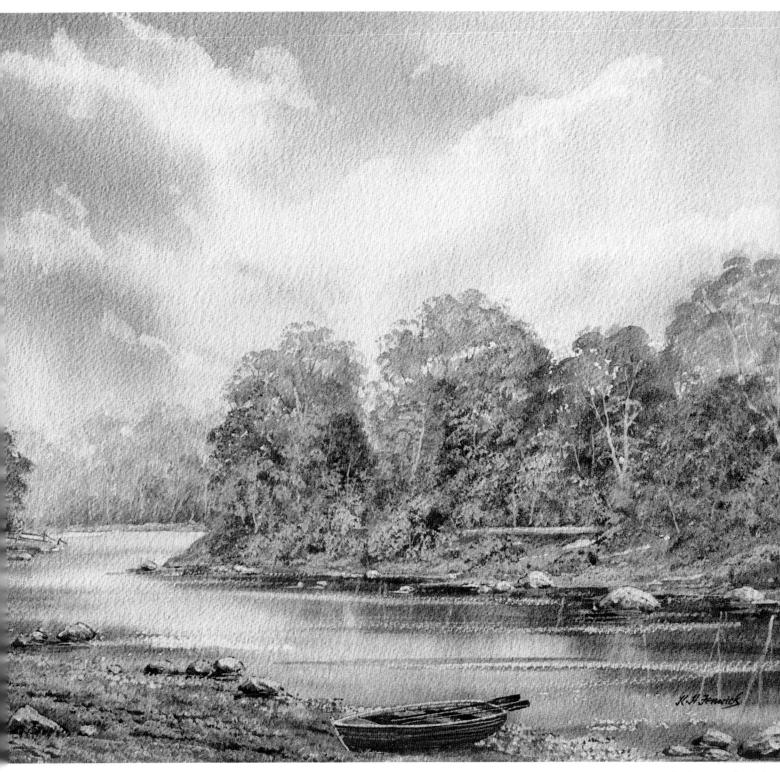

various websites with this facility.

Take the opportunity to visit every art exhibition/art show you can. Read as many art books as possible, you will learn something from all of them. Use your initiative and don't let opportunities pass you by.

Above all else - enjoy your painting. Good luck on your exciting journey!

Best wishes,

Keith Fenwick

ABOVE: Autumn Gold

PORTRAIT OF THE ARTIST

Keith Fenwick is one of the UK's leading teachers in painting techniques. He enjoys a tremendous following among leisure painters, who flock to his demonstrations and workshops at major fine art and craft shows.

Keith is a Chartered Engineer, a fellow of the Royal Society of Arts, an Advisory Panel member of the Society for All Artists and holds several professional qualifications including an honours degree. He served an engineering apprenticeship, becoming chief draughtsman before progressing to senior management.

Having spent many years in management in both industry and further education, he took early retirement from his position as Associate Principal/Director of Sites and Publicity at one of the UK's largest colleges of further education in order to devote more time to his great love, landscape painting.

Keith's paintings are in collections in the United Kingdom and other European countries, as well as in the United States, Canada, New Zealand, Australia, Japan and the Middle East.

Keith runs painting holidays in the UK and Europe, seminars and workshops nationwide, and demonstrates to up to fifty art societies each year. Keith can be seen demonstrating painting techniques at most major fine art and craft shows in the UK. He is a principal demonstrator for Winsor & Newton.

Keith's expertise in landscape painting, his writings, teaching, video-making and broadcasting ensure an understanding of student needs.

Keith has appeared on BBC, Cable TV and presented Granada TV's Art School.

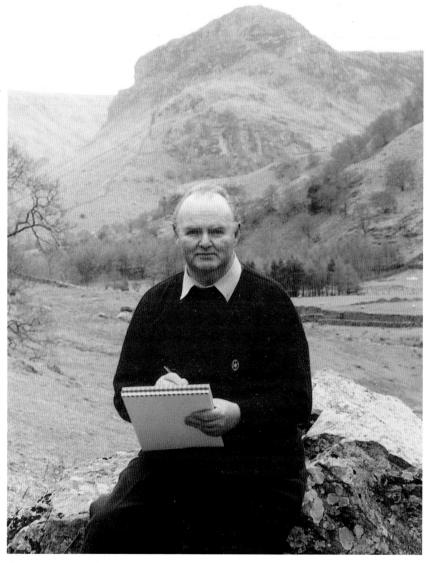

Sketching at Stonethwaite with Eagle Crag in the background.

Keith's books

Trees, Rocks and Running Water Skies, Mountains and Lakes Buildings, Bridges and Walls Atmosphere, Mood and Light have all proved very popular, as have his twenty best-selling art teaching videos, which have benefited students worldwide. He is a regular contributor to art and craft magazines.

Keith finds great satisfaction in encouraging those who have always wanted to paint but lack confidence to try, as well as helping more experienced painters to develop their skills further. He hopes this book will be a constant companion to those wishing to improve their skills and experiment with new ways to paint the landscape.